CREATIVE
SKETCHING WORKSHOP

INSPIRATION, TIPS AND EXERCISES FOR SKETCHING ON THE MOVE

PETE SCULLY

APPLE

Contents

CREATIVE
SKETCHING WORKSHOP

INSPIRATION, TIPS AND EXERCISES FOR SKETCHING ON THE MOVE

First Published in the UK in 2015 by
Apple Press
74-77 White Lion Street
London N1 9PF
UK

www.apple-press.com

10 9 8 7 6 5 4 3 2 1

Manufactured in China

ISBN: 978-1-84543-629-2

Publisher: Mark Searle
Editorial Director: Isheeta Mustafi
Editor: Nick Jones
Assistant Editor: Tamsin Richardson
Design concept: Lucy Smith
Cover design: Agata Rybicka
Book layout: Tony Seddon

Cover Image Credits
Front cover: Pete Scully, Aldgate East, London, UK.
Spine: Pete Scully, Looking uphill, San Francisco, USA.
Back cover: Sigrid Albert, Under the U2 Eberswalder Straße station
in Berlin, Germany.

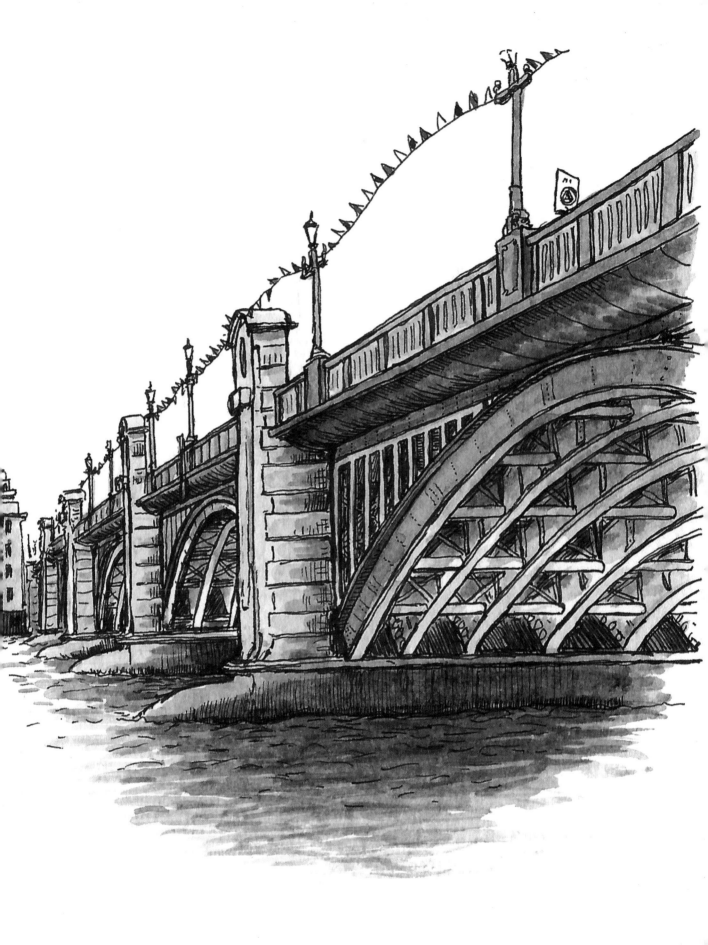

INTRODUCTION: Pete Scully

I sketch to record my world, but it sometimes takes a bit of practice. I went in and out of drawing for a long time, sometimes doing none at all for months. About 14 years ago I spent a year in Provence, France, and the change in scenery from rainy London inspired me to sketch my world more. But it was only after moving to California in 2005, when I discovered people starting to post their location drawings online, that I suddenly became motivated to sketch every day, and shared my own journey in my sketchblog. I was peering over the shoulders of other sketchers, both online and in group sketch crawls in San Francisco or Berkeley – seeing how other people did it, what pens they used, how they chose a subject, how fast they sketched. This exposure inspired me; I wasn't taking art classes, I had no formal training, but I started to learn through discovery of the online urban sketching community.

In this book, you will meet a number of intrepid sketchers from around the world, showing us in a series of workshops how they approach everyday sketching subjects you may come across. Rita Sabler from Portland, Oregon, shows you how she records a day in the life of her daughter, as well as sketching meal times and musicians. Nina Johansson from Stockholm, Sweden, who was one of my first sketching influences, explains how she approaches famous landmarks using different media. Singapore-based urban sketcher Paul Wang uses his vibrant painting style to draw buildings using shapes. In London, England, James Hobbs draws parks, gardens and waterside scenes with his distinctive bold lines. In Sydney, Australia, Liz Steel shows us ways to approach sketching both deserted spaces and our everyday workplaces.

Kumi Matsukawa from Tokyo, Japan, paints tall structures high above, while closer to earth she sketches people in motion. In New York, Melanie Reim guides us through the often daunting subject of sketching crowds. Ilga Leimanis in London talks about different ways of sketching architecture, animals and portraits, while in Istanbul, Turkey, Samantha Zaza shows us how she draws portraits of people encountered on her travels. In Santa Monica, California, Shiho Nakaza gives tips on sketching cafés, while Los Angeles artist Virginia Hein shows us views from the passenger seat on the American highway. This journey around the world will hopefully show you that sketching is for everybody, an individual pastime owned by you and for which there is no right or wrong.

In each of these artists' workshops, you will get a chance to explore different ideas and use them as starting points to practise your own sketching. This is a book designed for those who may be getting into sketching, or for more seasoned sketchers who want to broaden their range of subjects. We might not be showing you how you should sketch, but we hope to show you how to get the most out of what you can sketch, and through practice, raise your confidence levels. If you've ever been stuck on 'what to sketch', just remember that anything can be interesting if you take an interest in it, and sketching is one of the best ways to get interested in the world around you. All you need is something to draw with and something to draw on.

Pete Scully, Phonebox, Davis, USA

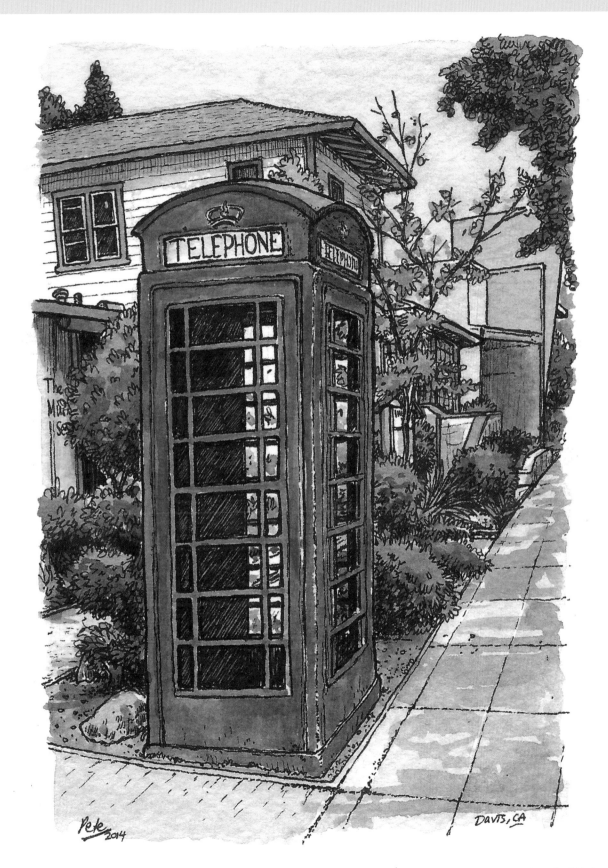

TELEPHONE

TELEPHONE

Pete 2014

DAVIS, CA

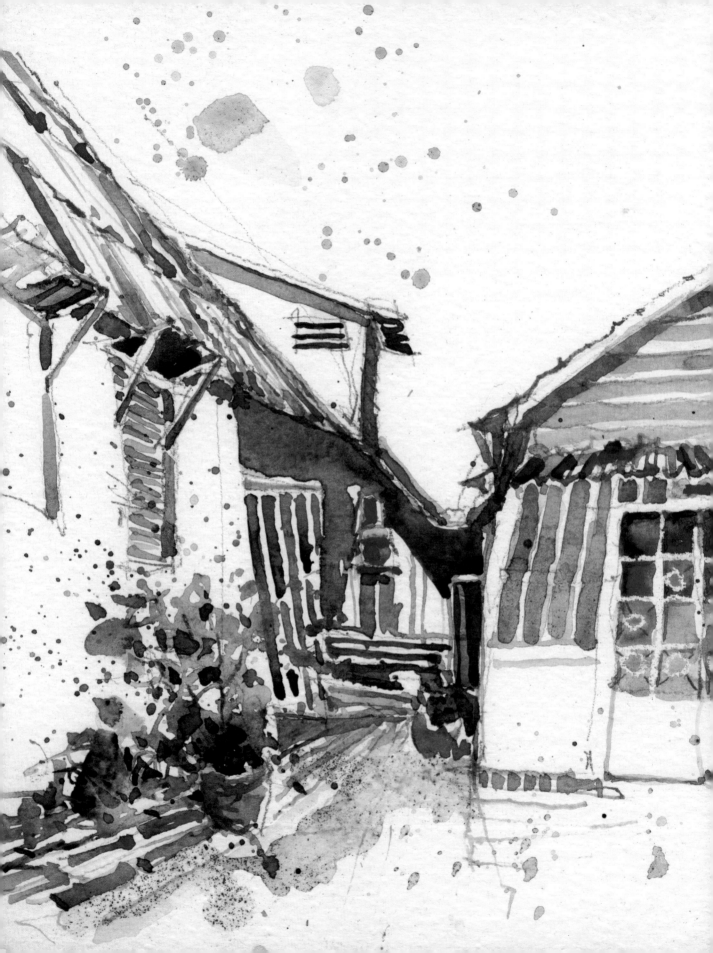

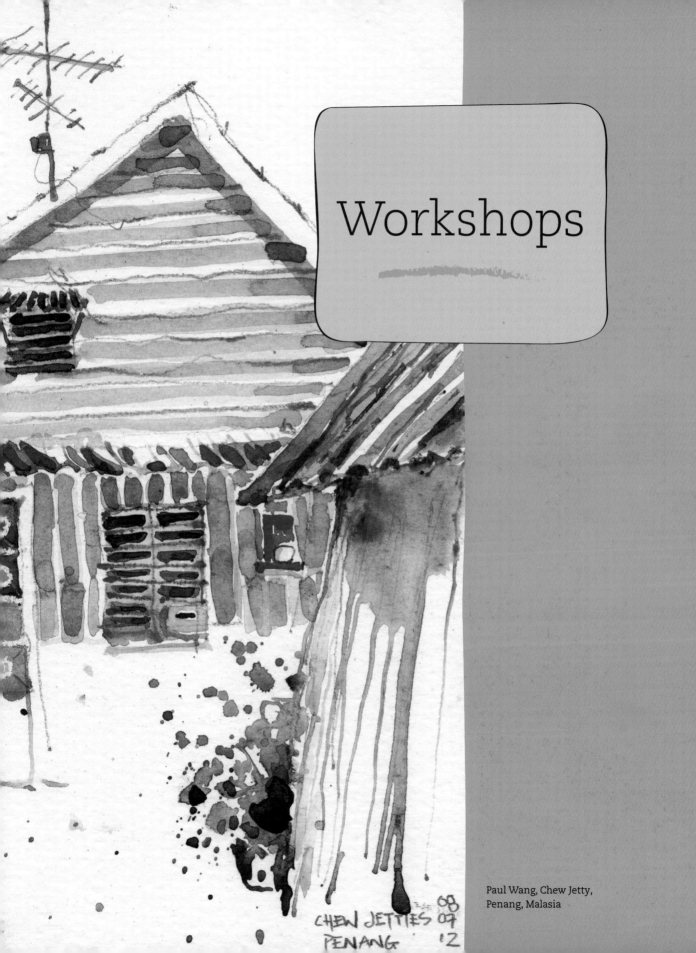

Workshops

Paul Wang, Chew Jetty,
Penang, Malasia

CHEW JETTIES 08
09
PENANG 12

BAR SKETCHING: Pete Scully

Sketching in bars and pubs can be both challenging and relaxing. Bars are like interactive urban theatres, offering a slice of people's lives as they mingle together. Join me at the bar, have a drink, relax and let the atmosphere soak into your sketches.

IDEAS TO GET YOU STARTED

1. Location. The very first challenge involved with sketching a bar is an obvious one – where to sit. Bars can be busy, and the best view may be taken. Go where there is space. Sometimes chance location can provide the best inspiration – sketching more intimate social scenes is often more reflective of a bar's personality than larger all-encompassing scenes. Find a nice spot and draw what you see.

2. Sketch your drinks. Glasses and cups are a good place to start, and useful practice for sketching curved objects. Notice how the light passes through or reflects on glass, or the shading of the beer bottle or mug of coffee. Another good starting point is the beer taps. Many brewers these days provide tap handles in all sorts of shapes and colourful designs. Try giving them thick, bold outlines to stand out, especially if you draw the rest of the bar afterwards. For a larger bar sketch, drawing the taps first can help with your sense of measurement – from your perspective, the taps reach so high, they line up with the shelf of bottles behind and so forth.

3. Work on the interior perspective. When I draw large bar scenes I sometimes start in the middle and work my way outwards, growing the sketch out from a central focal point; but more often than not I start on the left and work my way right. I never know how long it will take me to get as far as I am happy with, so I try not to bite off too much at once; in many highly detailed two-page panoramas I will get two-thirds in and feel burned out, but I already have the sketch I want. However, even when starting out very micro, it's a good idea to consider how the overall perspective will play out, and draw some lines in pen or pencil.

4. Sketch bottles behind the bar. Most bars tend to have a lot of bottles on display. While bottle shapes can be fun to draw, rows of similarly-shaped bottles can become rather maddening, so don't worry about being super accurate. The same can be said for stacks of glasses. Being a bit more sketchy with those elements, using looser lines and simpler shapes, reflects the way our eyes process them in real life. Play with the light to bring out the reflections. The best way to convey the illusion of light on paper is to increase the darkness of the areas around it.

5. Be playful with your materials. Sketching in a low-light interior, you may have to work harder to see things. Sketches are personal reflections, not photos. Be playful with your materials; if using pen, mess around and scribble a bit. Let chance take over. If using paint, you may have greater constraints in low light, as some colours will not show up at all. Some sketchers like to lay down a layer or block of paint first before starting a bar sketch, and then draw over the top, perhaps using white gel pen to add reflections or other effects.

6. Sketch the people. Bars, pubs and cafés are very social places. People will talk to you – sketching is a common conversation starter. Be discrete when sketching people, and courteous if they want to see. Be cautious of those around you – drinks often accidentally spill. Bar staff are busy and move quickly, being hard to capture in a sketch, but the number one rule when sketching them is to show them working hard! Including people in your sketches breaks up the repetitiveness of your scene, and sketches gain so much more character when they contain people.

THIS PAGE: Counting every detail, Little Prague, Davis, USA

OPPOSITE TOP: Escaping the rain, Dublin Castle, Camden, London, UK

OPPOSITE BOTTOM: De Vere's Irish Pub, Davis, USA

ALL IMAGES PETE SCULLY

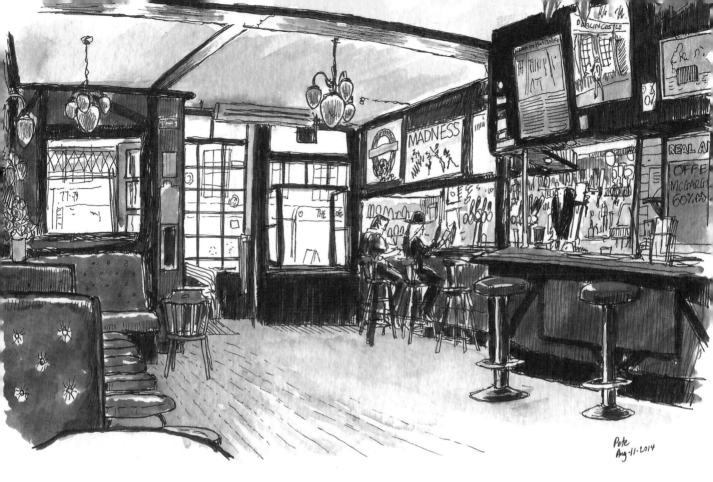

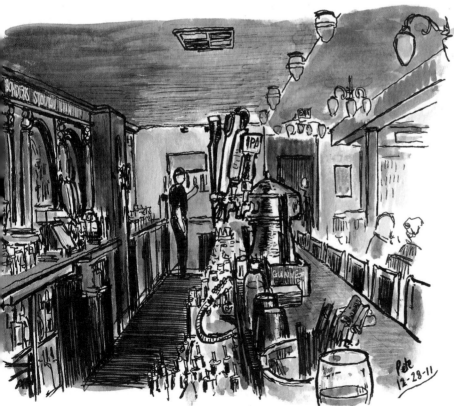

THIS EXERCISE WILL HELP YOU:

- Master interior perspective
- Discover ways to express light and shading
- Convey atmosphere in social settings
- Sketch people at work and play
- Sketch in low light

Bars give the urban sketcher a range of different skill sets to practice, such as interior perspective, low-light sketching, reflections from different surfaces, repetitive shapes and of course people. In the following examples I share my own approach to bar sketching, and how I overcame the difficulties involved.

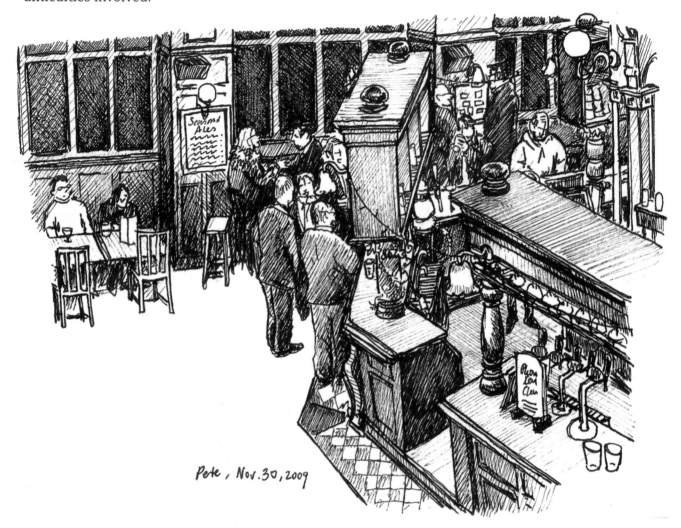

Pete, Nov. 30, 2009

THIS PAGE: The Coal Hole, London, UK

OPPOSITE: Sophia's, Davis, USA

ALL IMAGES PETE SCULLY

CREATING A SCENE FROM ABOVE

Most bar sketches are done from an eye-level perspective, but in this pub on London's Strand I was lucky enough to sketch from above. I kept the floor completely white rather than add the patterns to give the sketch a distinctive shape, which illustrated the way people were huddled at the bar or the tables by the wall.

DARK INK OVER WARM WASH

With this sketch I wanted to convey the warm
light from the bar in an otherwise low-lit room.
I laid down a couple of warm yellow/orange
washes, and then just let loose with the pen.
The people at different levels at the bar contrasted
with the orderly rows of bottles, and I made sure
to sketch the barman hard at work. I used a little
white gel pen to help accentuate the lighting
a little more.

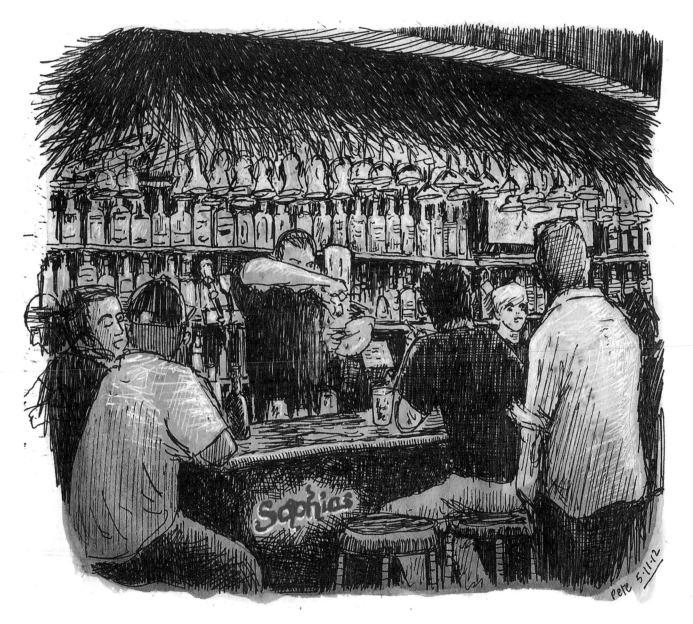

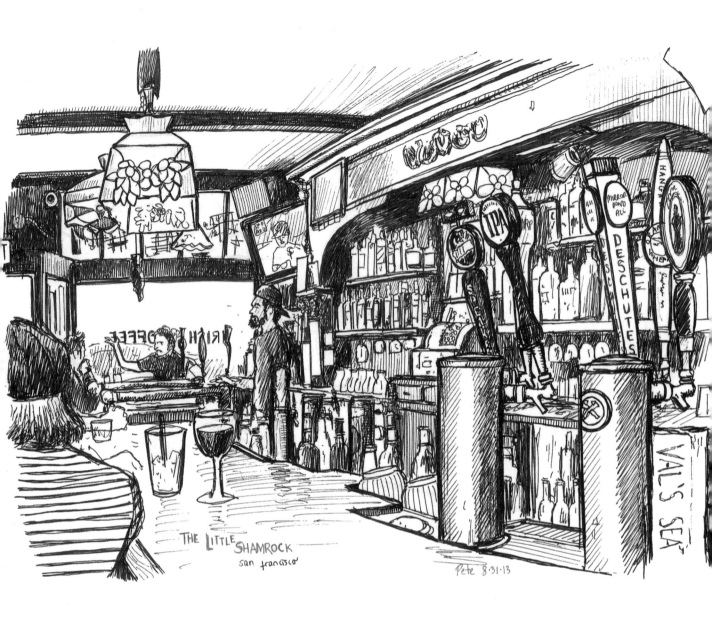

THE LITTLE SHAMROCK
san francisco

Pete 8·31·13

SHOWING LIGHT BY ADDING DARK

THIS PAGE: The Little Shamrock, San Francisco, USA

OPPOSITE: Sweet Spot, Santa Rosa, USA

ALL IMAGES PETE SCULLY

After sketching the exterior of this century-old San Francisco pub opposite Golden Gate Park, I came in to have a pint and sketch the bar. I started with the beer taps, giving them a thick outline to help them stand out, before mapping out the rest of the scene. Sketching in pen only I had to emphasise the dark elements behind the bar to show the light on the bottles, and the September sunlight filtering in from the window reflected on the smooth lacquered bar. I chatted to the bar-staff and the people seated next to me, and watched the guys at the end of the bar gesticulate about sports and other important issues. Bars are places for stories, and this one has a great many to tell.

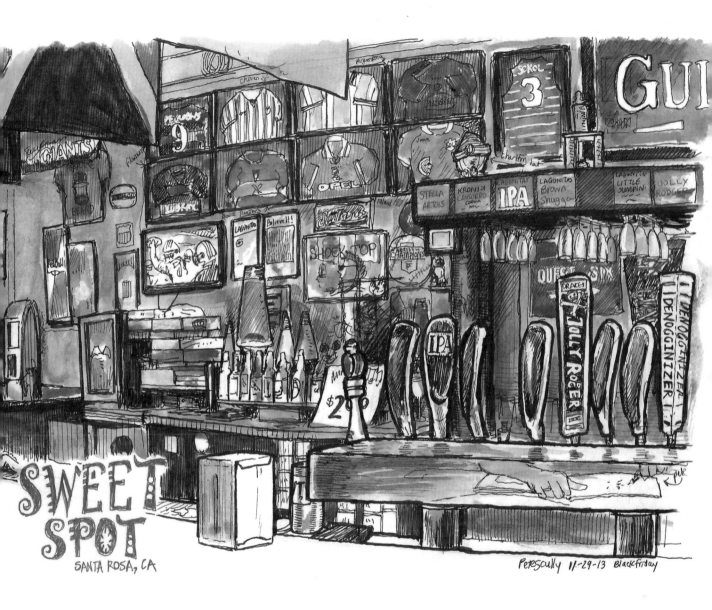

CAPTURING COLOUR AND DETAIL

We were visiting family in Santa Rosa, and in the evening I went to a local bar, Sweet Spot, to sketch the colourful displays of football shirts on the wall. This was an exercise in both observation of detail and of measuring by sight; I wanted to make sure everything lined up just as I could see it. Of course, one thing to remember is that unless someone is physically comparing it to the actual spot, it doesn't matter if it is not exactly perfect, because what you are drawing is a representation, not a photograph, and you can get a lot more real feeling in a sketch.

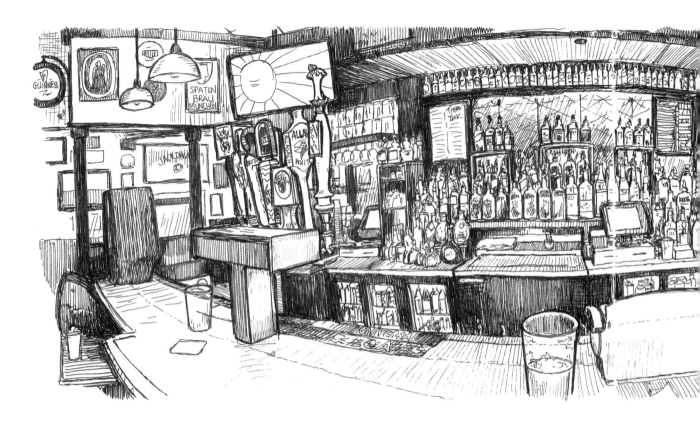

OPPOSITE TOP: Wunderbar, Davis, USA

OPPOSITE BOTTOM: University of Beer, Davis, USA

ALL IMAGES PETE SCULLY

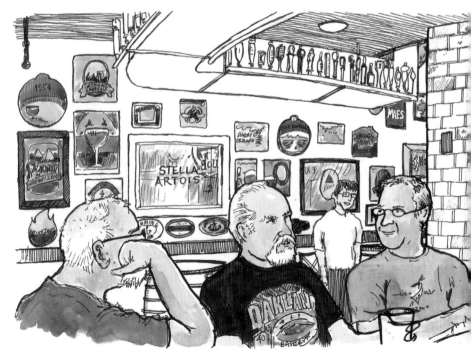

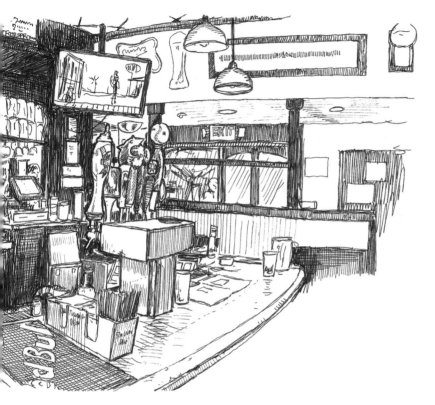

CURVING THE PANORAMA

I played with the perspective in this one, curving it so that I could get either end of the bar into the sketch. This is a mid-sized bar area, and I was lucky enough to find a seat right in the middle. The light was inconsistent, changing from bright to coloured, so it was not always easy to see well. I don't recall how long this took to sketch, but I think it was about three beers. It's easier to measure time in drinks, though when I am sketching I tend to drink or eat very slowly. If attempting a sketch like this, it is good to plan it out a little, but don't be afraid to dive straight in. In this sketch I drew in 'layers' – the front layer (the bar, glasses, beer taps) first, then the area behind the bar from the fridges to the ceiling, followed by the side and the lamps, before I finally added the bottles and mirror.

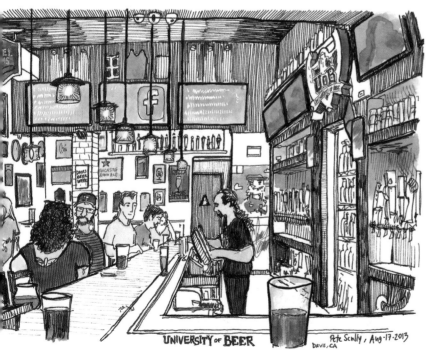

UNIVERSITY of BEER
DAVIS, CA
Pete Scully, Aug·17·2013

PORTRAYING PEOPLE AND PLOTTING PERSPECTIVE

Summers are hot in Davis, and this bar was the perfect place to come in on a Saturday afternoon and cool off. It's an attractive place to sketch, with colourful metal beer signs lining the walls. I had to concentrate on the perspective, but with interior perspective, I try to line up the things that are the same height – hanging lamps, shelves, etc. – to use as guidelines. People may be different heights, but on average most people sitting at a bar will be at roughly the same head height, so use people as a natural perspective line. I listened to the fellows at the bar talking about all the things that used to be on that particular street in decades past. I drew them with smiles on their faces, and I was smiling myself.

CITY CAFÉ: Shiho Nakaza

Cafés are good places to sketch because they allow you to sit in public and observe. They are usually less formal than restaurants and have better lighting than pubs or bars, which is important if you want to paint. The relaxed atmosphere of cafés will allow you to sketch without rushing to finish your sketch.

For this exercise, find a seat with a table that is not likely to be jostled or be in the way of people walking by. Consider taking a seat by the window if you want to include the view of the outside. Choose a corner table or sit with your back against the wall if you do not want to draw attention to yourself. Use a small sketchbook and portable art supplies that fit comfortably on a table. Being a customer of the café yourself will allow you to blend in with the crowd so you can observe freely.

IDEAS TO GET YOU STARTED

1. Observe details that could tell a story. Take a moment to observe before you put any marks on the paper. Take in the characteristics of the place. Are there any interesting decorations, colour combinations or architectural details? Is the café bright and sunny, or dark and cosy? Is it daytime or nighttime? You may even be outdoors. Next, observe the people. Are they engaged in a lively conversation, or are they quietly studying or reading? Watch how people are sitting or moving, and observe what they are wearing.

2. Develop your sketching speed. You will find you'll be able to sketch faster with additional practice. Learn to develop your sketching speed by capturing people's gestures and noting simple shapes. Learning how to draw faster will help your sketching skill overall by allowing you to capture the scene in an efficient manner.

3. Learn to draw people. Cafés are good places to learn to sketch people because most customers at a café will stay seated long enough for you to sketch them with more detail than people who are actively moving or exercising. Experiment with varying the time you visit the café; different crowds will visit the café during different times of the day. Usually there is a flow of customers coming and going, so this gives you plenty of variety to practice.

4. Draw a prop or an architectural detail to establish a sense of place. Including props such as cups or a group of tables and chairs will indicate where you are because most people know what cafés look like. Try drawing people with their drinks to further communicate that this is a café. Show scale by drawing people relative to their surroundings. If the setting is special – maybe it's outdoors, or inside a notable building – adding architectural details or outdoor furniture such as umbrellas will help tell the story.

5. Draw portraits. If you are new to sketching people, it is easier to capture portraits of people who are engrossed in an activity and sitting still, like those who are reading or looking at an electronic gadget. You can focus on simply drawing the upper body visible above the table. Start by observing how they are tilting their head. Note how people sit differently. Draw a circular shape for the head and a curve for the direction of the body, then add details.

6. Draw a group of people. Start by observing two people who are engaged in a conversation. Pay attention to their gestures. How are they sitting? How are they moving their hands? Are they nodding, tilting their heads, sitting askew or crossing their legs? What kinds of facial expressions do they have? Capture how they are interacting with each other by sketching their gestures first, or draw an overall shape of the group before going into detail.

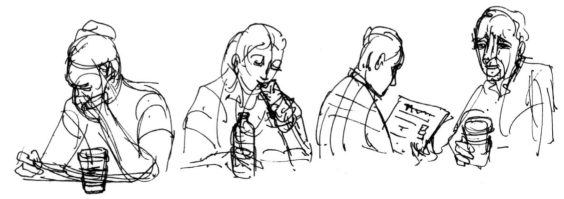

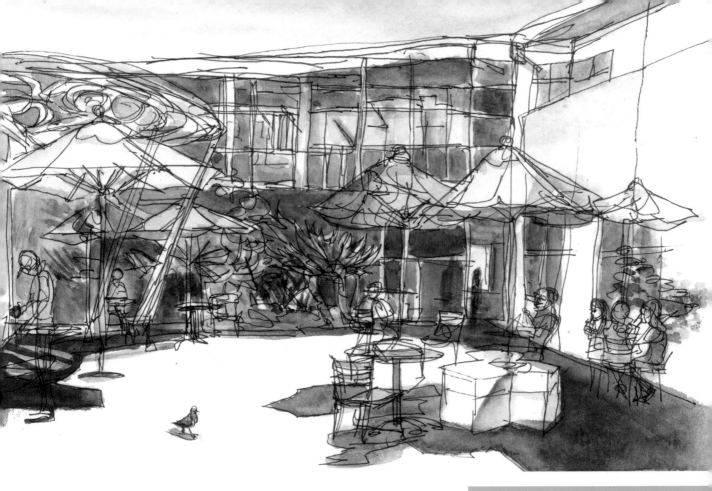

OPPOSITE: Group portraits,
Santa Monica, USA

THIS PAGE TOP: Santa Monica
Public Library, USA

THIS PAGE BOTTOM: Café thumbnails,
Santo Domingo, Dominican Republic

ALL IMAGES SHIHO NAKAZA

Every artist has a unique approach to sketching in cafés, and will have different reasons for finding them an appealing subject matter. Cafés are commonly found in cities around the world, so you can often find one and sketch there while you are travelling. Some sketchers actively seek out cafés to draw in, while others sketch simply to pass the time. Some sketchers frequent the same cafés regularly, which allows them to become familiar with the places while still allowing them to notice the changes that happen during each visit.

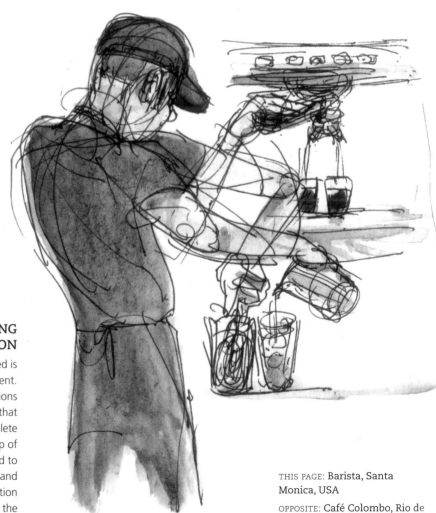

SPEED SKETCHING PEOPLE IN ACTION

A good way to develop your sketching speed is to sketch someone doing a repeating movement. I watched a barista go through the same motions every time he made coffee. This assured me that there was no need to capture the complete action all at once, even though each cup of coffee was made within minutes. I started to make a sketch of one part of the action, and waited and added more details when that action was repeated for another order. I overlapped the arms performing each part of the process to emphasise movement.

THIS PAGE: **Barista, Santa Monica, USA**

OPPOSITE: **Café Colombo, Rio de Janeiro, Brazil**

ALL IMAGES SHIHO NAKAZA

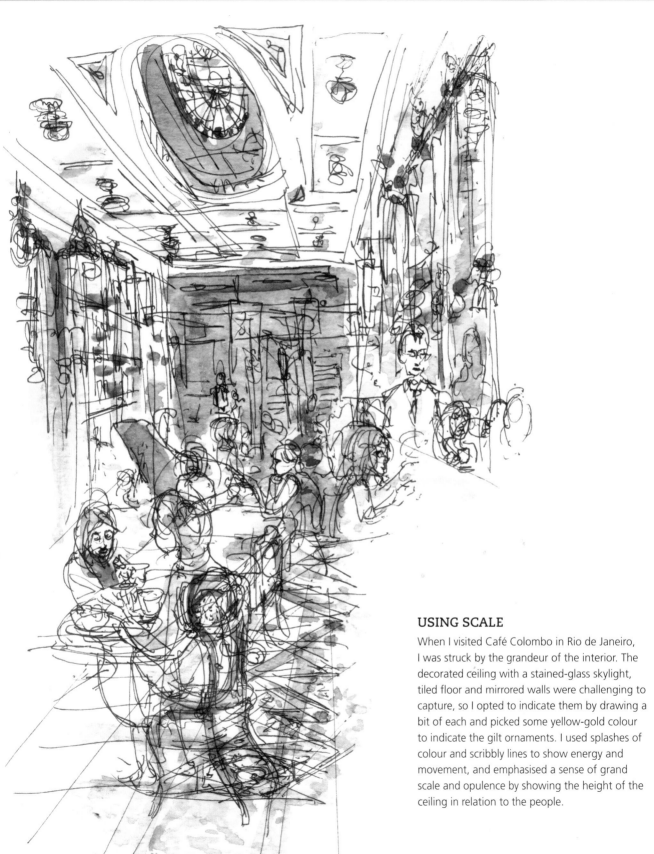

USING SCALE

When I visited Café Colombo in Rio de Janeiro, I was struck by the grandeur of the interior. The decorated ceiling with a stained-glass skylight, tiled floor and mirrored walls were challenging to capture, so I opted to indicate them by drawing a bit of each and picked some yellow-gold colour to indicate the gilt ornaments. I used splashes of colour and scribbly lines to show energy and movement, and emphasised a sense of grand scale and opulence by showing the height of the ceiling in relation to the people.

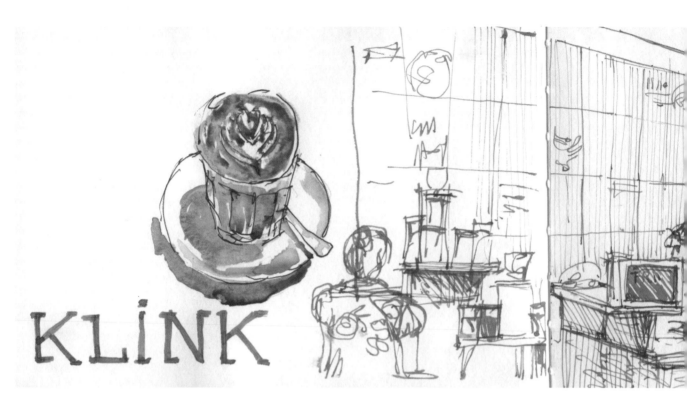

COMPOSING A SCENE

You may be more interested in describing the counter space (right), which usually has an assortment of containers and equipment along with people who are taking orders and making drinks. Composing a scene together with still objects and people in action will help tell the story of what is happening at this café. Play with lines, colour and texture to communicate what the counter looks like. (Many cafés allow you to sit at the counter to sketch, but be mindful of people waiting for a seat if the place is busy with customers.)

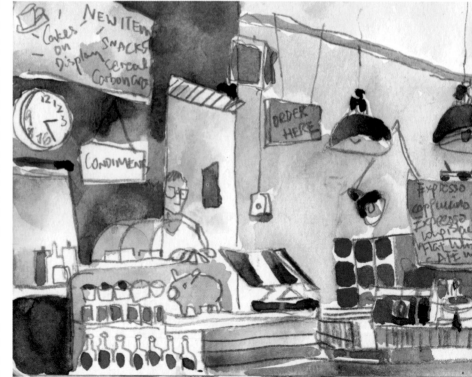

THIS PAGE TOP: Liz Steel, Klink Handmade Espresso, Sydney, Australia

THIS PAGE BOTTOM: Paul Wang, Tolido's Expresso Nooks, Singapore

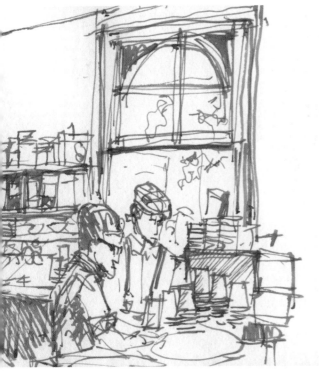

OBSERVING AND JOURNALING

Sometimes the focus of your sketch will be on journaling your experience of having a drink in a café (left). You may want to make a sketch of the cup itself, and add text for further explanation of what you were doing. This kind of sketch is a visual diary that records your activity while often allowing you to experiment with new art materials or colours. Unlike sketches that emphasise the capturing of quick actions, this type of sketch will allow you to put more thought into arranging the elements on a page to create a pleasing composition.

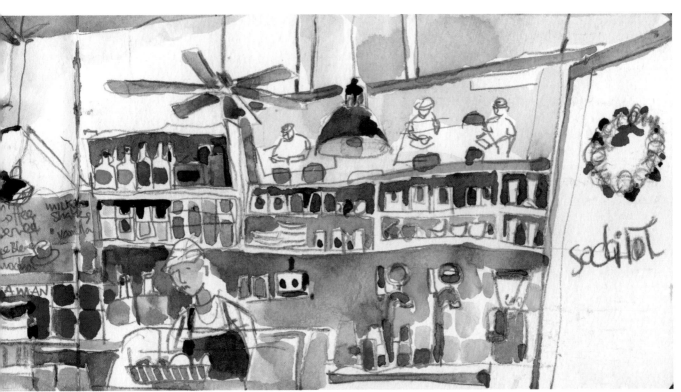

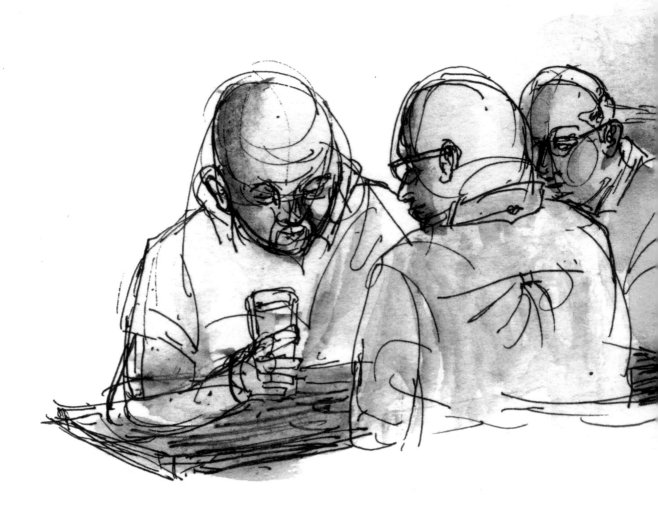

DRAWING GROUPS OF PEOPLE

For this sketch I concentrated on capturing people rather than the interior. I paid attention to the different activities that people were involved in and different directions that they were facing in order to capture variety in action. I overlapped the figures to show depth. Colouring the background area dark with neutral colours while colouring the group in the foreground with lighter and brighter colours also helped to convey a sense of distance and brought focus to the people talking in the foreground.

ESTABLISHING A SENSE OF SPACE

Here the focus is on establishing a sense of space. Note that the interior is drawn from the vantage point of the table in the foreground. This table is drawn only partially, which implies that the artist was sitting at this table to draw and could only see the space immediately beyond the sketchbook, in turn inviting the viewer to explore the artwork from a sketcher's point of view. Additional props like equipment on the counter and art on the walls further describe the café.

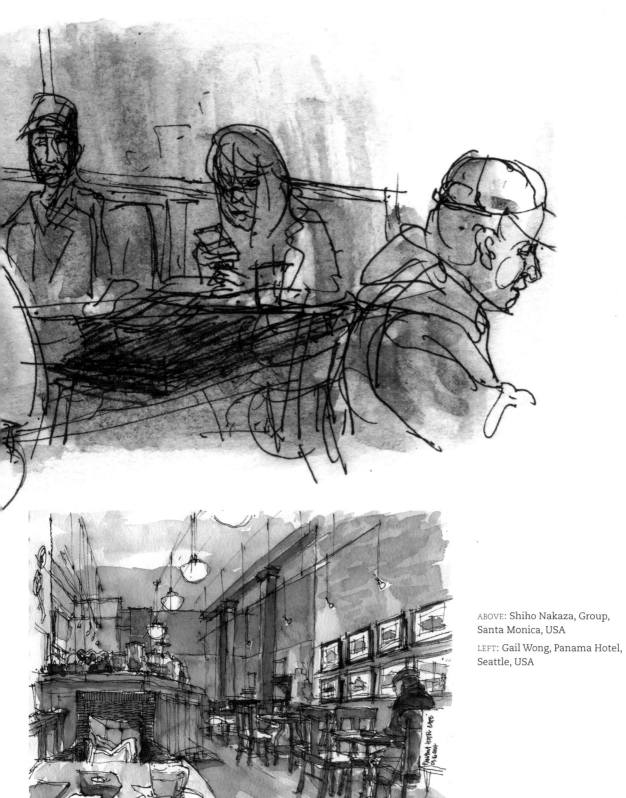

ABOVE: Shiho Nakaza, Group, Santa Monica, USA

LEFT: Gail Wong, Panama Hotel, Seattle, USA

COOKING AND MEAL TIMES: Rita Sabler

Cooking and eating food is something that we do universally as human beings, and drawing at meal times is a fun exercise that commemorates this daily necessity. Drawing things that are sitting in front of us and won't move anytime soon is more relaxing than trying to capture moving targets, although there is always the danger your subject could be eaten.

IDEAS TO GET YOU STARTED

1. Go treasure hunting. Visit your local farmer's or fish market and collect samples of the most unusual and interesting foods you can find. Exotic fruit, quirky mushrooms, strangely shaped root vegetables, bright peppers, alien-looking shellfish. Go for visual interest – this will also give you an additional challenge when it comes to cooking it later. Pick things to draw with a lot of personality and texture. Go to places that you typically do not visit. Things we are not accustomed to seeing make for exciting sketch subjects.

2. Work on composition. You could simply draw your plate before or halfway through the meal, or try arranging and drawing things by food group, texture, colour or assembling your produce in such a way that one subject becomes the centre of your composition. Give yourself a time limit for this exercise, so that the result still looks alive and loose.

3. Treat yourself to a multi-course meal. One delicious and exhilarating exercise is to capture all of the courses as they are being brought out. You could do it at a family dinner or a fancy restaurant. Have your sketchbook ready but leave space for the food. Be ready to draw quickly or your companions will get impatient and eat your 'model'. Ask for names of the dishes and write them down. Make captions of how things taste and smell to bring the viewer even closer to your subject.

4. Give your drawing a sense of dimension. Most of the things you will be drawing at meals will involve close-ups – no need to worry much about perspective. However, do not overlook shadows and highlights; they will make your subject seem a lot more real. Look for shadows that are cast by plates and utensils as well as by the food itself. Pay attention to the highlights as well – strategically left areas of white paper can do wonders for your drawings of delicious fruit, or the glistening scales of fresh sardines.

5. Draw all the steps involved in preparing a dish. Make small vignettes of all of the steps in preparation, from chopping to adding ingredients to stirring. The idea here is to focus on the process – the steps leading to the final result. You can use arrows, numbers and captions to further reinforce this idea. Don't forget to include the rendering of the finished product – a fancy cake or a roasted turkey in all of its delicious glory.

6. Draw people engaged in food preparation. If you know someone who is a great cook and derives great pleasure and pride from cooking or baking, ask them if you can draw them, or invite some friends to come and cook together in your kitchen. You will have to work quickly and make sure that you can capture their hands as they knead and chop. What's more, many interesting conversations and secrets are exchanged in the kitchen.

THIS PAGE: Morel mushroom, Pitaya, Buddha's Head, Portland, USA

OPPOSITE TOP: International Women's Day brunch, Hood River, USA

OPPOSITE BOTTOM: Seafood, Portland, USA

ALL IMAGES RITA SABLER

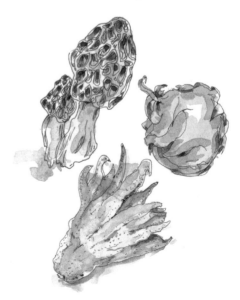

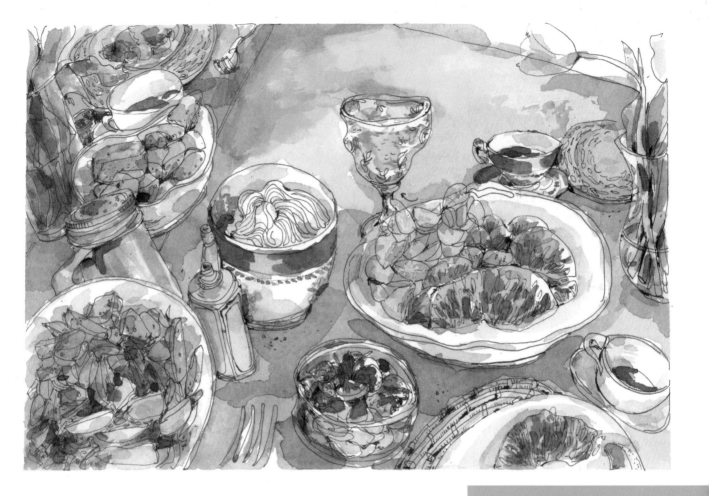

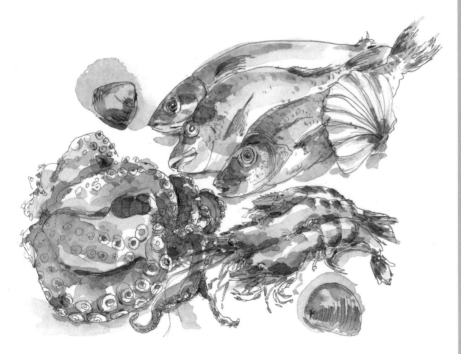

THIS EXERCISE WILL HELP YOU:

- Observe and draw shapes and the texture of individual ingredients and prepared food

- Convey the taste, smell and experience of a meal

- Practise composition techniques

- Draw people involved in cooking

- Learn to report the multi-step process from start to finish

As I draw anything from a jar of mustard on my breakfast table to a fancy multi-course dinner, my goal is not to paint a perfectly rendered still life, but to make a sketch that is alive and loose and gets a sense of the transient moment of my everyday life.

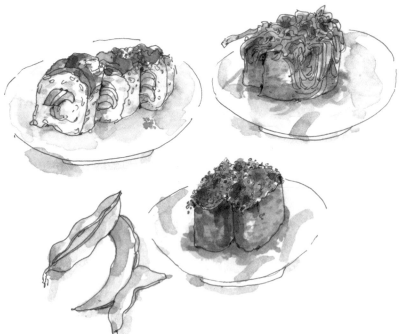

DRAWING SUSHI

Sushi can rightfully claim its spot as the most aesthetically pleasing food in the world. Drawing sushi (left) is a great exercise for someone who likes to use vibrant colours. I, for one, have to exercise a lot of restraint not to oversaturate my reds and greens. I add a little bit of indigo to my dark forest green to colour the seaweed. The shapes are pretty simple, so one can focus almost entirely on colours and textures.

DRAWING A VALENTINE'S DAY BRUNCH

It's a good idea to draw courses as they are being introduced by your server or host. I drew this delicious four-course brunch (right) while on a romantic date for Valentine's Day. I didn't have time to plan a thought-out composition – I drew dishes as they were being brought out and before they disappeared. Before I began to apply colour I marked the highlights on my subject with the faintest pencil line to remind myself not to colour over them.

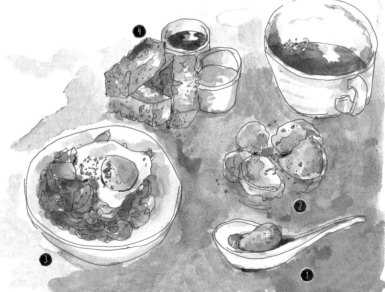

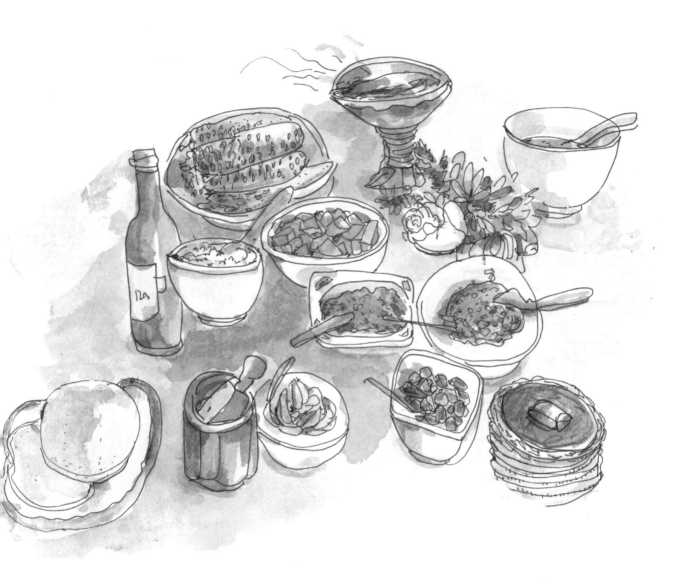

DRAWING A MAYAN BBQ

This delicious meal was prepared in an outdoor
kitchen on the beach near Tulum, Mexico. The
colours – oranges of the fresh papaya, rich
browns and yellows of the grilled corn, the
greens of cucumbers, guacamole and salsa –
went quite nicely together. The resin of a tree
(copal) was smouldering away at the head of the
table. I stood over the table with the sketchbook,
which allowed me to move around and get a
better view of the contents of each plate as they
were being set on the table.

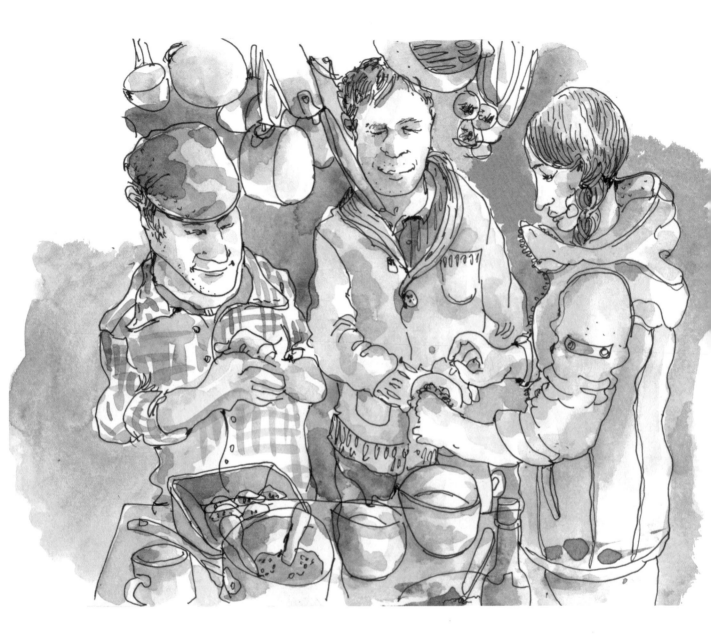

CHINESE NEW YEAR DUMPLING MAKING

THIS PAGE: Making dumplings on Chinese New Year, Hood River, USA

OPPOSITE: Breakfast at Beaterville, Portland, USA

ALL IMAGES RITA SABLER

For Chinese New Year some friends of mine got together to learn how to make dumplings. We gathered around the kitchen island, rolled up our sleeves and went straight to work. I made sure the sketch captured the ingredients and some of the cookware, as well as the action of meticulously folding the gentle wrapper around its delicious contents. As the hands were folding, my friends were teasing each other about their skills at picking the right amount of the stuffing, as no one wanted to be the one whose dumpling burst in the boiling water.

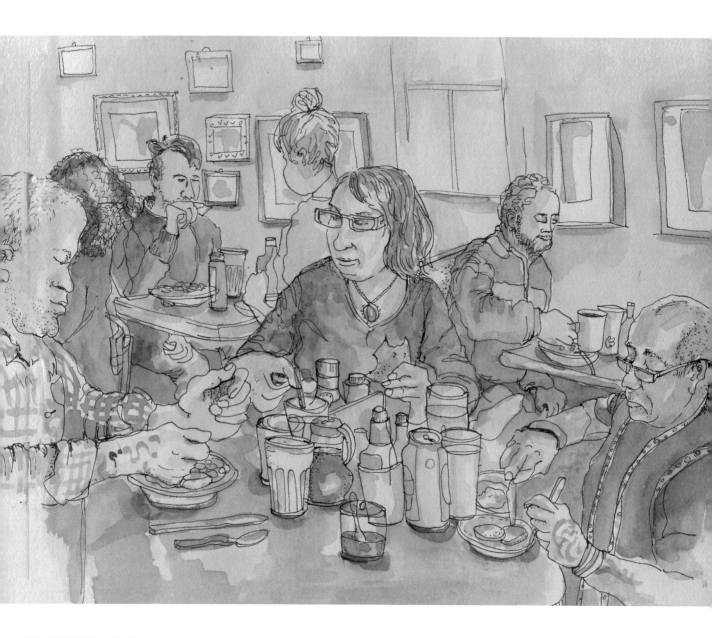

DRAWING A RESTAURANT MEAL

Drawing restaurant meals is almost second nature for me, as there is a lot of 'sketching' time one gets while ordering and waiting for food. Drawing people while they are enjoying their meals requires a little more risk-taking from a sketcher, especially if you are drawing complete strangers. I find most of the time my subjects are so consumed by their meal and conversation that I go almost unnoticed. Restaurant tables are typically crowded with dishware, jars, condiments, utensils and glasses. Make sure you draw those in, as they instantly give the sense of the place in time.

WORKPLACES: Liz Steel

We all work in different places and in different ways. We might not have an office job from nine to five, but we do the same things on a daily or weekly basis. Sketching the place where we do our work and the tools of our trades can say a lot about who we are and what we do.

The way that we organise our space, interact with other people and respond to our environment affects the comfort and ease in which we work. It is this connection between what we are doing and the objects and space around us that I explore in this exercise.

IDEAS TO GET YOU STARTED

1. Draw your workspace – your main work area/surface.
Most of us spend a lot of time working at the same spot, so pause in the middle of a project and draw the view sitting at your desk. Alternatively, step back and sketch it from a different angle. Using a pen, start drawing one object and then the next until you have created a sketch of your whole area. Add crosshatching to indicate the colour, shading or texture.

2. What are the tools of your trade? Rather than tackle a whole scene, look for a random composition of a few tools as they are placed during use. For this exercise, use paint first and only partial outlines, if needed, at the end. Focus on the overall shapes and try to simplify them as much as possible.

3. Draw the environment where you work. When it comes to sketching complex scenes, such as office interiors, setting up a line of sight and a few major shapes with pencil first will help to get everything in the right place initially. You can then start filling in the details, working as descriptively or as expressively as you like, depending on the time you have to complete the sketch. Include your co-workers and your connection with the outside world.

4. Visit and sketch the workspaces of friends. Before going out in public and sketching complete strangers, you might like to sketch the workplaces of your friends. Think about what is important for them and the way they work – how is it different to yours? Is there anything about their workplace that describes their character?

5. The workplaces of others when you are out and about. Observe the people that work in places you visit during your daily life. What are their workplaces like? What would it be like to work in that environment? When you sketch the worker, make sure you include this context as it is a major part of their story. If the workers are absent, how much do the workplaces tell the story about what work goes on when they are inhabited?

THIS PAGE: Carol Hsiung, The office visit, Westchester, New York, USA

OPPOSITE TOP: Gabi Campanario, The Seattle Times, Theo Chocolate Factory roaster, Seattle, USA

OPPOSITE BOTTOM: Liz Steel, My home studio, Sydney, Australia

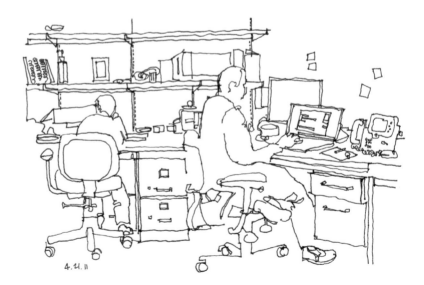

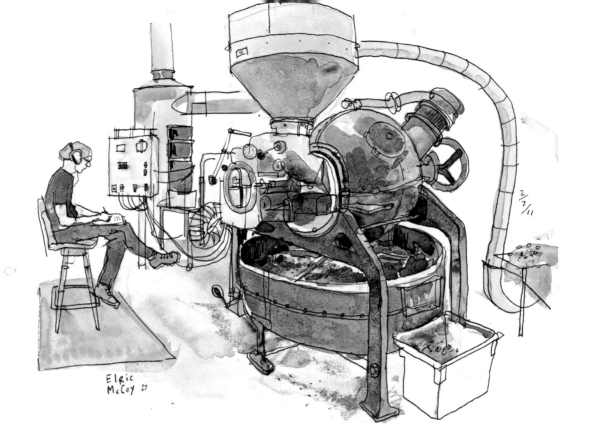

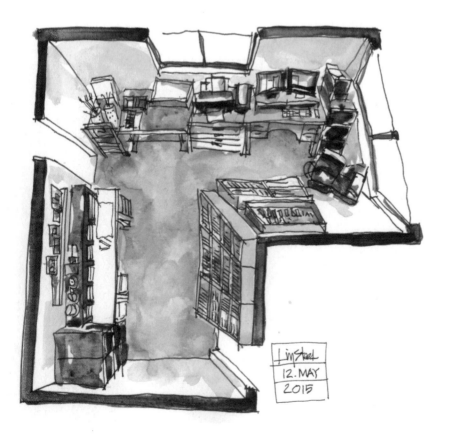

This exercise will get you sketching your own workplace and tools, using lines and shapes, before tackling more complex scenes out on location. By recording your own space, you will become more attuned to the workplaces of others everywhere you go, giving you a richer story to tell in your sketches.

THIS PAGE: Model-making, Sydney, Australia

OPPOSITE: My desk, Sydney, Australia

ALL IMAGES LIZ STEEL

TOOLS OF THE TRADE

Rather than tackling a complex scene, a few tools on your work surface can also tell a story about what you were doing. By focusing on the shapes and painting these first, you can create a more expressive sketch than if you start drawing in pen. Try to simplify and connect the shapes as much as possible. Add lines afterwards, only where needed to define major edges, details or text. Finally, indicate the work surface but only partially, once again mixing line with colour. In the sketch opposite, I used watercolour paint, water soluble pencil and ink to create a loose sketch of my model-making tools. The paint splashes express the messiness of getting glue everywhere!

DRAW YOUR WORKSPACE

There are often many objects crowded onto my desk, so I started with the outline of my keyboard and then progressively worked from one object to the next, carefully observing the relationships between them. How long was one edge in relation to the next? Did they overlap? What was the negative space between objects? After the outlines were completed, I used crosshatching to indicate shading first, then added more hatching to indicate the dark colours, and finally some texture. Although your workspace might be a very complex, even messy scene, working in this way will enable you to capture the whole thing, one object at a time.

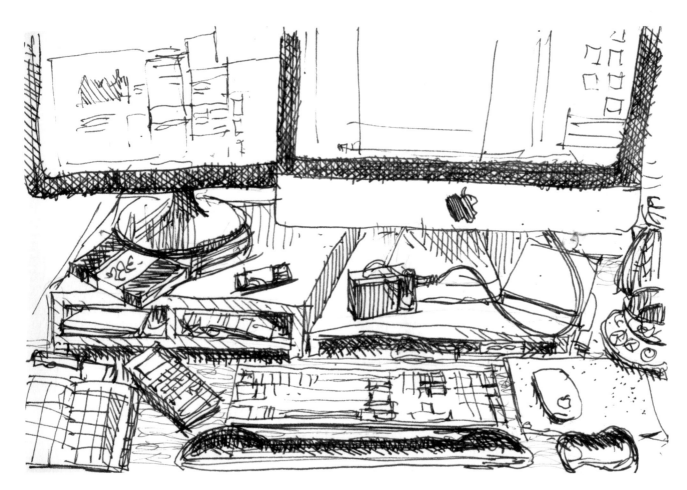

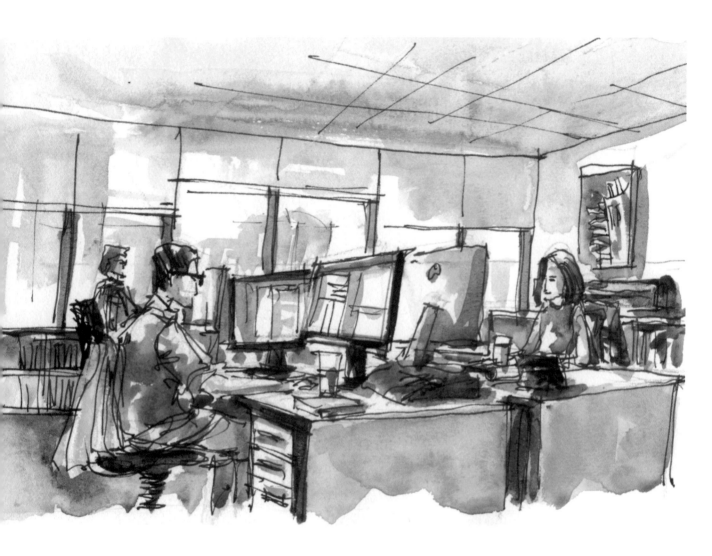

YOUR WORK ENVIRONMENT

For a complex interior scene it is often helpful to start with a few pencil guidelines to ensure that everything is located with a degree of accuracy, before having fun with the details. I started with the line of sight, which, as I was seated, approximately aligned with everyone's eyes. I added a few perspective lines for the ceiling and the desks, and then some rough shapes for the people. Once this set-up was in place, I was able to work loosely, adding all the details with my pen, and then finally watercolour.

WORKPLACES OF FRIENDS

After tackling your own work environment, go and visit a friend's workplace and see how it is different from your own and what it tells you about them. This sketch of my dad's shed brings back many memories of Saturday afternoons when I was a kid, watching him work. His workbench is made up of a random collection of recycled cupboards, shelves and furniture, and although packed with lots of tools and materials, every item is carefully located. The old radio and models from my university days hanging from the roof rafters say so much about my dad – how he collects, sorts and reuses everything!

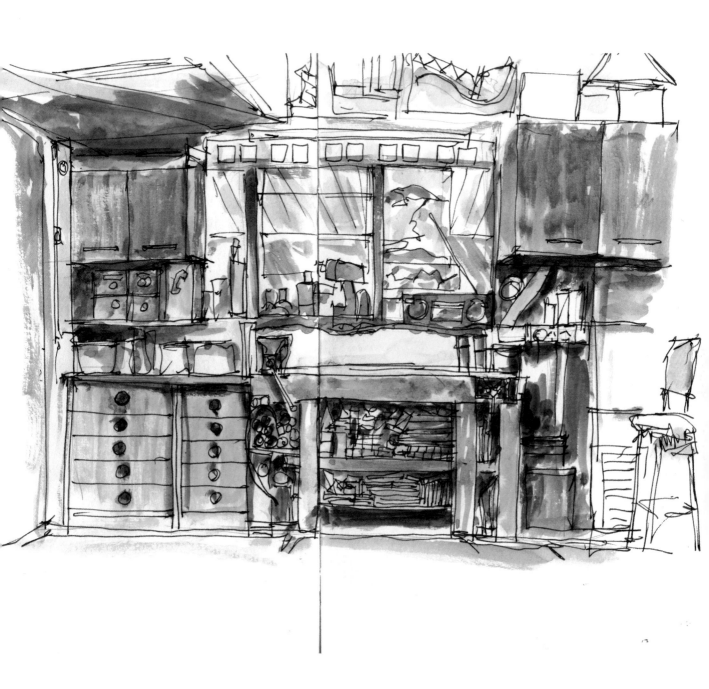

OPPOSITE: **Architect's office,**
Sydney, Australia

THIS PAGE: **My dad's shed,**
Sydney, Australia

ALL IMAGES LIZ STEEL

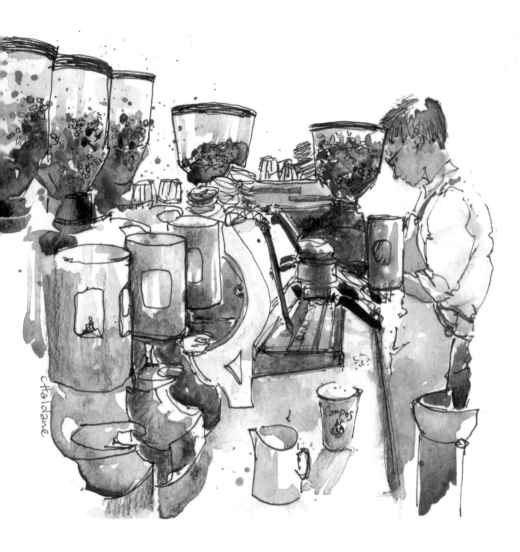

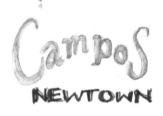

THIS PAGE: Chris Haldane, Coffee Heaven, Campos Newtown, Sydney, Australia

OPPOSITE TOP: Sylvia Bargain, Tout en négociant, Cahors, France

OPPOSITE BOTTOM: Stephen Reddy, Cameron Catering, Seattle, USA

WORKPLACES OF OTHERS 1

We know that baristas spend all day making cups of coffee, but often all we see is a head behind a big machine. This sketch shows us the other side and captures the feeling of being surrounded by coffee beans. The carefully placed milk jug and takeaway cup in the foreground are also an important part of the story. The repetitive nature of making coffees will help you draw a moving barista, as he will come back to the same positions over and over again.

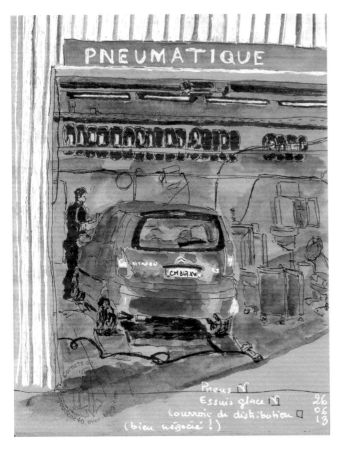

WORKPLACES OF OTHERS 2

This sketch tells us a lot about what it would be like to work as a mechanic. The composition includes the exterior of the garage, with its signage, and the light draws us inside through the big opening. The car, the object of the mechanic's work, stands out due to its bright red colour, while the mechanic himself, with all his tools, and the row of tyres, fills in the rest of the image. The use of toned paper and white highlights really captures the inside/outside nature of this workplace.

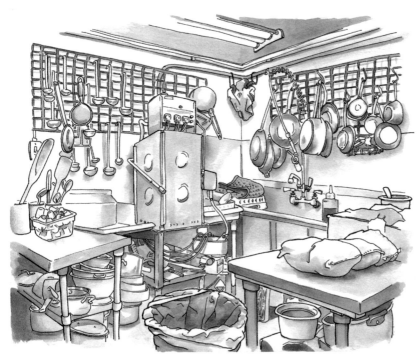

WORKPLACES OF OTHERS 3

Even though there isn't a person included in this sketch, we get the full sense of how busy and active this place would be when inhabited. The number of kitchen utensils and pots and pans, close at hand and waiting for use, is what gives this strong impression. Limiting the sketch to a monotone study helps control the complexity of this scene, making it easily readable. The point of view chosen, looking between the benches, draws us into the composition and we feel as if we are standing in the middle of the kitchen, ready to start cooking.

SKETCHING A SERIES: Pete Scully

Even the most creative of minds can get stuck. What do I draw?
How do I find inspiration?

One way is to pick a particular type of object around the home – shoes, tools, bottles – or maybe something outside, such as fire hydrants, newspaper stands, interesting cars or larger buildings such as churches. Then, all at once or over a period of time, draw a series of them. That way, you'll always have a subject to come back to to get your creativity flowing again.

IDEAS TO GET YOU STARTED

1. Start small and draw fast. Drawing large and complicated objects can be daunting. Find a series of small and simple objects that can each be drawn in less than half an hour. Finishing one quickly will motivate you to move to the next.

2. Draw to create mementos. Find objects that you may not always have forever and immortalise them in a sketch. Good examples are your children's shoes, toys, movie tickets, keyrings, favourite pens, sports equipment. Such drawings become immortal keepsakes. Drawing your meals is a popular sketching theme, and a great way to create a diary of what you've been eating. Sketching quickly before it gets cold is a good idea!

3. Explore! Use the search for similar-themed subjects as an excuse to wander. I like sketching fire hydrants, and it's fun to go looking for them. Other urban themes to sketch include lamp posts, phone boxes, postboxes, chimneys or old vehicles. You'll be amazed at the variety of each theme you discover.

4. Draw animals. You could draw the local cats in your area, or each of your friends' dogs, if you're so inclined. Go to an aquarium and draw twenty different types of fish. If you are the birdwatching type, take your sketchbook out and capture different breeds as you see them – but you have to be quick!

5. Sketch a series of themed buildings. If you live in a big city, or if you like to travel, you could sketch a series of buildings by the same architect (Christopher Wren in London is a good example). You might like to sketch a series of churches, or train stations, or perhaps old pubs, bookshops or antique shops. Bridges are a fun subject too.

6. Sketch a series of people. Harder to 'theme', but perhaps quick portraits of every member of your family, or local business owners, or your professors. Sketching from life usually helps the immediacy of the theme, but if drawing from photos, you might draw a set of your favourite film stars, sports stars or even infamous celebrity villains.

7. Keep it all together. Consider drawing your theme in a single sketchbook, to give you something to look back at when it is finished. You might like to draw each object in the same general style, or take the opportunity to draw similar objects in different styles, to experiment with other ways of drawing.

THIS PAGE: **1967 Ford Mustang, Harvest Fair, Santa Rosa, USA**

OPPOSITE TOP: **Saucony shoe, September 2011, Luke age 3 years**

OPPOSITE BOTTOM: **18th Street, San Francisco, USA**

ALL IMAGES PETE SCULLY

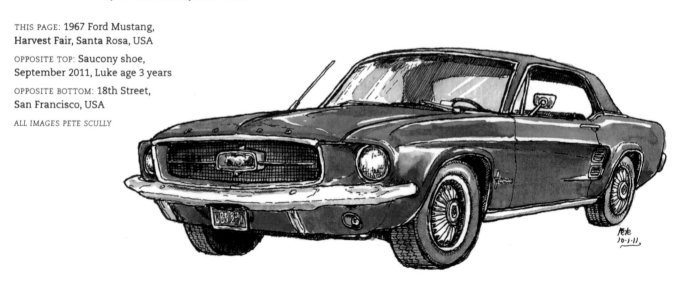

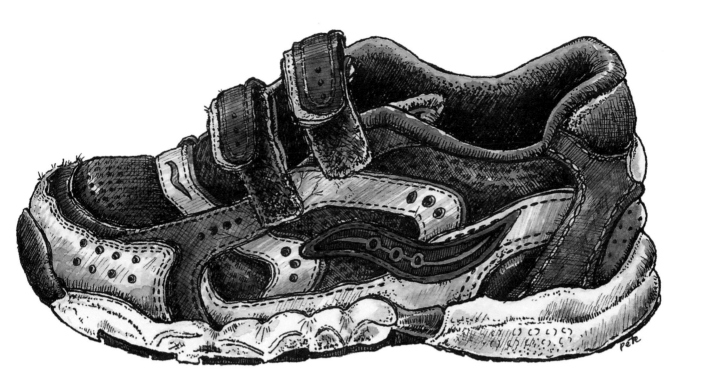

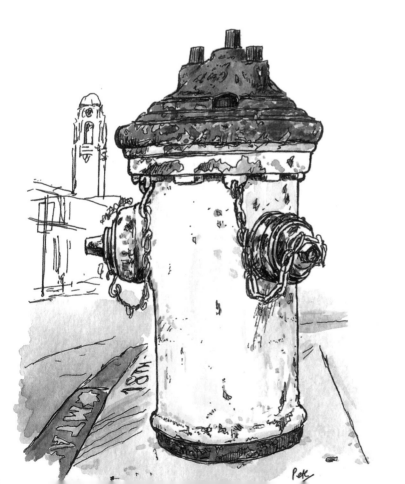

THIS EXERCISE WILL HELP YOU:

- Develop your interest in drawing the everyday
- Work on your observational skills
- Appreciate differences in similar objects
- Develop a specific style
- Draw quickly and often

The following examples show different ways to approach sketching a themed series, either at home or out and about.

LUKE'S SHOES

In this series I decided to sketch every single one of my son's shoes, in chronological order, from the very first to the latest. Each of these is in a single small Moleskine sketchbook in the same black-and-white style, from different angles, although I have done additional colour ones in a second sketchbook, which I use to draw all of his toys and things in general. As this is a project spanning several years, I have tried to keep the style similar, even though my personal techniques have evolved. As a record of my son's growth it is priceless, and far easier to accomplish than a scale drawing of the boy himself growing up. I'll probably still be sketching his shoes well into his twenties!

THIS PAGE CLOCKWISE FROM LEFT:

Rocket shoe, July 2009, Luke age 6 months

Football shoe, August 2009, Luke age 8 months

Vans shoe, August 2009, Luke age 1 year

OPPOSITE PAGE CLOCKWISE FROM TOP LEFT:

Circo sandal, October 2009, Luke age 18 months

Old navy shoe, December 2009, Luke age 21 months

USA shoe, January 2010, Luke age 2 years

OshKosh shoe, January 2010, Luke age 2 years

ALL IMAGES PETE SCULLY

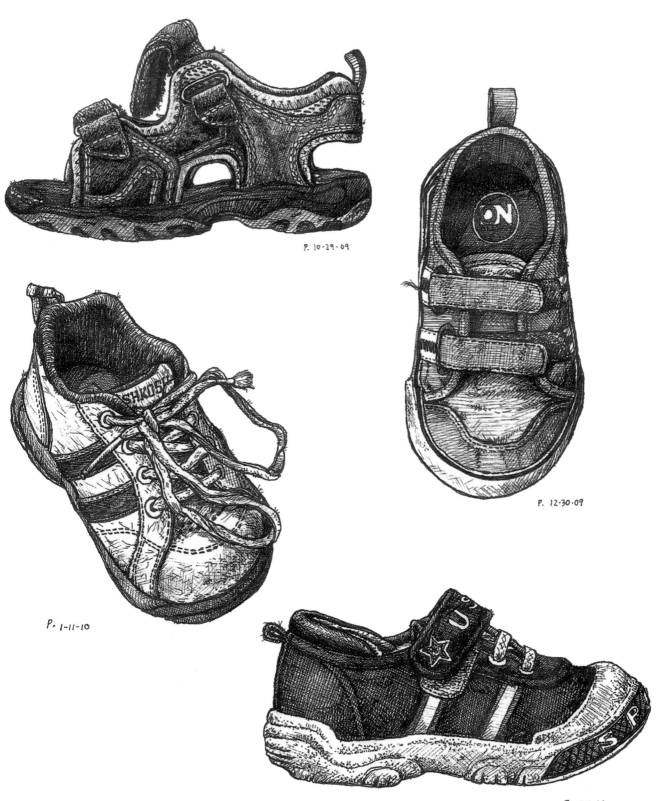

P. 10-29-09

P. 12-30-09

P. 1-11-10

P. 1-1-10

FIRE HYDRANTS

We don't have them in Britain, where I grew up, so when I moved to America I became fascinated with fire hydrants. Most people do not even notice them any more. However, it was only when I decided to sketch a series of fifty of them in a single month that I started paying attention to just how many varieties there were, even in my own small town. Each city has different types, painted in colours specific to the locale, often with additional colours added to indicate water pressure. It's not just the hydrants that I sketch, but also the other metal pipes you see poking out of the ground in America, backflow preventers and so on. Being so location-specific, I see them as a way of recording where I am. Now whenever I travel I try to sketch the local hydrants, and if I pass by hydrants that I have sketched years before, I remember them like old friends. I have even been called "that fire hydrant guy". I usually keep to the same style when sketching my hydrants, more often than not keeping the background to a minimum, and I never leave out interesting features like rust, dirt or graffiti.

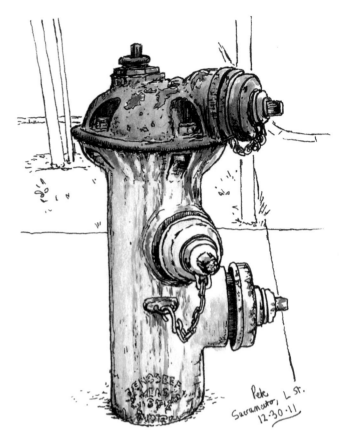

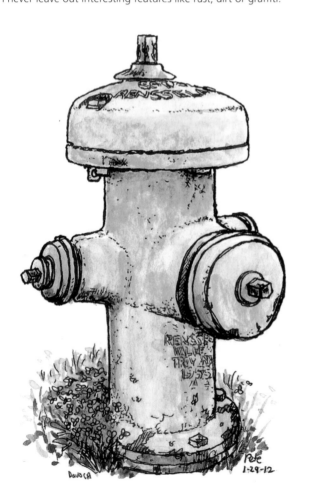

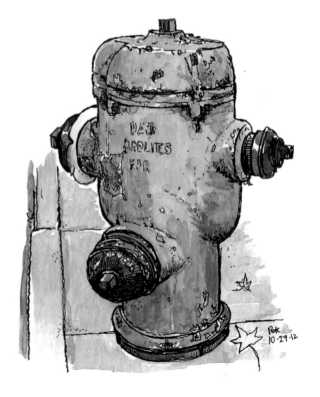

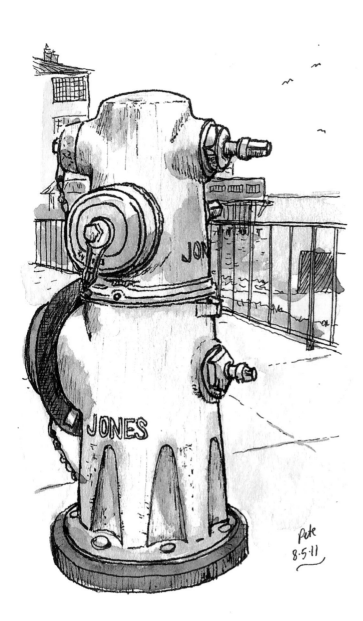

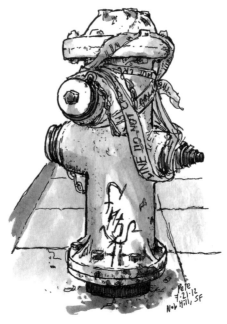

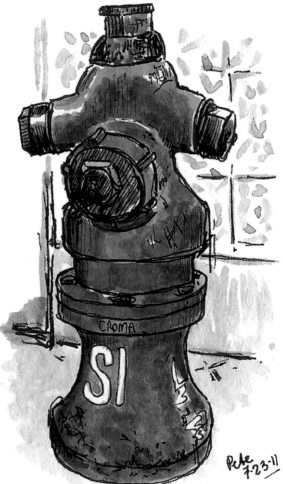

CLOCKWISE FROM TOP:

L Street, Sacramento, USA

Cannery Row, Monterey, USA

Jones Street, San Francisco, USA

Rua Santa Justa, Lisbon, Portugal

NW Second Avenue, Portland, USA

8th Street, Davis, USA

ALL IMAGES PETE SCULLY

OLD CARS

Sketching cars used to fill me with dread. Then I realised that it was partly because so many modern vehicles are pretty uninspiring, but older cars on the other hand could be magnificently beautiful. You don't see too many old cars lining the streets among the beige Toyotas, but I started to visit antique automobile exhibits, or attend meets for old car enthusiasts, and even discovered the local Automobile Museum. There I sketched old Mustangs, Buicks and old race-cars, and chatted with the proud owners, who told me stories of past triumphs. The difficulties I had with drawing cars – tough perspective, drawing decent ellipses for the wheels, windshield reflections – were overcome by applying myself to drawing something that held so much interest. I have also been greatly inspired by the work of other old car sketchers online, such as France Belleville van Stone, Lapin and Florian Afflerbach. I find it hard to resist sketching any old car I come across; I have grown to truly love them. And I don't even drive!

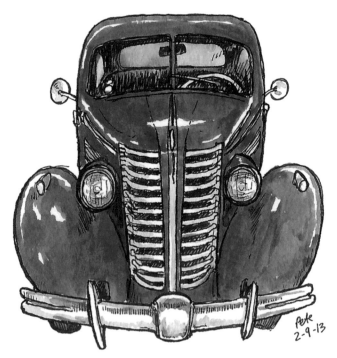

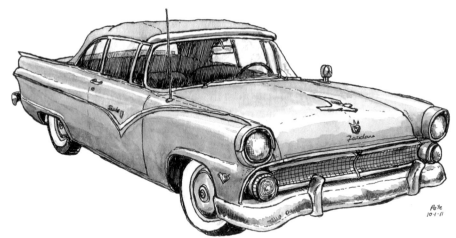

THIS PAGE TOP: 1938 Buick Special, California Automobile Museum, Sacramento, USA

MIDDLE: 1955 Ford Fairline Sunliner, Harvest Fair, Santa Rosa, USA

BOTTOM: 1914 Humobile Model 32 Touring Car, California Automobile Museum, Sacramento, USA

ALL IMAGES PETE SCULLY

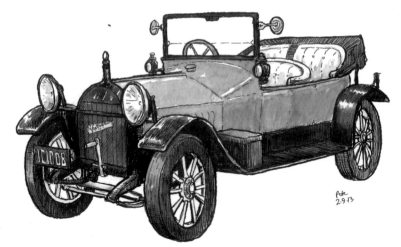

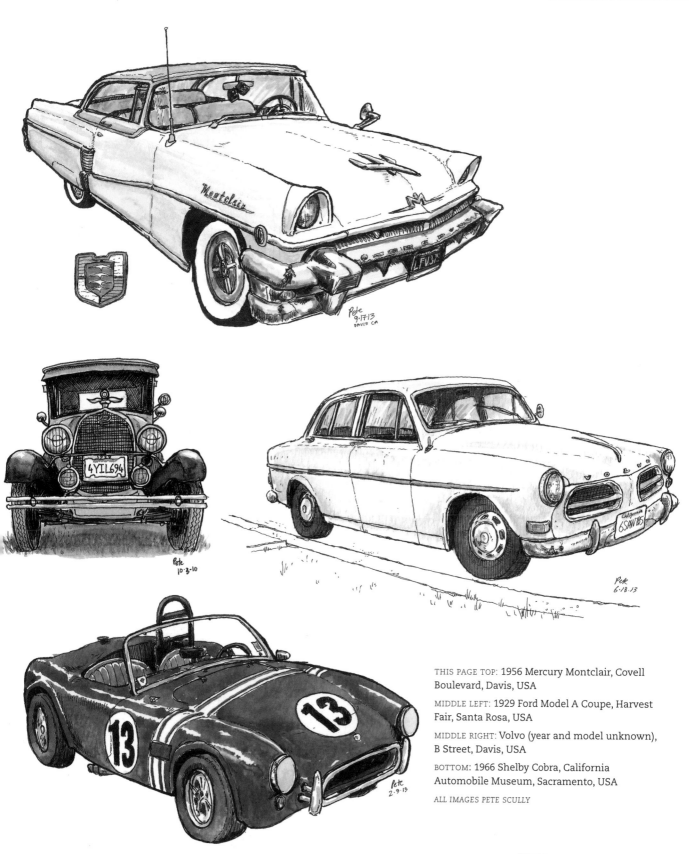

THIS PAGE TOP: 1956 Mercury Montclair, Covell Boulevard, Davis, USA

MIDDLE LEFT: 1929 Ford Model A Coupe, Harvest Fair, Santa Rosa, USA

MIDDLE RIGHT: Volvo (year and model unknown), B Street, Davis, USA

BOTTOM: 1966 Shelby Cobra, California Automobile Museum, Sacramento, USA

ALL IMAGES PETE SCULLY

PARKS AND GARDENS: James Hobbs

The way in which a park or garden can change over the course of a year is a great natural wonder. Changes from day to day are barely perceptible, but there is an almost theatrical development over months that can be exciting and enlightening to follow by drawing and painting.

Head to a local park with your sketchbook, or perhaps focus on your own garden, or a neighbour's garden visible from your apartment, or maybe a public green space or botanic garden that is open to the public. Even a single tree growing on a pavement can tell us so much about the time of year it is.

IDEAS TO GET YOU STARTED

1. Take the long view. Trace the seasonal changes as they change your chosen green space over the course of a whole year by drawing and painting from the same location, through burgeoning growth, blossoming, fruition, decline and eventual fall. Ensure that you have a sheltered place to work, such as a conveniently placed café, to handle the cold of winter and the heat of summer.

2. Mark-making. Nature offers such a huge variety of textures, forms and movement. Focus on making a variety of energetic marks in dry media, such as pencil or charcoal, to accurately describe with drawn gestures the scene before you. Experiment – and be prepared to fail (we all do from time to time).

3. Times of the day. Paint a park or garden scene at the beginning and then end of a single summer's day, paying particular attention to the way the colours have changed and how the falling shadows have altered the focus of the view.

4. Look for a backdrop. Draw or paint a garden or park scene against a backdrop of buildings so that as it is drawn throughout the year, and the leaves fall, the backdrop comes into vision to create a different view. This can be effective in urban areas where architecture comes into view during the leafless winter months, and then disappears again the following spring.

5. Zone in. A single tree, rather than an entire garden, can be a great subject to follow nature's course through the seasons' changes. Visit it several times throughout the year to record its changing state. Keep a single sketchbook for this purpose and date each work.

6. Work expressively. You can't draw every leaf. Loosen up, enjoy the marks you make and create a variety of effects that suggest the depth of the foliage and greenery, so areas recede and others come forward. This may take you into a less representational way of working – go with the flow.

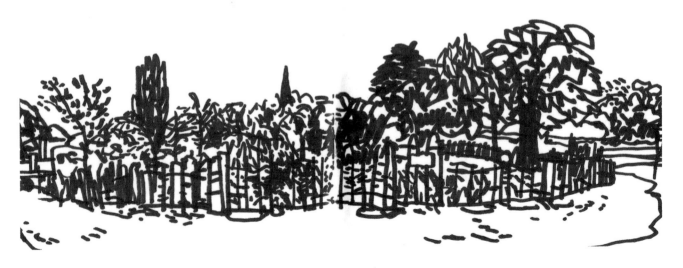

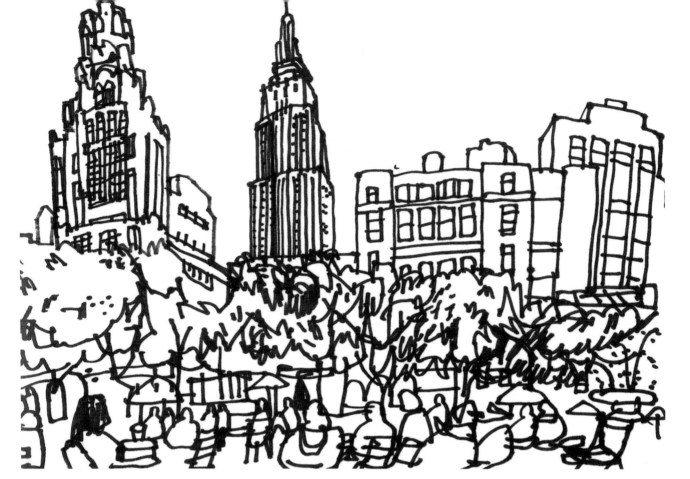

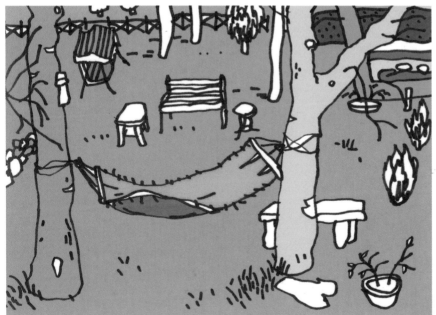

THIS EXERCISE WILL HELP YOU:

- Experiment with mark-making

- Make foliage distinct

- Study shadows and the shift of light

- Create a sense of depth

- Draw with expression

- Build a connection with your subject

OPPOSITE: Clissold Park, Stoke Newington, London, UK

THIS PAGE TOP: Bryant Square, New York, USA

THIS PAGE BOTTOM: Hammock, Le Marche, Italy

ALL IMAGES JAMES HOBBS

Parks and gardens are an attractive subject to draw because of their ever-changing state: from day to day, through weather conditions and our yearly seasons.

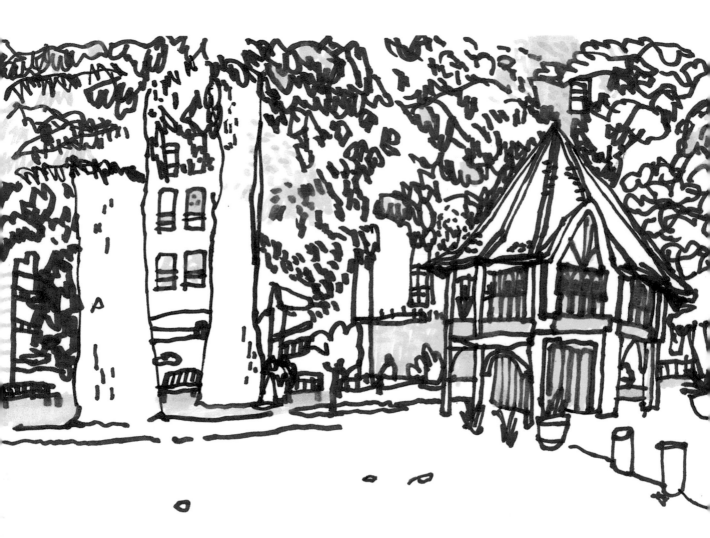

FIND ABSTRACT QUALITIES

THIS PAGE: Soho Square, London, UK

OPPOSITE: Tower, Hackney, London, UK

ALL IMAGES JAMES HOBBS

I found myself early for an appointment and had time to sit and draw in this garden square in the centre of London (above). It was a view that largely chose itself: it was what I could see from the park bench that was free. The foliage of the trees became a rather playful experiment of enjoying the marks as I put them down. I was looking at the view, but the more I drew, the more I enjoyed its abstract qualities. The gardener's hut anchors the drawing to reality, but what is before you can simply be a springboard to something more imaginative.

USE GESTURAL MARKS

The aim of this drawing below was to create the effect of a variety of different types of tree, shrub and other plant life through gestural marks. Using a broad pen, as I have here, forces you to consider the bigger picture: there is no scope for detail as forms have to be expressed in a few lines and shapes. There is, however, still scope for a range of marks to create visual interest across the page and suggest depth and receding shapes.

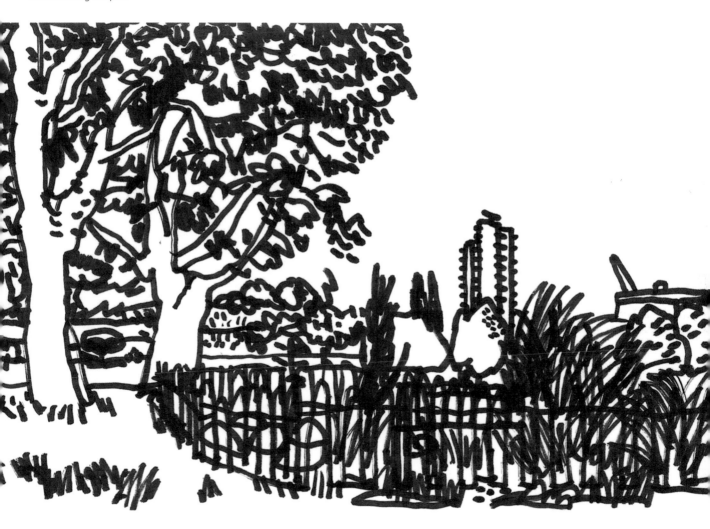

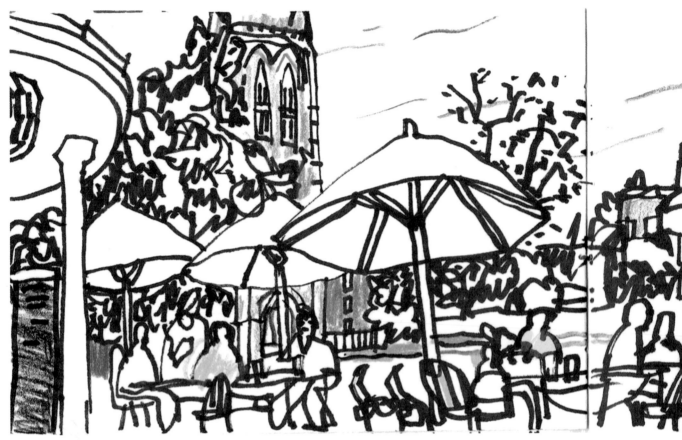

THIS PAGE: Clissold Park café,
Stoke Newington, London, UK

OPPOSITE: Clissold Park trees,
Stoke Newington, London, UK

ALL IMAGES JAMES HOBBS

SUGGEST VISUAL JOURNEYS

I was attracted by the vast expanse of emptiness in this urban park (right), which I reinforced by drawing the scene across the spine of my sketchbook. This created a number of visual journeys the eye can take – down the path to the right, across the grass to the left – as it scans across the page. The tree is placed slightly off centre so that it doesn't run across the gutter of the sketchbook, and to prevent the scene becoming symmetrical. The marks used to draw the central tree suggest a degree of foliage without using a single leaf-shaped mark.

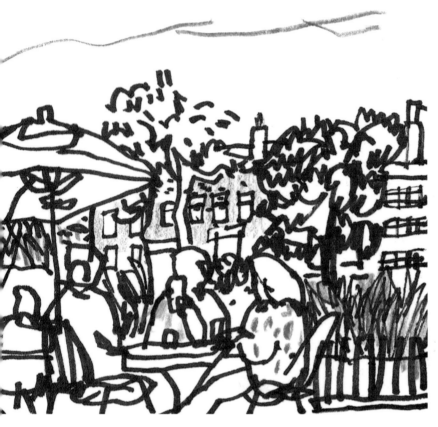

SELECTING A VIEWPOINT

Cafés are a natural place to draw in, and never better than outdoors in a park. They offer a regularly changing cast of customers coming and going, a background of nature and a steady supply of refreshments to either warm you up or cool you down. It is the natural place to locate yourself if you are drawing the park throughout the year to record its seasonal changes. I drew this scene (left) from a favourite seat in our local park, and used coloured pencils to pick out a few areas when I had returned home.

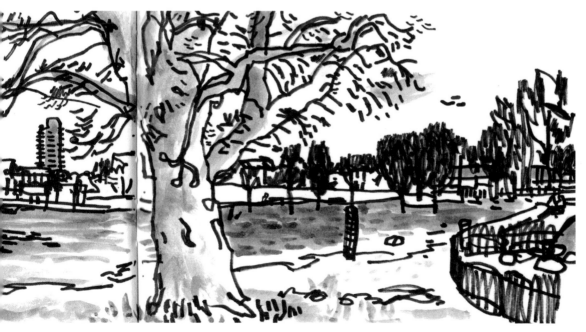

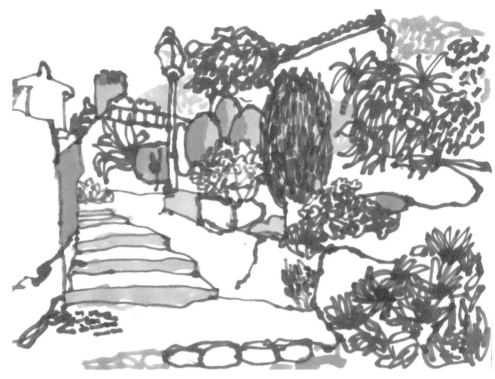

THIS PAGE TOP: Obidos, Portugal

THIS PAGE BOTTOM: The High Line, New York, USA

OPPOSITE: Ocean Drive, Miami Beach, USA

ALL IMAGES JAMES HOBBS

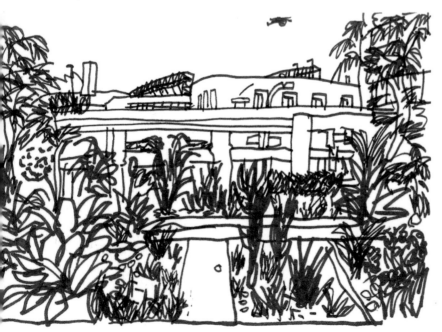

CREATE A CONTEXT

A drawing such as this (left) is as much about where the park is, as the park itself. The High Line is a disused elevated railway in Manhattan that has been lovingly turned into an aerial greenway. Plants push up through the abandoned track. By letting in something from the periphery of the scene, such as the tops of these Lower West Side buildings and a passing helicopter, you can create a context and tell a story. Years after I drew it, I can recall the sense of calm amid the city as I look at this drawing.

EXPERIMENT WITH TONE TO CREATE DEPTH

I used a set of grey pens to draw this garden and steps (opposite top) that I chanced upon in an almost traffic-free walled town in Portugal. Much subtlety can be found by drawing with just black ink, but these softer, warm tones were an enjoyable opportunity to experiment with different types of foliage and shadows. The lightest grey, for instance, was used to depict the most distant trees, and the darkest to draw the rather playful leaf shapes in the foreground. It can be a jolt to the system to use a new medium, but one that encourages new attitudes and directions also.

LOOK FOR THE UNFAMILIAR

Travel always heightens the senses: the new and unfamiliar is always an attraction to include in the sketchbook. These palm trees in the park on Ocean Drive (below), set against the distinctive Art Deco hotels, have to the traveller an 'exotic' look to them. But, as always, it is vital to look closely and draw what you see rather than what you think you know. Even for a quick drawing such as this, spend some time looking and make the marks that describe best the type of trees that are your subject.

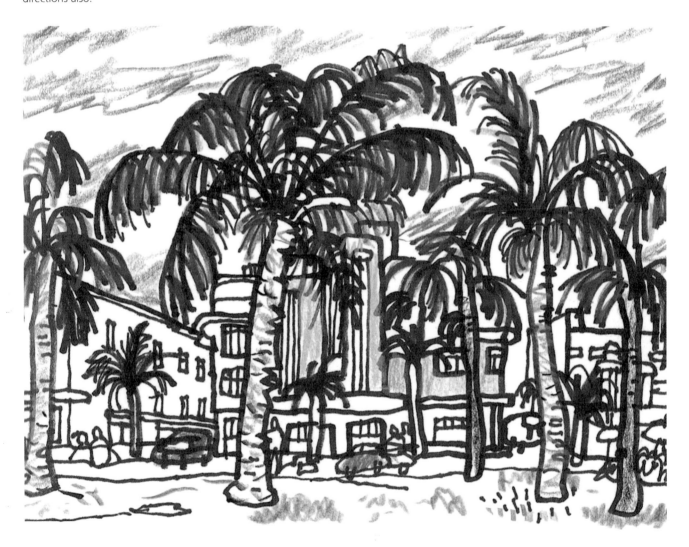

STREET SKETCHING: Pete Scully

The act of drawing street scenes is an essential tool for the urban sketcher as visual recorder. The streets of our towns and cities are where our daily lives interact, where past meets present, where the unchanging meets the constant movement of modern life. I like to draw streets as a future reminder of what they once were; so many scenes that I have sketched over the years have been irrevocably changed – shops closing, new buildings going up, life moving on. Every time I visit my home city of London, there is always something that has changed – an old pub has been torn down, a new skyscraper has gone up – but what never changes is the street itself, a living, breathing place like a river rippling with histories unseen and traffic and people very much in the way.

For this reason, streets can often be hard to draw. You need to see over cars, see through people and breathe in traffic fumes, and that doesn't even factor what to do if it rains. In this exercise we will look at ways to approach sketching the streets around you, from both an up-close and a panoramic perspective, and overcome the challenges involved with these busy places.

IDEAS TO GET YOU STARTED

1. Start small. Instead of drawing a single image, draw a series of smaller sketches over a two-page spread. Capture close-up elements of the street – a newspaper stand, a road sign, passers-by, a mannequin in a shop window – and let them overlap, leave them unfinished, add a few overheard words around the edges. Draw 'urban furniture' such as fire hydrants or bins. Small snippets of life usually give a larger overall impression and a more interesting narrative of a street than a sweeping panorama. Try not to worry about the need to be 'definitive', and just draw what catches your eye; this is a personal experience.

2. Practise people. Streets usually have people on them, and it is often the human element that attracts us to a sketch. People can also help disrupt the repetitive elements of the street scene. You are unlikely to capture exact likenesses as people pass by and there's no need to, but use them as inspiration. It is good to have a backup of generic gestures – walking, standing, pushing a stroller – that you can fall back on. If your street scene is highly detailed, use quicker, sketchier strokes to express the fleeting nature of pedestrian flow.

3. Draw a single shop or other urban building. Bars and cafés also make good subjects, but a nice interesting shop front, especially one that has been around for a long time, captures a street's character. Try to capture what stands out about it – perhaps it has a colourful window display or a bold sign. I like the more everyday shops such as newsagents that are less visually 'managed', and I always include the cracks in the pavement and the peeling posters on the door. If you draw from the other side of the street, you will get a more 'head-on' angle, but you will get the interruption of traffic.

4. Try using minimal colour. Full colour is great, and I like to spend a long time colouring in my sketches after drawing on location. However, minimal colour can often be a lot more effective. Try drawing a scene in which you only colour in one or two elements, such as a road sign or the umbrellas of a café, and watch how suddenly they jump to life. The same goes for detail: filling in just some of the elements, such as leaves on a tree or windows on a tall building, can save a lot of time and still make for an effective drawing. The mind does a great job of filling in the rest.

5. Draw a two-page panorama. Streets are long places, and the length of a two-page spread will allow you to fit as many elements in as you can. Practise the perspective, allow the curve of the street to lead the eye. It's a good idea to plan out the street scene with a light pencil or simple pen lines before adding the details. Think carefully about your composition; you might consider adding larger objects in the foreground such as the trunk of a tree or a street sign. This will not only create the illusion of depth but will also break up the drawing, making it a more interesting composition. It also places you geographically in the sketch.

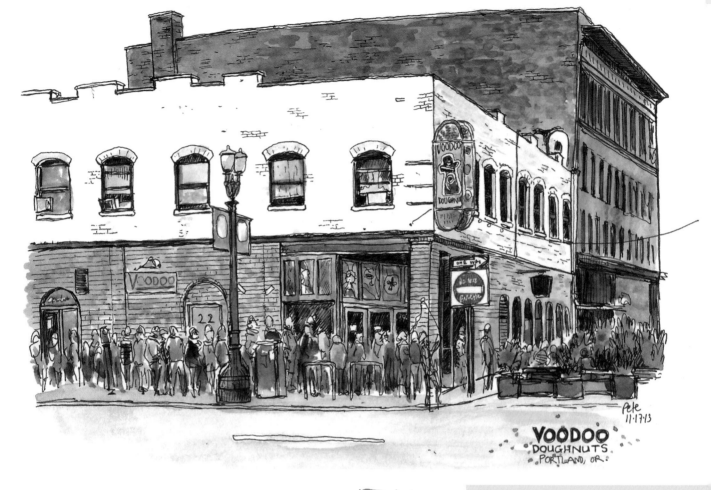

People queueing for doughnuts, Voodoo Doughnuts, Portland, USA

VOODOO
DOUGHNUTS
PORTLAND, OR.

OPPOSITE: Looking uphill,
San Francisco, USA

THIS PAGE TOP: People queueing
for doughnuts, Voodoo
Doughnuts, Portland, USA

THIS PAGE BOTTOM: Tackling tricky
perspective, Barcelona, Spain

ALL IMAGES PETE SCULLY

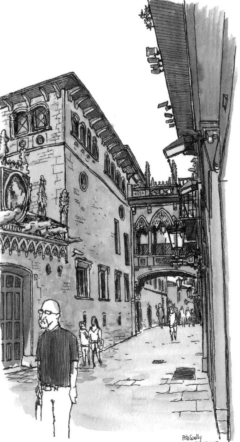

THIS EXERCISE WILL HELP YOU:

- Practise different perspective skills

- Learn to draw complicated scenes quickly

- Measure by sight

- Tackle composition and depth

- Gain confidence with public sketching

- Learn to position yourself geographically in a sketch

The street can offer so much to draw, but also offer many challenges. Here are some examples.

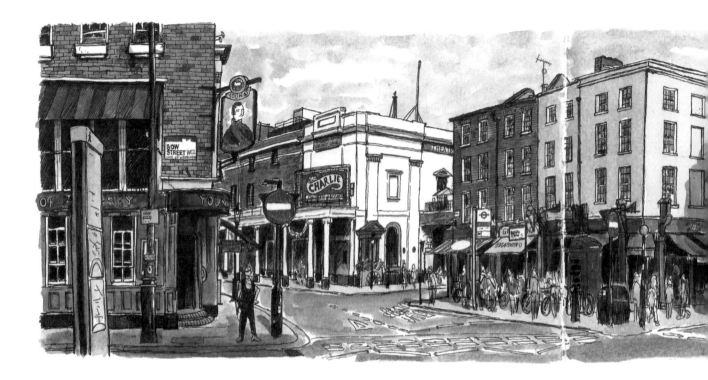

THIS PAGE: Bow Street/
Monmouth Street, London, UK

OPPOSITE: Castro Street,
San Francisco, USA

ALL IMAGES PETE SCULLY

MINIMAL COLOUR AND WIDE PERSPECTIVE

San Francisco, with its dramatic hills and vistas, is a perfect place to practise sketching the tricky perspective of a sloping street. This was drawn one cool April morning in the colourful Castro district (right), but I decided to leave the ink work uncoloured except for the bright red sign of the historic Castro Theatre. The streetcar cables up above were very helpful as naturally drawn perspective lines. This two-page panorama took me less than an hour. This is an example of how absolute minimal colour can not only be more visually effective, but can save a lot of time.

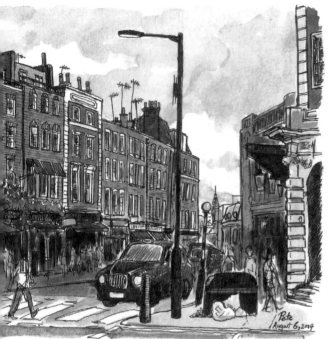

SPREADING ACROSS TWO PAGES

This two-page panorama (left) took me three hours standing on site, in which time I did all of the ink work and some of the colour, before retiring elsewhere to add the rest of the paint. I wanted to capture the curving perspective at this busy junction, drawing the eye downhill towards the Strand. It wasn't too busy when I first started sketching, but by the end it was filled with pre-theatre crowds, stopping to ask me directions and take a peek at my progress. Urban sketching can be quite a public pastime, so put away the headphones from time to time and interact with the world you're sketching.

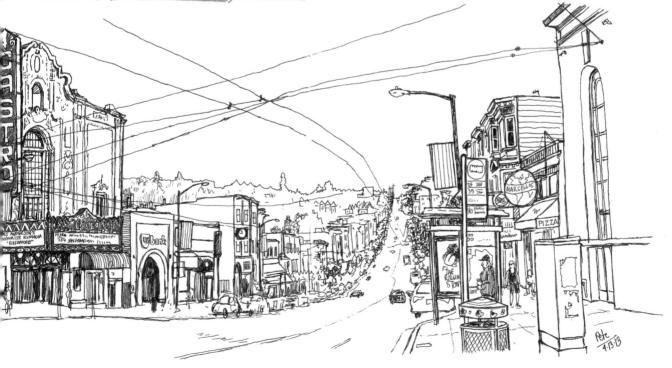

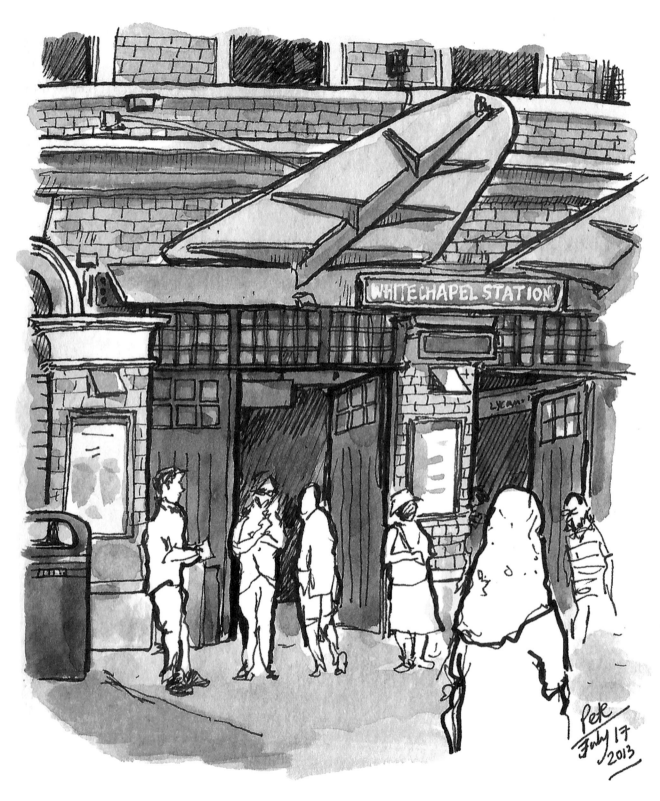

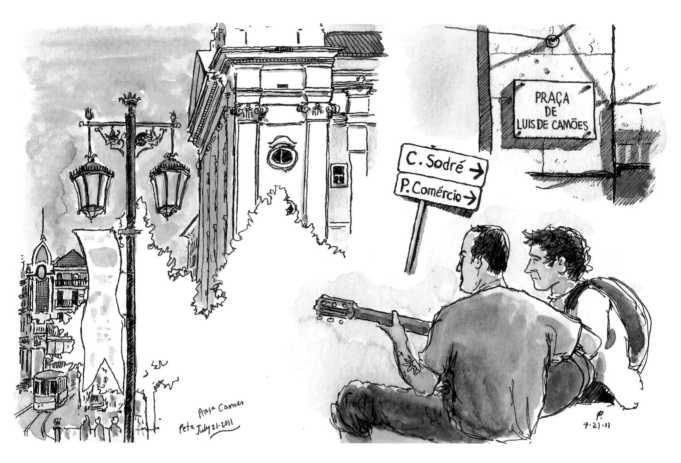

Praça Camoes
Pete July 21-2011

7·2|·11

PEOPLE VS. ARCHITECTURE – DRAWING THEM DIFFERENTLY

It was a sweltering hot day, and I had organised a sketchcrawl themed around the London of Jack the Ripper, beginning at Whitechapel Underground Station. I sketched this after the initial crowd of sketchers had dispersed, and I waited around to greet latecomers. Whitechapel is a busy area and people of all backgrounds crowded up and down the high street. I was most interested in the old tube station, with its Ripper-era brickwork and modern glass awnings, but I wanted to capture the people passing by. I left them unpainted, which served to highlight both the building and the people. Since this was a sketchcrawl, I had a lot of ground to cover, so I kept it relatively quick at about 45 minutes, but still managed to draw the brickwork and add paint on site. I used a white gel pen for the station sign – an invaluable tool!

TELLING THE STORY WITH SMALLER SKETCHES

While at the urban sketching symposium in Lisbon, Portugal, I took a workshop focused on capturing a busy plaza with a series of unfinished sketches. I approached this by focusing on drawing small snippets, such as the view towards the tramways, a couple of guys hanging out with a guitar, the shadows of the old masonry street sign. Such an approach to sketching a street gives a more interesting narrative to what is actually happening there than the sweeping panorama, and I put a lot of emphasis on the yellows and blues to illustrate the bright and sunny feel to the square.

OPPOSITE: Whitechapel Station, London, UK

THIS PAGE: Praça Camoes, Lisbon, Portugal

ALL IMAGES PETE SCULLY

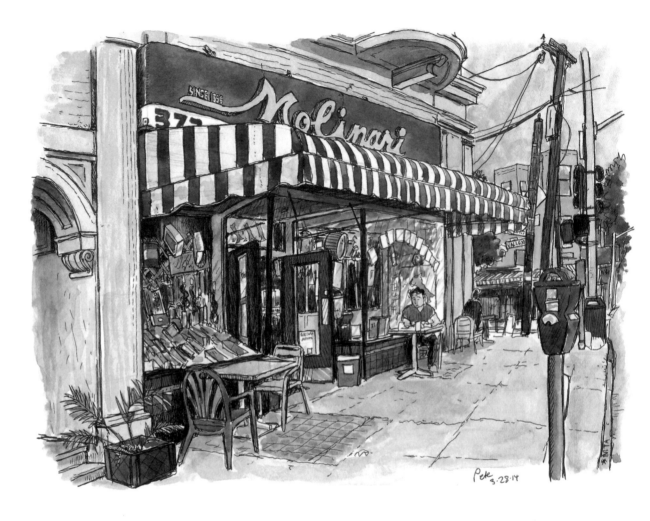

SKETCHING FROM A TIGHT ANGLE

THIS PAGE: Molinari's,
San Francisco, USA

OPPOSITE: E Street, Davis, USA

ALL IMAGES PETE SCULLY

Finding the right place to sketch is essential, and you simply may not find the perfect viewpoint. I prefer to stand when I sketch; it gives me both flexibility and a better viewpoint, but also forces me to sketch a bit faster. I sketched this old Italian deli (above) while standing on a very narrow pavement in San Francisco's North Beach. There wasn't a lot of room – one step back and I'd have been squashed by traffic – but this was my best possible angle and I was able to capture the personality of the neighbourhood and the closeness of the curb. I also kept the parking meter; at one point a car parked there without paying, and the driver asked me to watch her car while she ran into the deli. Standing there with my Moleskine, I may have looked like a warden myself!

PUTTING URBAN FURNITURE UPFRONT

I often like to allow objects to step out of the frame of the sketch, such as with this strange metal device on E Street, Davis (right). It's called a backflow preventer. I could have just sketched the house behind, but including the urban furniture in the foreground gives it more personality and it was by far the more fun aspect to draw.

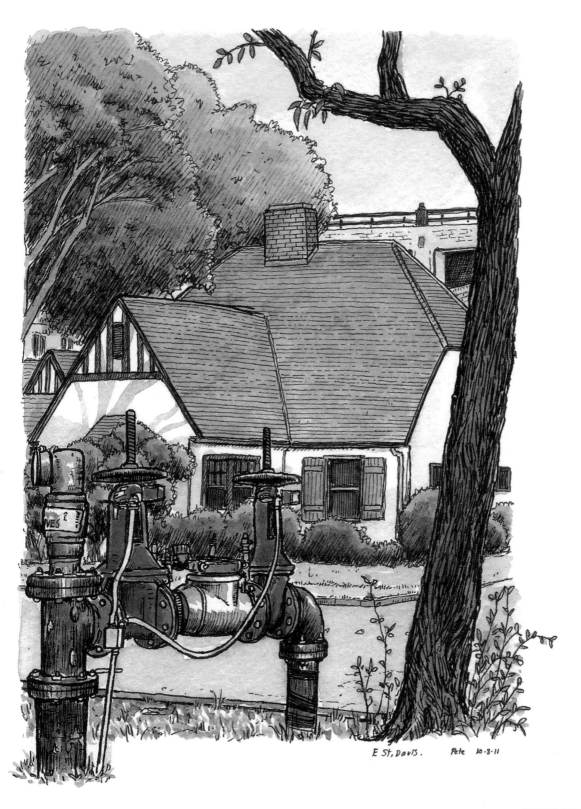

E St, Davis. Pete 10.8.11

WATERSIDE SCENES: James Hobbs

One of the greatest ways to relax in life is to sit next to water, whether it is rushing and noisy, gently lapping, flowing through rocks or crashing in waves onto the shore. Its contemplative nature can encourage us to slow down, take things in and respond to the scene before us.

Water scenes can include beaches, lakes, oceans, rivers, islands, boats, fountains and much more, and there is almost certainly at least one of these near you that can be the subject of this exercise.

IDEAS TO GET YOU STARTED

1. Capturing character. What is it about the location that you are drawing or painting that best captures its character? It isn't always the view that is most popular with tourists or postcard manufacturers that will capture its essence. Look for new angles and places off the beaten track so that the work that you make is specific to the location you are visiting, and not just another painting of an anonymous water scene.

2. Focus on colour. Beach resorts in particular can be fantastically colourful places, whether that colour is from nature, or more artificially created through buildings and seaside attractions. Beach equipment is usually designed in an array of vivid colours, boats can be painted in primary colours and brilliant summer sunshine only enhances this. Find a scene that has an array of bright colours, and work them into a composition alongside the colours of nature around you.

3. People. There is no better place for watching and drawing people than while they relax on the shore. Over the course of a day in the sun, dramas unfold and people come and go, sitting as still as life models or offering subjects of movement and energy. Try drawing a variety of poses – shorter for those subjects walking or taking part in beach games, longer for those at rest and therefore more stationary.

4. Expression. The sun doesn't always shine, and nothing reflects weather conditions quite like an expanse of water. Water becomes choppy, clouds loom, breakers crash onto rocks. Draw the atmosphere and energy of a coastal scene – specifically through the water, sky and coastline – without becoming bogged down in detail. Keep your marks loose and lively. And if you are lucky and the weather is good, focus on the light, reflections and colour so that your drawing or painting expresses those conditions.

5. Panoramas. The landscape format – the longer side of the paper going widthways, with the shorter side as its height – is named because it is often, but not always, the most appropriate way to hold the page to draw outdoors: the horizon line can be an overpowering aspect of a scene when you are working in nature. Accentuate this by opening your sketchbook wide and drawing across the spine of two facing pages to fully embrace the horizontal lines of beach scenes.

6. Study the water surface. Look closely at the surface of the water, how it is affected by tides, currents or the wind. How do the colours shift as you look farther into the distance, and where the water meets the horizon? Can you see through the water to its bed? Where are the reflections most intense and where do shadows fall?

THIS PAGE: Rocks, Guernsey

OPPOSITE (CLOCKWISE FROM TOP LEFT):
Coastline, Northumberland, UK
Bathers on a beach, Laghi di Lamar, Italy
St Mary's, Isles of Scilly, UK
Pier, Teignmouth, Devon, UK

ALL IMAGES JAMES HOBBS

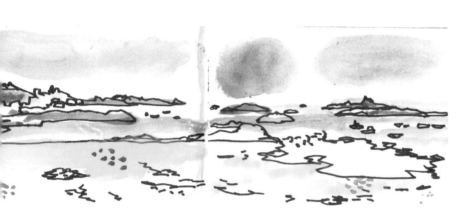

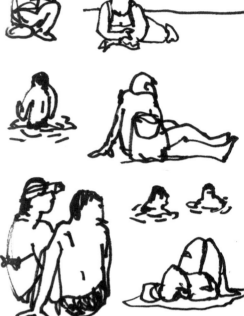

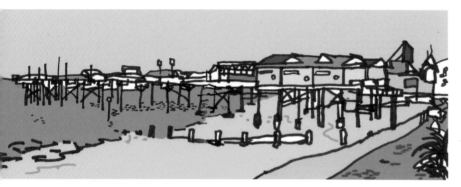

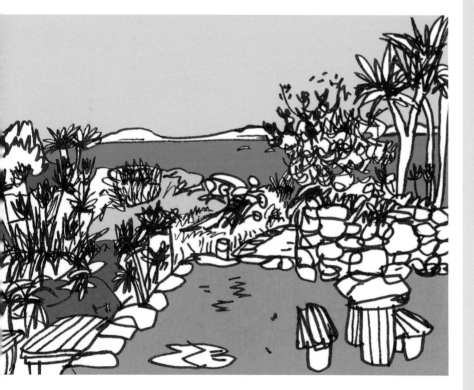

THIS EXERCISE WILL HELP YOU:

- Take time to stop and look closely at your subject

- Focus on the character of the scene before you

- Work in an expressive way to reflect the conditions

- Draw people at rest and in motion

- Explore the strong horizontal lines of a coastal scene

- Tell stories of the waterways

We all have ways of working that we feel most confident about, but don't be afraid to strike out on something new; water scenes come in all shapes and sizes and offer all kinds of subjects, urban and rural, so there are plenty of opportunities to experiment and try new approaches.

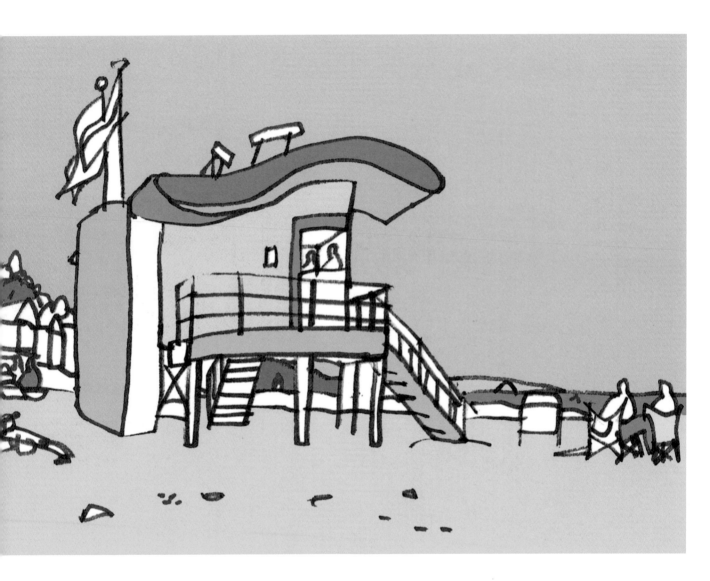

ON THE BEACH

The beach can be an excellent place to draw and paint for a wide variety of reasons. Holidays on the beach may be one of the best opportunities you have to get a sketchbook out. There is time to relax, unwind, explore and experiment.

Architecture, people, water, sand, movement, colour; pick up your towel and sit back down on it somewhere new when you need a new subject. Back at home, I added digital colour for this drawing of an English coastal scene.

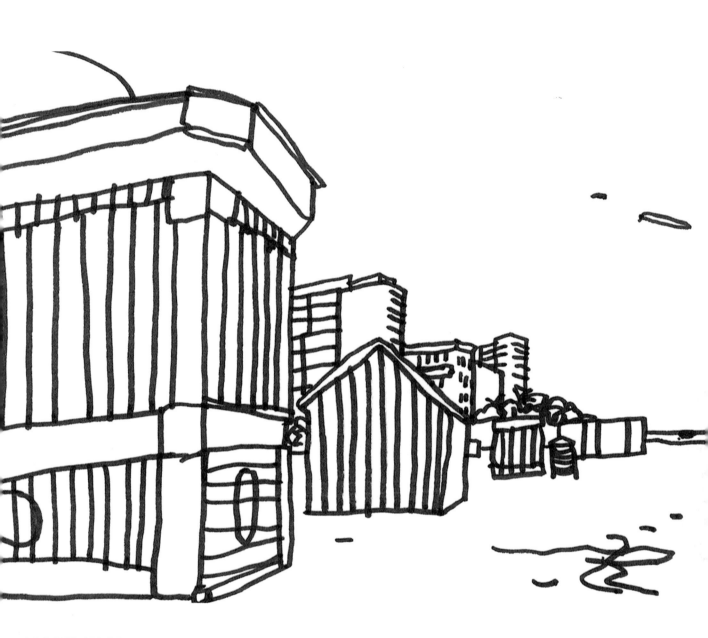

ARCHITECTURE

Beaches are often surrounded by distinctive architecture, from refreshment cabins and piers to lifeguard huts and hotels. It is often the character of these buildings that can give a drawing a distinctive sense of place. This scene of Miami Beach features hardly any water at all, but for me, with the huts and towering hotels behind the boardwalk, it speaks of the coast of South Florida.

OPPOSITE: Lifeguard hut, Bournemouth, UK

THIS PAGE: Beach huts, Miami Beach, USA

ALL IMAGES JAMES HOBBS

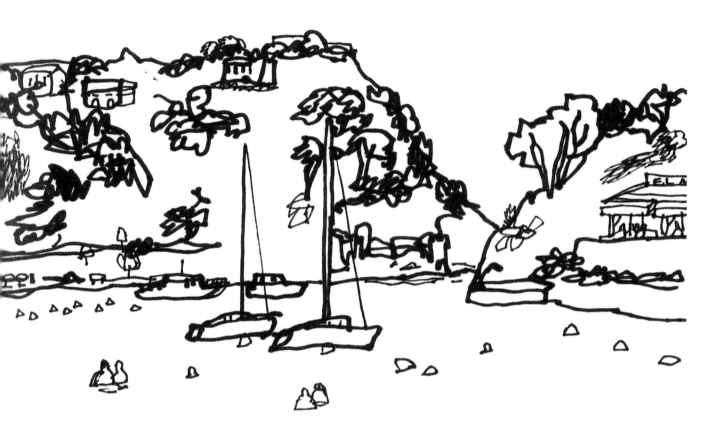

THIS PAGE: Headland,
Cala Galdana, Menorca

OPPOSITE: Boats on
Lake Annecy, France

ALL IMAGES JAMES HOBBS

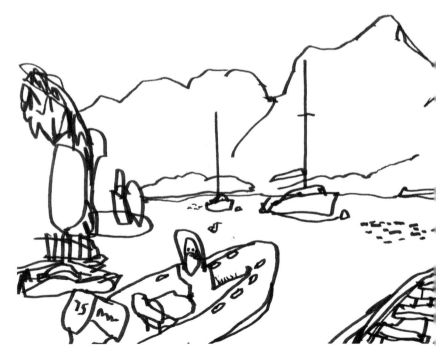

RELAXED MARKS

This is a drawing (opposite) where I simply lay on the beach in the sun and drew. People bobbed about in the sea, cooling down, boats occasionally passed through the buoys on their way to and from the ocean, and the sounds of chatter and laughter wafted over from the café across the water. It is often when we are in such a relaxed mode that our drawings reflect it. People tend not to bother you as you draw on a beach: we have our own territories marked out by towels and umbrellas.

LANDSCAPE FORMATS

There are times when a standard landscape format may not capture the full effect the scene before you demands. Here I have opened wide a landscape format sketchbook and worked across its central spine. This can seem the natural thing to do to show the shapes of the distant mountains and suggest different visual journeys that the viewer can take across the water. This way of working can only be done using a landscape format sketchbook – or try a so-called Japanese sketchbook, which opens up like a concertina, giving the opportunity to draw a 360-degree panorama.

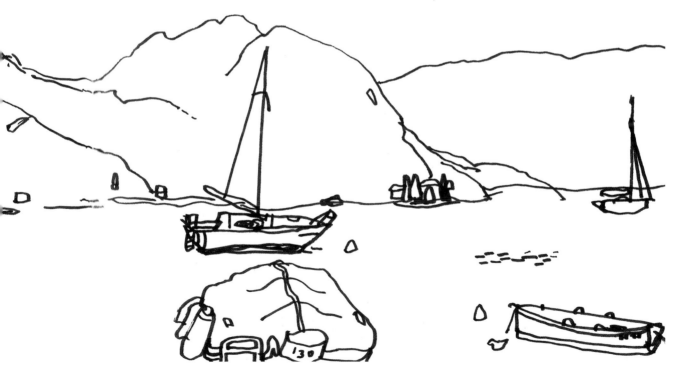

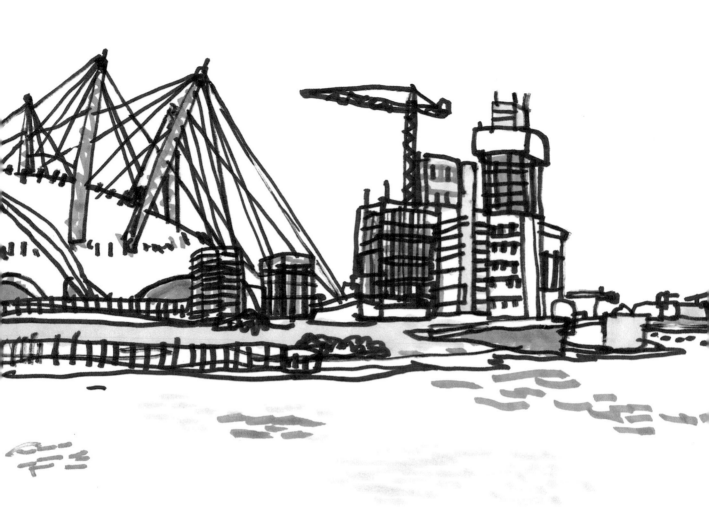

TELLING STORIES

Waterways inevitably have extraordinary
histories and, as here (above), developing futures.
London's historic dockyards ran right into the
city until relatively recently, before moving
downstream to become a rapidly changing scene
of urban regeneration. What you draw on the
riverbank can tell the story of the river: the
emphasis in this drawing is on the buildings and
construction work, but the river, depicted by just
a few lines in a variety of greys, is the at heart of
the story nonetheless. Water may only take up
a small area of a composition, yet it can still be
its focus.

WATER WILDLIFE

A visit to a wetlands centre led to these very quick drawings of aquatic birds that nest there (below). Because of their constant movement, I drew them across the page, sometimes starting one, and then returning to it for the final few marks when it had returned to the same position. The large numbers of birds meant it was possible to have several drawings on the go at any one time. I don't think an ornithologist would correctly identify these birds from my drawings, but this is a good exercise in getting the essence of a moving subject onto the page quickly and learning how to make effective marks.

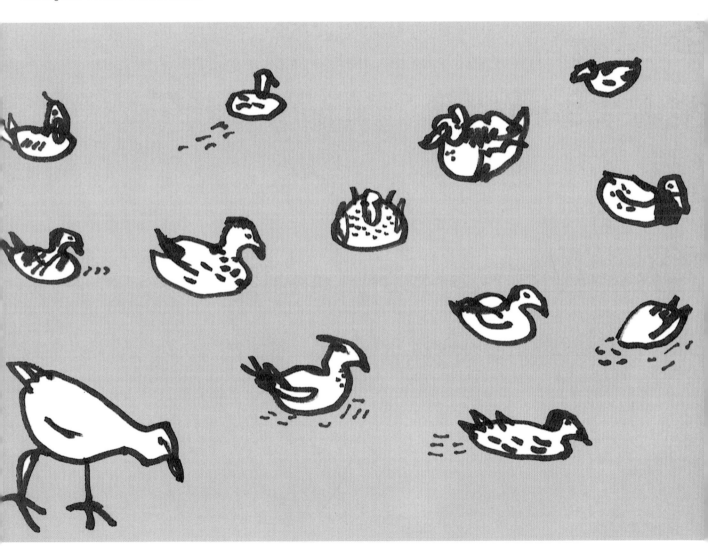

HIGH-SPEED PASSENGER SKETCHING: Virginia Hein

Besides being a fun way to pass the time as a passenger, sketching on a road trip offers the challenge of trying to capture something that's (literally!) fleeting. It's also a wonderful way to experiment with different media and sketching approaches – the 'high speed' aspect of sketching as a passenger on the road lends itself so well to spontaneous experimentation. It can also be great 'memory training' as well, since you may sometimes need some recall to finish the sketch. Let the road trip begin!

IDEAS TO GET YOU STARTED

1. Start simple, start small. Choose a tool like a pen or pencil that will give you quick, free-flowing lines – you want your lines to flow as easily as handwriting. Choose a sketchbook that fits easily in your lap; it can be a single page of a field sketchbook, or a double spread of a bound sketchbook.

2. Keep your sketching kit easily portable. Your 'studio' is a car seat, so you want to keep your kit fairly simple – your favourite pen, a few pencils, a small travel watercolour set. Water brushes are ideal for high-speed passenger sketching – that way you don't have to have an open container of water! And you'll definitely want to have some rags or paper towels on hand.

3. Where are you going? While you can practise high speed-sketching on the road just about anywhere, an open highway or motorway with scenery that doesn't change constantly is ideal, especially if you're just starting out. With practice, you'll know what you want to include, and what you want to leave out. A dense, urban street will be more challenging to sketch while moving than an open country road.

4. Start with a (relatively) fixed point. It might be the car immediately in front of you, or a distant view of a mountain or other landscape feature ahead of you. Of course it can and will change as your vehicle moves – but this will give you a starting point from which to build your sketch.

5. Practise seeing and drawing depth. One of the great things about sketching on the road is that you have the perfect opportunity to observe depth and perspective: you can often see the horizon line, which becomes the anchor for your sketch. Road edges, neighbouring lanes as well as buildings and other structures along the road will often give you the lines to your vanishing point directly in front of you. You can observe and draw depth by noticing objects appearing smaller the farther away they are.

6. Change it up to keep it interesting! Do you always start a sketch with line? Try painting in some colour shapes that you see in the landscape first, and then add line. Try some bold, calligraphic strokes with a brush pen. Experiment with different media.

THIS PAGE TOP: Joshua Tree road, Joshua Tree National Park, California, USA

THIS PAGE BOTTOM: Joshua Tree sunset – leaving Joshua Tree National Park, California, USA

OPPOSITE TOP: Driving home near Palm Springs, Highway 10, California, USA

OPPOSITE BOTTOM: Driving through Morongo Valley, Highway 62, California, USA

ALL IMAGES VIRGINIA HEIN

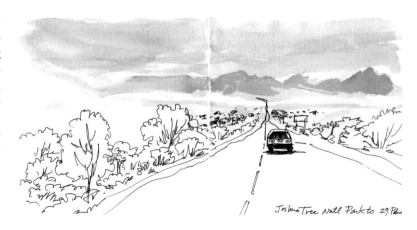

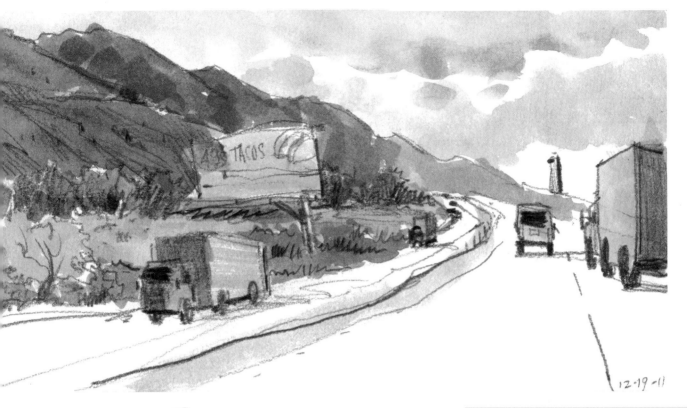

12-19-11

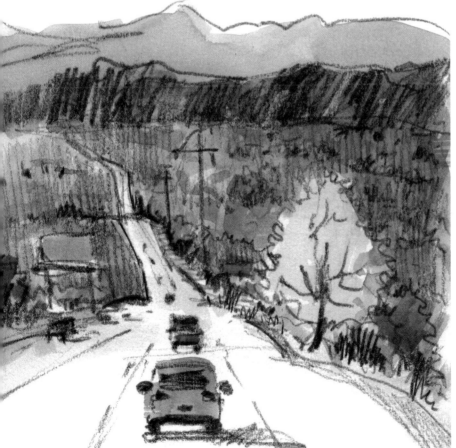

THIS EXERCISE WILL HELP YOU:

- Practise capturing the essentials of a view quickly

- Practise focused observation of your subject while drawing

- Build on your first few lines with colour and tone

- Develop skills of observation and sketching depth and perspective

- Experiment with different approaches: line first, then colour; or colour washes with line added

In each of these sketches, I was travelling by car for many miles on California highways. A long journey is a perfect opportunity to try out these exercises, but shorter jaunts around your neighbourhood will work fine as well!

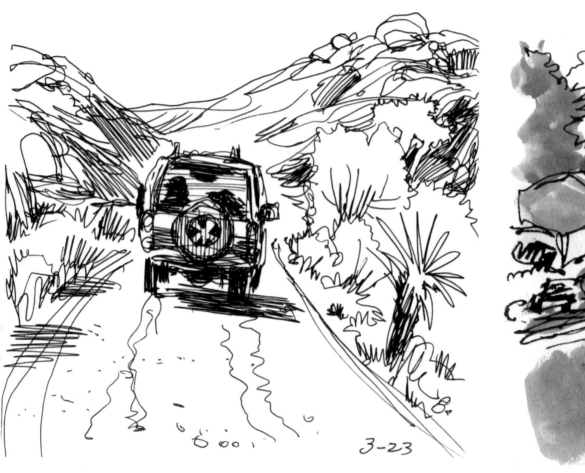

START SIMPLE, START SMALL

When I first started passenger sketching on road trips, I worked exclusively with an inexpensive, fine-line black pen in a small square sketchbook. I practised drawing with an almost continuous line – keeping my eye on the road more than my drawing – just letting the ink flow freely across the page. When I draw, I try to start with a relatively fixed point (e.g., the car just ahead on the road) and draw in the scene around it. The fun and the challenge is seeing how much I can capture – of not just the scene, but the feeling of movement. In this drawing of a jeep in Joshua Tree National Park, my line bumped along with the movement of the car on the rugged desert road.

THIS PAGE: Following the jeep, Joshua Tree National Park, California, USA

OPPOSITE: Spring break – coming home, 210 Freeway through San Gabriel Valley, California, USA

ALL IMAGES VIRGINIA HEIN

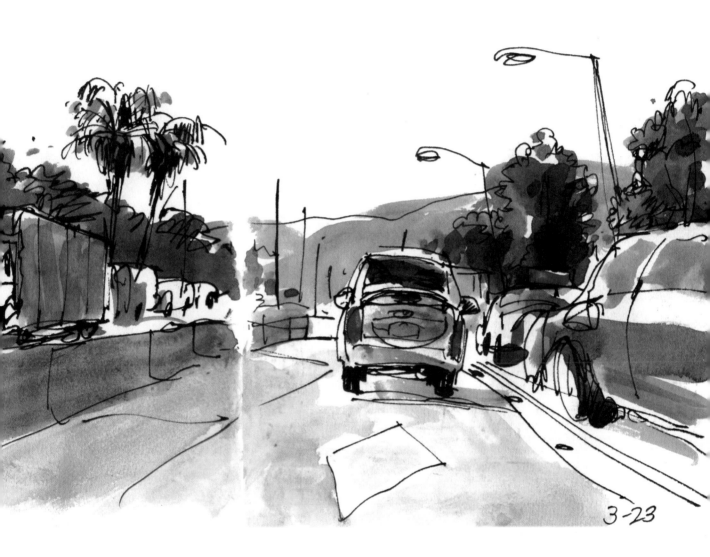

3-23

ADD ATMOSPHERE WITH SOME
TONE AND COLOUR

You can add a feeling of atmosphere without a full colour palette – a few monochromatic values can add a lot to the feeling of atmosphere, with just some colour for emphasis. With more time, you may want to keep building to full colour; this usually requires a relatively unchanging scene, or else good recall! In this drawing, I started with a quick ink sketch, and then added a mixed grey watercolour wash. I made two passes (for two values of tone), and then added the touches of bright red.

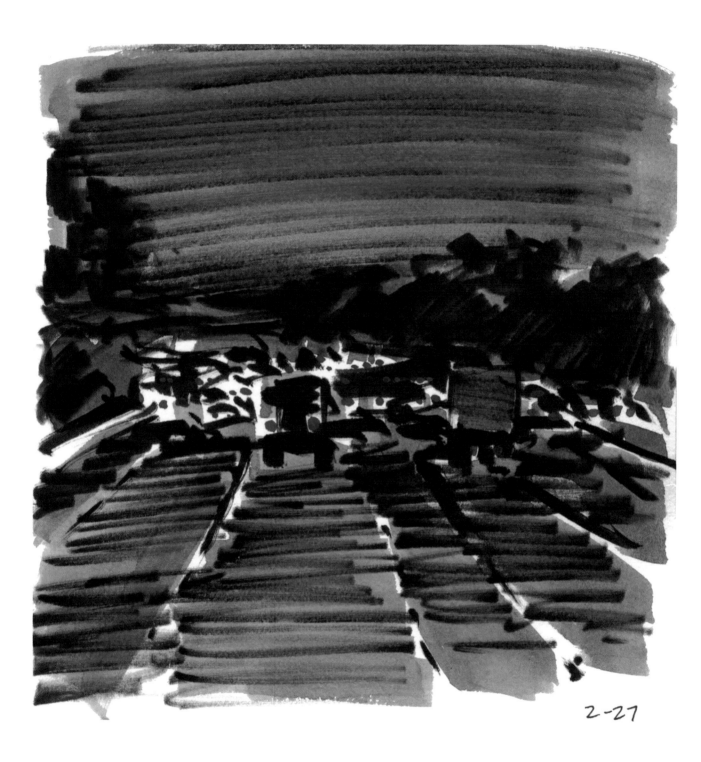

2-27

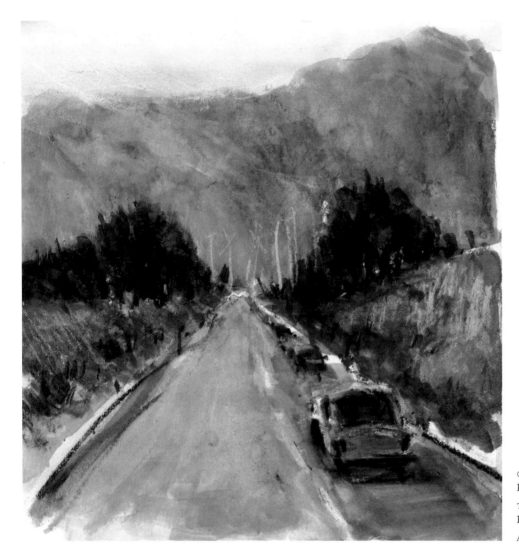

OPPOSITE: 210 Freeway, Pasadena, California, USA

THIS PAGE: Highway 62 near Palm Springs, California, USA

ALL IMAGES VIRGINIA HEIN

DIFFERENT TIMES OF DAY – OR NIGHT

While travelling, you're bound to be on the road at different times of the day or night. This is a great opportunity to observe and sketch the landscape around you in the changing light. Without much light to see your page, you'll have to keep the media simple. Here, I used a black brush pen, and added a pre-mixed grey-blue wash and some spots of bright red for the lights.

EXPERIMENT – DIFFERENT MATERIALS, DIFFERENT LINES

Playing with different media in your high-speed sketching is another great way to change up the way you usually work. Here, I was experimenting with water-soluble pastels and some watercolour to try to capture the startlingly blue mountains looming ahead on a misty day near Palm Springs, California.

ARCHITECTURE: Ilga Leimanis

Architecture is around us all of the time. Whether you find yourself in an interesting space or an ordinary one, there is always something to draw. Challenge yourself to find inspiration wherever you are, either at home, on holiday, at rest or travelling.

IDEAS TO GET YOU STARTED

1. What is your point of view? Think about your relationship to your space. Where are you? Are you inside or outside? At the top or the bottom? To the left or right? How close or far away are you? Take a walk around the area to locate a good point of view to start from. Time permitting, try another view at the same location. How do the drawings differ? Which is more interesting?

2. Focus on directional strokes. Drawing spaces can be a real challenge. Let the direction of the planes of the building – the walls, floor and ceiling – help you describe the structure and enhance the feeling of the space. Make marks or lines go up or sideways to show how that plane is read in space. For organic shapes or rounded arches, accentuate these marks for interesting drawings, making the eye move around the page and implying a movement in the space.

3. Show scale and distance. Tell the viewer how large or small something is by using cues they will know, such as people, trees or cars. Separate your drawing into three distances: far distance for objects really far away, middle distance, and the foreground for what is nearby.

4. Experiment with materials and colour. A simple black fineliner is all you need to make interesting architecture drawings, but why not experiment with colours and materials? Try ballpoint pens and coloured markers, pencils or oils sticks for colour. Add wet materials such inks or gouache or watercolour crayons for a cross between working with a brush and a pencil.

5. Cut the paper. Glue in parts of maps, receipts or tickets from your travels to help tell the story of the surrounding architecture. Add colour with coloured paper and texture with printed images from different sources by gluing them onto the page as a shortcut to achieving the effect you want.

6. Travel with your sketchbook. Pack simple materials and a small sketchbook to take with you on holiday. Find opportunities to draw the different spaces that surround you and the architecture around you wherever you may find yourself in the world.

THIS PAGE: Ortelius Drew, Maloe Melo, Amsterdam, Netherlands

OPPOSITE TOP: Ilga Leimanis, Two Temple Place, London, UK

OPPOSITE BOTTOM: Tim Baynes, Marina Bay Sands, Singapore

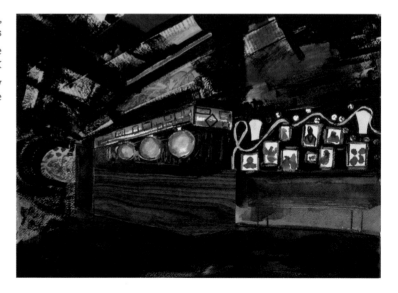

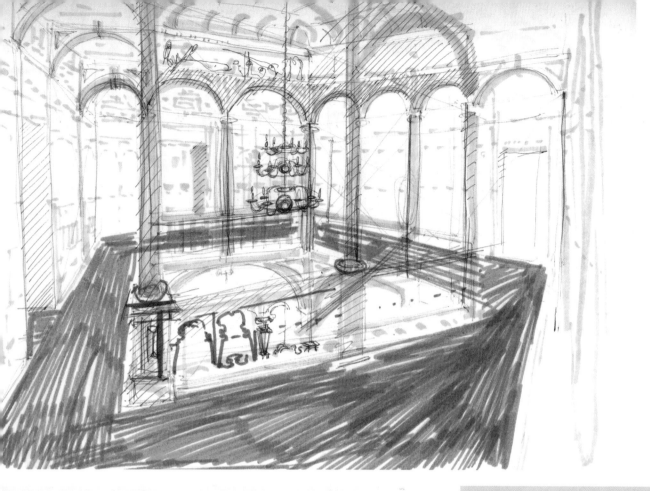

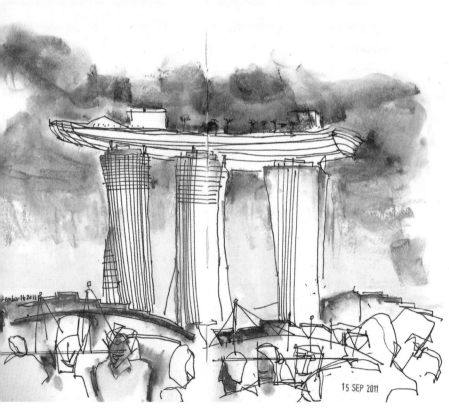

London 16 2011

15 SEP 2011

THIS EXERCISE WILL HELP YOU:

- Draw architecture and spaces

- Show the scale of buildings in relation to other objects

- Consider direction of planes – vertical, horizontal or angled

- Add texture and colour through marks or cut paper

- Explore mood and emotion

- Draw from memory and observation

Architecture can include all buildings, streets, temporary or seasonal pavilions, interiors and exteriors, domestic or palatial, skylines, markets, stations, churches, bars and cafés, theatres or even tents.

POINT OF VIEW

I have drawn the Serpentine Pavilion in Hyde Park, London, every year since 2007. The pavilion in 2011 was a black box with an open roof by Peter Zumthor, featuring a garden inside by Piet Oudolf. I started by constructing the outline and blocking in the shapes of the structure, then filled in with lines in the direction of that plane: vertical lines for a vertical plane, horizontal lines for a horizontal plane. I spaced the lines farther apart for lighter areas and closer together for darker areas where more shading was needed. A few rough lines and colour accents were enough to communicate the interior garden. By comparison, Smiljan Radić's 2014 pavilion was an organic-shaped, rounded structure. I used a similar technique with one ballpoint pen, finding the direction of the curved walls and inclines of the floor to help define that space. A feeling of movement accompanies the directional lines.

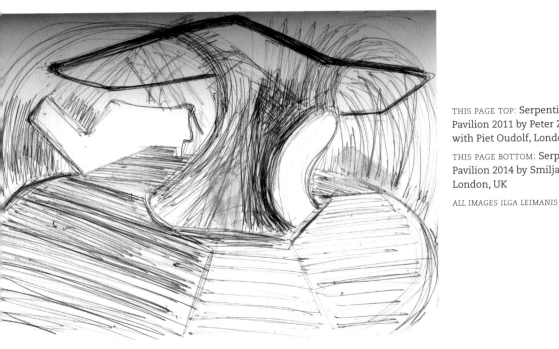

THIS PAGE TOP: **Serpentine Pavilion 2011 by Peter Zumthor with Piet Oudolf, London, UK**

THIS PAGE BOTTOM: **Serpentine Pavilion 2014 by Smiljan Radić, London, UK**

ALL IMAGES ILGA LEIMANIS

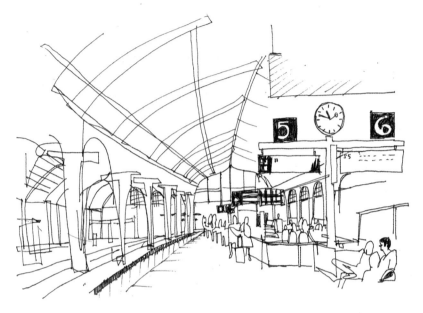

CONSIDER SCALE

Add people or recognisable objects such as cars or trees to make sense of the size of the architecture. People look small in the quick sketch of a train station interior by Ignacia Ruiz (left). Establish the height of a person standing in relation to the walls and block in a simple silhouette. Similarly, a few cars or trees in the foreground serve to communicate the height of the buildings, the scale of which would otherwise be ambiguous. Tim Baynes has a tree in the foreground of his Hong Kong skyline (below) to show the size of the buildings behind it, and then by comparison the height of the much taller buildings.

THIS PAGE TOP: Ignacia Ruiz, Alexanderplatz Station, Berlin, Germany

THIS PAGE BOTTOM: Tim Baynes, Aboard the star ferry, Hong Kong

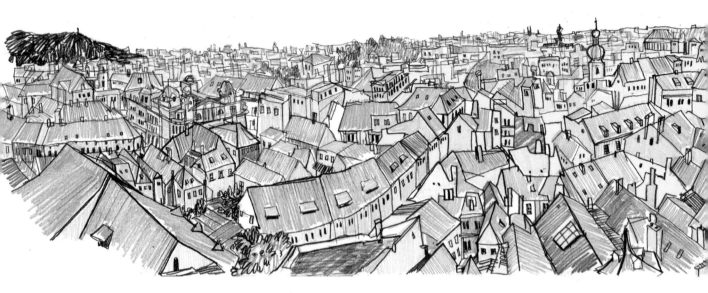

DISTANCE

Use darker and lighter, bigger and smaller lines to convey distance – darker and bigger lines will draw the objects closer to you, lighter, paler, smaller marks will depict objects farther away. Bold lines will jump out and fine lines will recede in the distance. Ortelius Drew used diluted black ink for paler and darker tones (right). Illustrator Ignacia Ruiz carries her sketchbook everywhere. In Prague, she drew the city from the clock tower in fine detail (above). Try separating the distance roughly into three: far, middle and near, adding more details and increasing the size as you approach the foreground. Try a limited colour palette – warm for roof tiles, cool for walls.

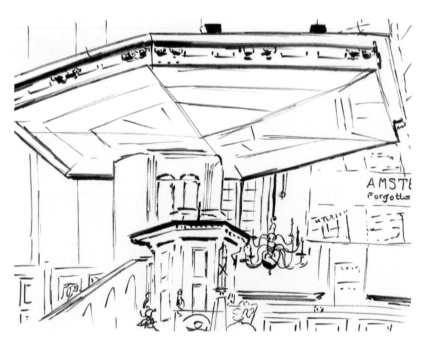

THIS PAGE TOP: Ignacia Ruiz, Prague from the clock tower, Prague, Czech Republic

THIS PAGE BOTTOM: Ortelius Drew, Westerkerk v1, Amsterdam, Netherlands

OPPOSITE PAGE TOP: Kinga Kowalczyk, Grandparents' house, Poland

OPPOSITE PAGE BOTTOM LEFT: Tim Baynes, New York skyline from room 1209, New York, USA

OPPOSITE PAGE BOTTOM RIGHT: Ortelius Drew, De Bijjenkorf, Restaurant, Amsterdam, Netherlands

FROM MEMORY

Kinga Kowalczyk drew her grandparents' home from memory (left). Less rooted in observation, these drawings evoke emotions of a place and time you no longer have access to. It is also a way to test your skill. Start with a floor plan, think about how the space was arranged, then make some small test sketches reconstructing the feeling of the space. If it doesn't work out the first time, try again; sometimes a few attempts are necessary to achieve the feeling you want.

ADD CUT PAPER

In addition to drawing, add some cut paper to the image for variety. Tim Baynes takes his sketchbook with him on his travels; he added sections of a map to this drawing of New York's skyline (left). Ortelius Drew added blue coloured paper for window panes and wood grain texture in the floor (above).

FAMOUS LANDMARKS: Nina Johansson

When travelling, there are always sights to see at every destination. Each city has its own landmarks, places that tourists from near and far visit and take a quick snapshot of, before moving on to the next interesting must-see spot.

You don't have to travel to get a deeper experience of a famous landmark. Pick any well-known building or venue near where you live, and spend a day sketching it. Leave the camera at home, because after sketching a landmark you will never forget it.

IDEAS TO GET YOU STARTED

1. Sketch from afar. Don't go directly to the vicinity of the landmark. Find a place where you can see it from afar, and capture an overview of how it is situated among other buildings. That way you will get a sense of the scale of the place and how it fills its space. Is it overshadowing other buildings? Does it stick up high above the other rooftops?

2. Move up close. Visit the place, touch it, smell it and go inside if you are allowed to. Get to know the place. Choose a spot where you get an interesting angle, and capture as much as you can of it.

3. Get the details. Many landmarks have a lot of interesting details that you may not notice during a quick visit. Now that you have drawn this place and spent some time around it, fill the page around your landmark sketch with details from the site. Sketch that quirky door handle along with the stone face above the window, and don't miss that funny little statue guarding the entrance!

4. Tell the story about the other visitors. Landmarks tend to draw a crowd. People will come and go while you are sketching, but what are they doing there? Watch how people move around this place. Are they talking? Taking pictures? Or leaning backwards trying to grasp the fantastic ceiling above? Try to capture some quick gestural sketches of the other visitors in the environment. If you manage to also draw the landmark itself in the background, this will add to the understanding of the scale of everything.

5. Don't worry about the colours, get the values. To show the shape and depth of a building or other landmark, you need to capture light and shadow. In doing this, don't hesitate to use the wrong colours to make an eye-catching page design. As long as you get the lights and darks right, your drawing will be perfectly believable.

6. Tricks to fit a huge landmark on a piece of paper. You know the situation – you started drawing something fantastic, feeling pretty content with how it's going, only to discover that in the end, the subject doesn't fit on the surface of the paper. The secret is to plan ahead. Take measures with your pen and put small marks on the paper before you begin sketching. Mark the bottom, the top, where that row of windows starts, how much that flagpole sticks up from the tower – make space for everything from the beginning!

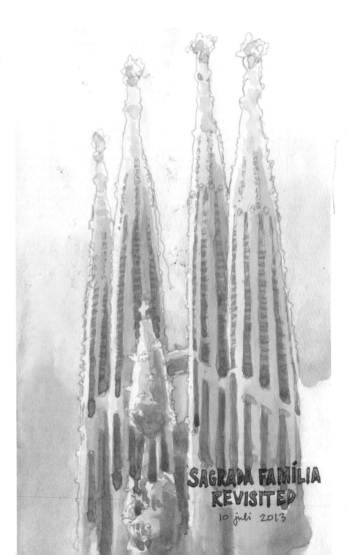

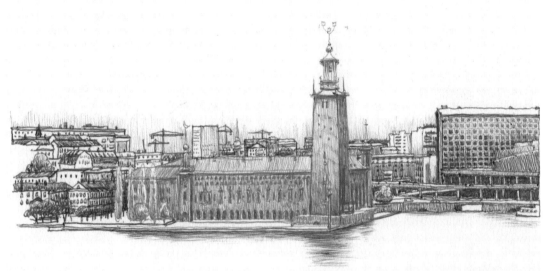

OPPOSITE: Sagrada Família, Barcelona, Spain

THIS PAGE TOP: Stockholm City Hall drawn from across the water, Sweden

THIS PAGE BOTTOM: Stockholm City Hall from a side street, Sweden

ALL IMAGES NINA JOHANSSON

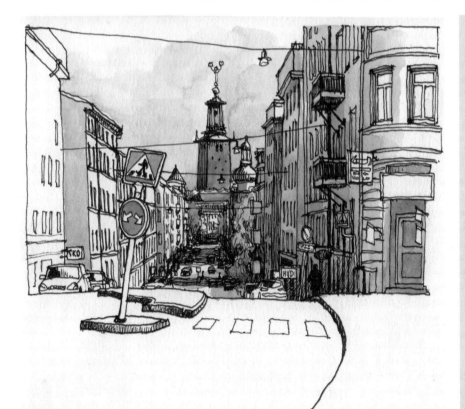

THIS EXERCISE WILL HELP YOU:

- Draw a portrait of a famous landmark

- Sketch people interacting with an environment

- Stop worrying about getting colours right

- Explore a landmark in drawings

- Fit a subject within the edges of the paper

For this exercise, bring along a few different kinds of sketching materials, for example pencils, watercolours, ink pens, coloured pencils or crayons. With these you will be able to explore your chosen landmark in all kinds of ways!

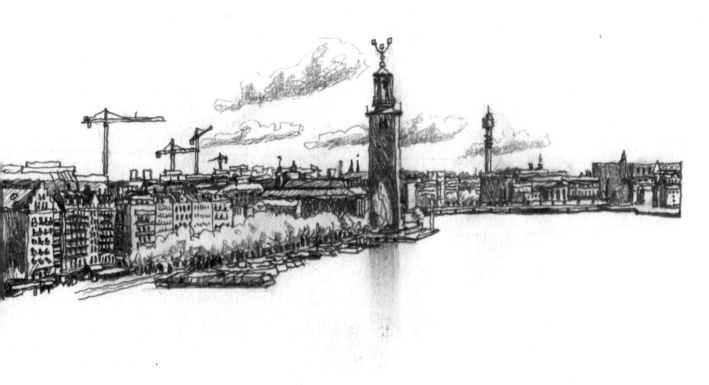

SKETCHING FROM AFAR

THIS PAGE: Stockholm City Hall from afar, Sweden

OPPOSITE: Stockholm City Hall up close, Sweden

ALL IMAGES NINA JOHANSSON

When I started exploring City Hall in Stockholm, I started from a bridge called Västerbron, where you get a view of the centre of the city. From there, you can easily see the size of City Hall, how it is surrounded by lower buildings, situated by the water and reaches higher than all the churches of Old Town. I chose to draw in pencil, so that I could sketch quickly. For the details of other buildings, such as windows and balconies, I just made quick marks, without thinking too much about exact numbers or placement – it was the overall impression I was after. Then I walked closer, to a street where you can see the tower of City Hall looming over the rooftops of the city. I worked in ink and watercolour, simplifying the colours of the buildings so that the red brick tower of City Hall got the most focus.

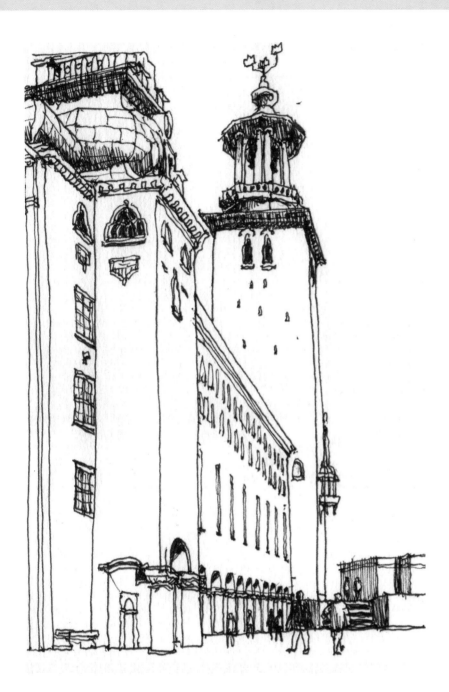

SKETCHING UP CLOSE

To get my close-up of Stockholm City Hall, I sat down at a steep angle to the building. From here, I could see both the main parts of City Hall and the people moving around it, without getting a row of trees in my way. I used a waterproof ink fineliner, knowing I wanted to add watercolours later. I feel fairly comfortable drawing directly in ink, but of course starting with a few faint pencil lines will make things easier when the perspective is tricky.

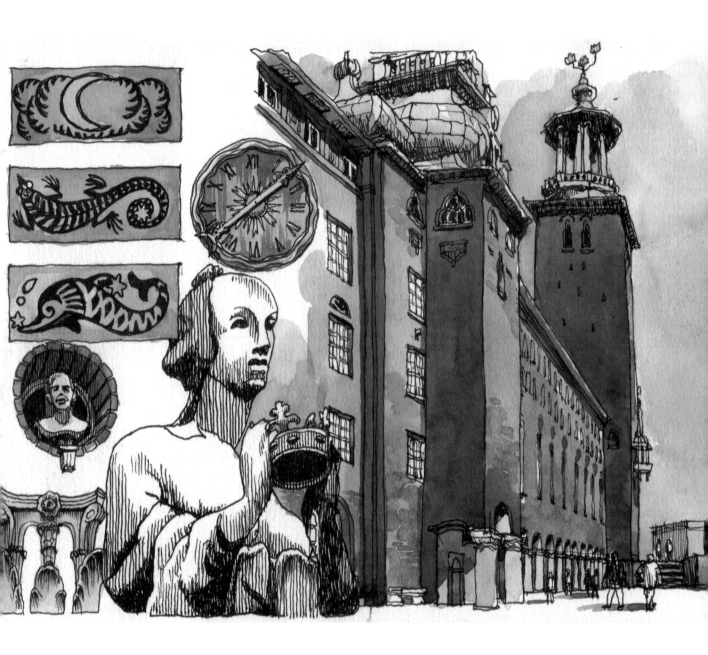

GETTING THE DETAILS

THIS PAGE: Stockholm City Hall details, Sweden

OPPOSITE: Stockholm City Hall in the afternoon, Sweden

ALL IMAGES NINA JOHANSSON

Most landmarks have unique details that might be fun to capture in your drawing. Stockholm City Hall is full of them; the more you look, the more you notice little paintings, sculptures, brick details and symbols everywhere. I picked out a few, working with ink and watercolour, to tell more of a story of the place I was sketching.

GETTING THE VALUES

Everyone knows a famous landmark when they see it; it doesn't matter what colours you draw it with. Just try to make light and shade look right – that will convey the building perfectly. By choosing colours other than the actual ones, you can convey a lot of the atmosphere of a place. How about low contrast orange hues for a sunny slow afternoon, or high contrast neons for a hyper busy, loud morning with lots of visitors? Stockholm City Hall in the afternoon sun does not have to be brick red. Teal blue and purple shows just as clearly how the light falls on the tower and inner façade, leaving little details in the deep shadows. I worked with big crayons here, to help myself concentrate on the light, and not get caught up in all the details.

CARRER DE LA MARINA, 9.45 PM

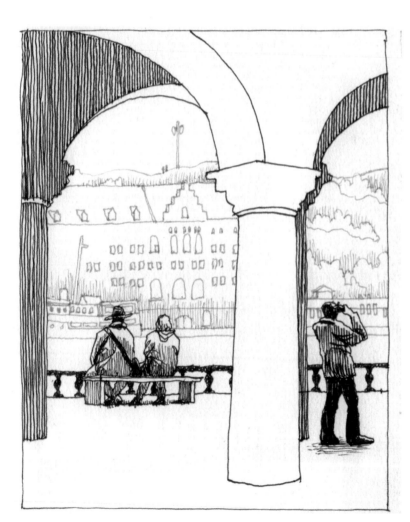

OTHER VISITORS

When I was drawing around Sagrada Família in Barcelona, Spain, a lot of visitors were queueing to get to the entrance (above). The queues were long and slow, and drawing what people were doing while they were waiting was a lot of fun, and told a very real story about what people were doing here. Once inside the church it's different, but outside, everyone is just waiting. At Stockholm City Hall (left), most people move calmly around, eyes pointed towards the tower and the high walls of the building. Many take photos, and most of them end up sitting down on one of the benches along the water, to watch the view toward Södermalm. When I sketch people from observation, I choose drawing tools that are fast, since people tend to move around. Ink pens and pencils are good; watercolours take too long to dry. To make sure that I capture the people before they move, I start with their outlines, then make a few simple shadows on them before moving on to the environment around them.

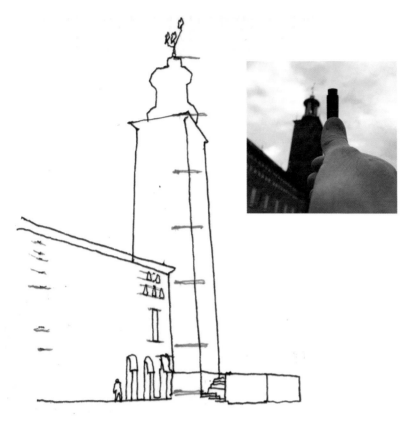

FITTING A LANDMARK ON A SINGLE PIECE OF PAPER

To make sure you fit your subject on the paper you are drawing on, take some measurements before you start drawing. I usually choose a specific piece of the building to use as a unit, and compare that to everything that I draw. In the case of Stockholm City Hall, I used the top of the tower as a unit, and found that from the angle I was drawing, the whole tower was about five-and-a-half units. I put those marks in red, but usually I just make tiny points with the same ink pen I'm drawing with; they will get mixed into the drawing before I'm done, and no one will notice them. I also did a few help lines for where the windows and arches go. And if you still don't manage to fit the whole thing on paper, don't worry. People will still recognise the landmark. You can always use humour to save a mistake. Write a humorous comment by your little mishap, or why not draw the missing piece somewhere else on the paper, or simply bend the building, comic style, to fit it on the page?

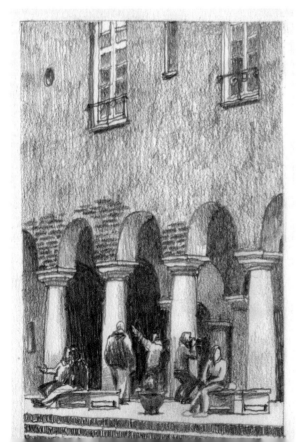

OPPOSITE TOP: Carrer de la Marina, Barcelona, Spain

OPPOSITE BOTTOM: People at City Hall, Stockholm, Sweden

THIS PAGE TOP: Measuring Stockholm City Hall, Sweden

THIS PAGE BOTTOM: People at City Hall 2, Stockholm, Sweden

ALL IMAGES NINA JOHANSSON

DESERTED SPACES: Liz Steel

In a big city we feel as if we are always surrounded by people and hustle and bustle. But there are places where people are absent, and their absence often tells a story.

Why are these places deserted? Is it to do with time or place? When were they last inhabited and teeming with life? Will they soon be crowded and noisy again? Or is it something about their location or function that gives them this deserted feeling? This exercise will explore ways of telling a story about these places, not only as they are now, but what they were or will be.

IDEAS TO GET YOU STARTED

1. Arrive early or stay late. Go to a heavily populated place out of season or out of hours. Arrive early to a big football match in a huge stadium; stay late in a concert hall until everyone else has left and sketch the empty place. How does the space feel in anticipation of a big event, or when everyone leaves?

2. Go out in inclement weather. Rain, wind, extreme heat or cold can cause a normally busy place to become deserted. Dress appropriately and brave the elements – you will be surprised how lively your work becomes when you are sketching in extreme conditions.

3. Search for monuments of the past. Our cities are full of abandoned warehouses and industrial areas that are no longer in use. Many of these places are being demolished for new developments, and much of our heritage is disappearing rapidly, so we need to record them while we can.

4. Travel to the edge. The edges of a great metropolis can contain unique deserted places that turn their backs on the city and look out onto an expansive vista. How can your sketch express the feeling that you are on your own at the farthermost edge of the city?

5. Look for remnants/indicators of human activity. Can you tell a story with the objects that have been left behind by the people that once used the now deserted space? Do these remnants explain who used the space and how?

6. Limit your palette. If you are in a location devoid of life, limit the colours you use to express this barrenness. Perhaps with a careful use of colour you can distinguish between the deserted place and recent activity, such as graffiti on an abandoned factory due for demolition.

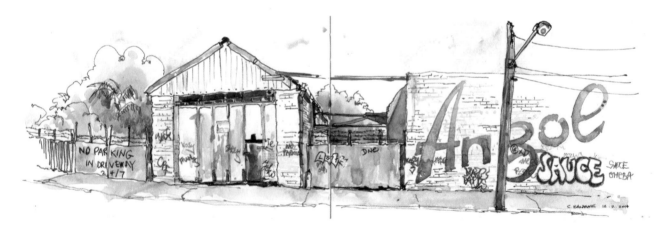

THIS PAGE: Chris Haldane, End of an era – Anzol factory demolition, Mortlake, Sydney, Australia

OPPOSITE TOP: Tia Boon Sim, A new stadium, National Stadium, Sport Hub, Singapore

OPPOSITE BOTTOM: Liz Steel, Lincoln Center in the rain, New York, USA

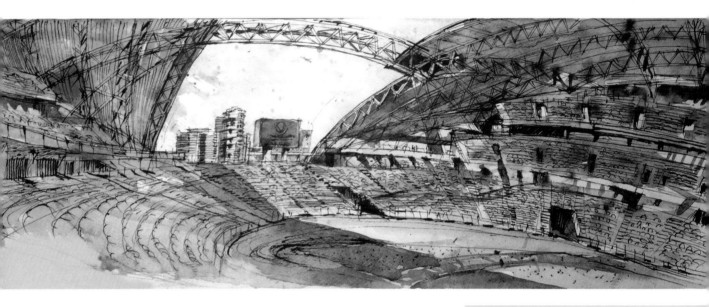

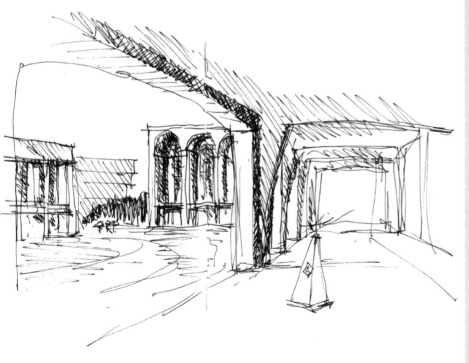

THIS EXERCISE WILL HELP YOU:

- Create a sense of an empty place through negative space

- Use inanimate objects to tell a story of human activity (past or future)

- Record how weather affects human habitation of a place

- Use composition to enhance a deserted space

- Use a limited palette

For this exercise you can either go to a busy place
'after hours', or search for abandoned areas that
are no longer part of people's daily life. The goal
is for your sketch to tell the story of why people
are absent from this place.

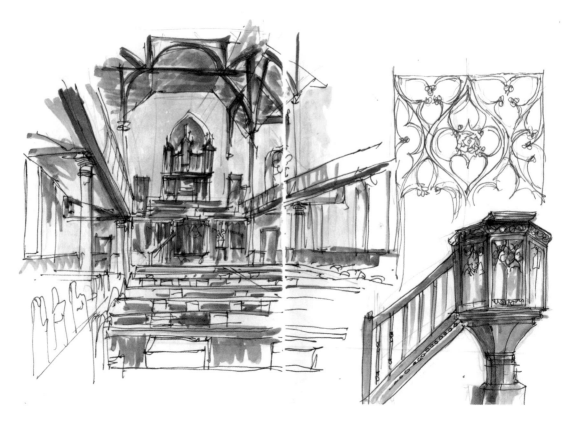

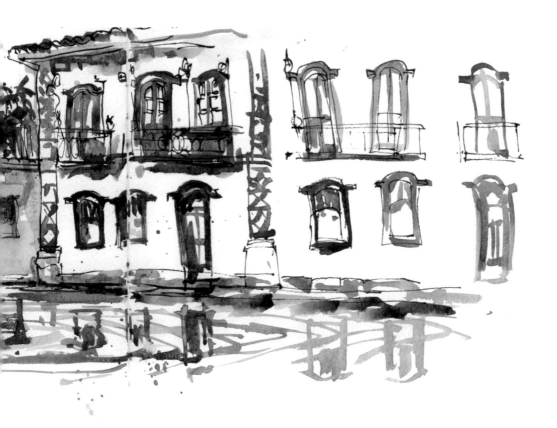

GO EARLY

I was let in early to sketch the interior of this church in Wales during a conference (opposite). While I was initially focusing on the interior space and the organ at the front, I suddenly became conscious of all the hymn books in the pews as indicators of all the people who would shortly fill the space. After subsequently being in the church filled with people singing from those hymnals, this sketch feels very barren to me now. When you are sketching deserted interiors, look out for indicators that tell you how the space will be used, and make sure that your sketch expresses that.

GO OUT IN INCLEMENT WEATHER

Paraty in Brazil is usually full of tourists, but at certain times of the year a king tide floods the cobbled streets for a few hours, cutting off parts of the town. The movement in the streets was not of people but of the rising and falling of the tidal waters and the ever-changing reflections. There is a certain spontaneity about this sketch, as I was not sure how far the water would rise, but thankfully I remained dry. When sketching in inclement weather, consider how the forces of nature have affected the use of the space, and look for indicators of how the locals have dealt with it.

OPPOSITE: Tabernacle, Cardiff, Wales

THIS PAGE: Flooded streets in Paraty, Brazil

ALL IMAGES LIZ STEEL

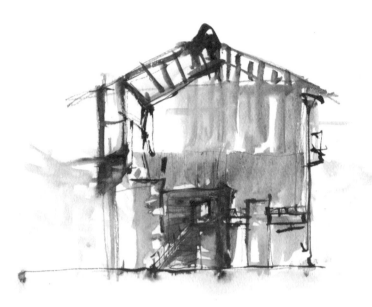

MONUMENTS OF THE PAST 1

Sometimes the abandoned warehouses of the past have already been partially demolished, exposing what were once interior spaces to the elements. If this is the case, you'll want to express this through an openness in your sketch, perhaps via plenty of negative space. There is no need to record all the textures of the various elements in detail, as sometimes a looser, expressive approach can convey a stronger feeling of desertion and decay. Look for areas where a number of different textures overlap, and experiment with paint and line to create contrast between them.

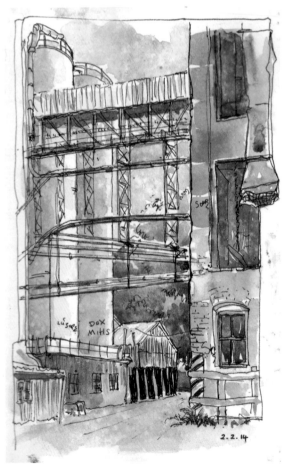

MONUMENTS OF THE PAST 2

There are many industrial buildings that are being demolished for new apartment buildings; therefore, it is important to keep an eye on what is happening in your city so you can sketch them before they are gone. Not only does the decaying nature of these old buildings tell a story of many years of use and then neglect, but there are often magnificent spaces that are now quiet and lifeless. The tall silos of this flour mill in Summer Hill were a local landmark, and this sketch from the inside captures this dramatic vertical space.

MONUMENTS OF THE PAST 3

Cemeteries are great deserted places to sketch. Not only do the graves and monuments make you think about people from the past, but often they are not carefully maintained. Gravestones might have fallen over or even been broken, and the vegetation might be overtaking the place. It is often a good idea to take a sketching friend with you if you are worried that it will be too quiet, and including them in the sketch will provide a strong contrast between now and then. If the trees and plants are very dense, make the most of some darks in your composition, as this will give the scene a sombre feeling.

OPPOSITE TOP: Liz Steel, Cockatoo Island, Sydney, Australia

OPPOSITE BOTTOM: Chris Haldane, A bygone era – Mungo Scott Flour Mill, Summer Hill, Sydney, Australia

THIS PAGE: Liz Steel, Sheffield Cemetery, Sheffield, UK

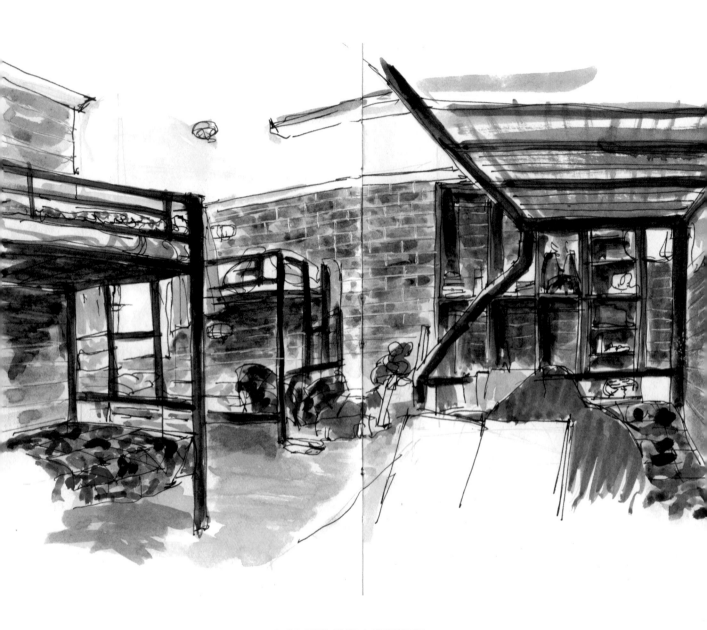

REMNANTS OF HUMAN ACTIVITY

THIS PAGE: Girls' dorm, Stanwell Tops, Australia

OPPOSITE: Tan Jetty, Penang, Malaysia

ALL IMAGES LIZ STEEL

A quiet moment in a very crowded and noisy girls' dormitory. The occupants' belongings scattered throughout the room give you a clue as to how noisy it would be when occupied. The patterned bedspreads and the heavy face brickwork of the walls were added to the sketch to give a sense of enclosure and even claustrophobia, which could be felt at times. Other great scenes to sketch similar to this one would be the rubbish left as the aftermath of a big party, or toys scattered all over the floor after a grandchild's visit.

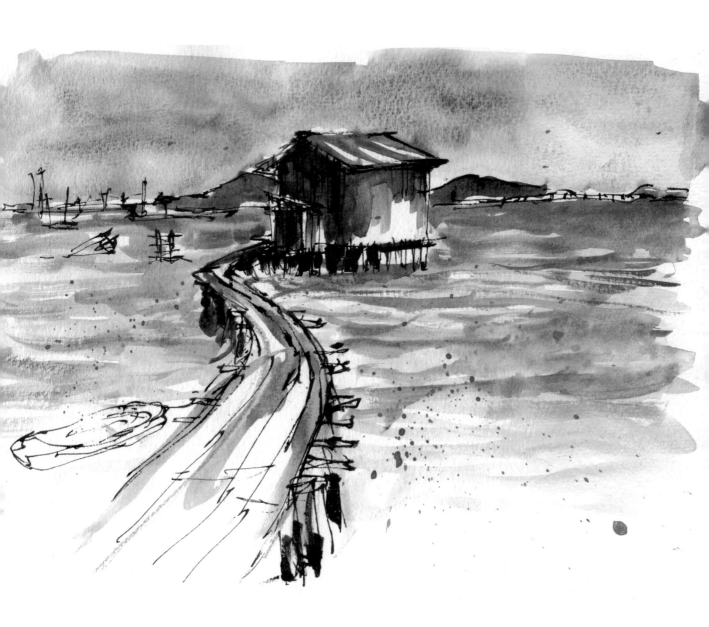

ON THE EDGE

Explore the edges of your city and see if you can
find areas that are deserted – places that turn
their backs on the city and look away into the
great beyond. Are these areas forgotten, or have
they been designed as a place of reflection?
By the composition of your sketch, can you tell
a story about the journey to the edge? Think
about where you place the horizon and how
this creates a sense of openness and space.

TALL STRUCTURES: Kumi Matsukawa

For this exercise, go to a place where you can see a tall structure. Experiment seeing it from a variety of distances and angles, and find the best position to sketch. The nearer you position yourself, the more dynamic your drawing will become, and you can capture the structure with a towering feel.

The same structure can look completely different depending on when you see it, in what season and in varying light. The composition, materials and the speed you draw can also make a significant impact on the final appearance of the sketch.

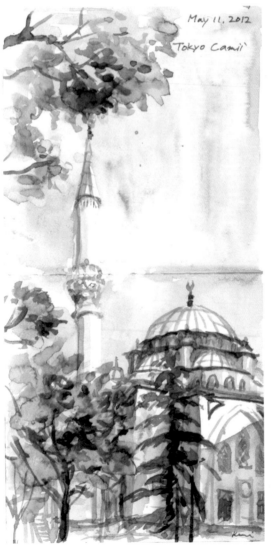

May 11, 2012

"Tokyo Camii"

IDEAS TO GET YOU STARTED

1. Decide what format of paper you will need. If you want to include surrounding objects and buildings, regular rectangle-sized paper will do. However, if you want to draw the structure only, then you might want to customise the paper to a taller format. I myself use four vertically placed postcard-sized papers.

2. See the structure from various distances and angles. A famous landmark or structure that is familiar to everyone from photos can have a much more unique look if you find an original viewpoint, or through trimming or unusual composition.

3. Measure the ratios and proportions and draw reasonably accurately. It is important to get the proportions right. I'm not suggesting you should draw as accurately as an architect, but you should draw the silhouette of the structure as roughly similar as possible. Pay extra attention to how areas shrink as they recede into the distance. This phase is challenging yet rewarding in the results.

4. Find the value of light and shadow by squinting. Colour accuracy is of secondary importance here. Use any colours or hatching you like to create the relative qualities of light and shadow. Compare the brighter sides of the structure against darker sides.

5. Add informative details. Include surrounding objects such as crane trucks, pedestrians, electric wires, clouds and so on. Elements like these can tell the story of a particular moment. Moreover, by including people and cars on the ground, you can draw comparison with the height of the structure against those elements, giving your drawing a convincing sense of scale; and if you draw people in the foreground, middle ground and background, your drawing will give a feel of distance and depth.

6. Visit the same place at different times, in different seasons and in different weather and sketch again and again. If you vary the circumstances of your drawing, you will discover new ways of looking at a structure. Frequent sketching leads to a greater understanding of, and even affection for, an object.

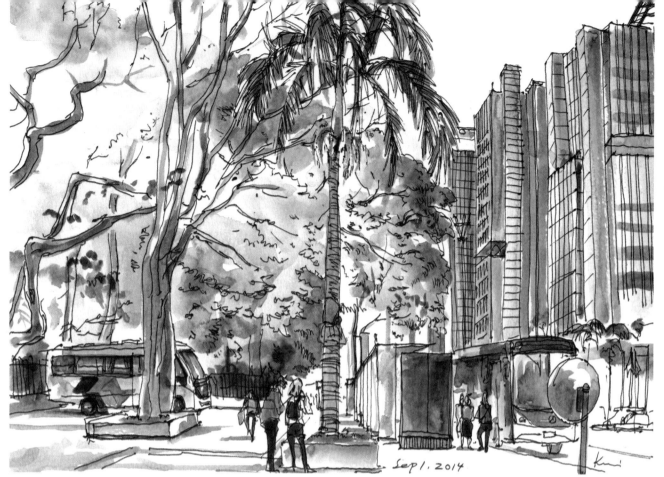

Sep 1, 2014

OPPOSITE:
Tokyo Camii, Tokyo, Japan

THIS PAGE TOP:
Sao Paulo, Brazil

THIS PAGE BOTTOM:
Tokyo Sky Tree, July 2009

ALL IMAGES KUMI MATSUKAWA

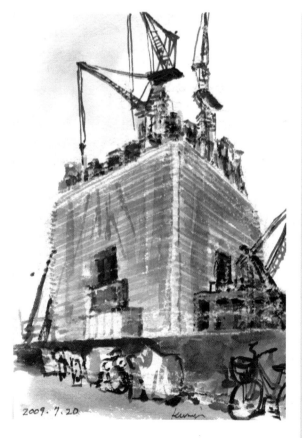

2009. 7. 20

THIS EXERCISE WILL HELP YOU:

- Learn to simplify structure

- Measure relative ratios to get the right proportion

- Compose surrounding elements

- Express the feel of light and shadow

- Develop a basic knowledge of perspective

- Observe and seize on the essence of a structure

Every artist will have their own original way of tackling a chosen structure, and each expression of that structure will have a unique charm showing how it appeals to that artist. Some will be structures and familiar places, and some will be from travel.

PORTRAYING THE CONSTRUCTION OF A BUILDING

I followed this structure being built by sketching from a fixed point several times. As the building grew higher, I needed to add paper vertically to capture the whole structure. I drew rough contour lines using orange crayon and finished the drawings with watercolour. I prefer vivid crayon lines to pencil ones. Since the building had been under construction and everything tended to look sober, these crayon lines served as nice accents as well as complementary colours in the blueish drawing. This building has a pretty simple silhouette and proportions, yet it has quite a complicated patterned structure with white pipes. Initially I tried to be faithful to reality in the choice of colours, but before long I prioritised the structure and sacrificed colour accuracy.

LEFT TO RIGHT:
Tokyo Sky Tree;
August 2009,
September 2009,
November 2009,
March 2010,
July 2010,
October 2010,
June 2011

ALL IMAGES
KUMI MATSUKAWA

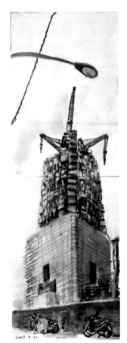

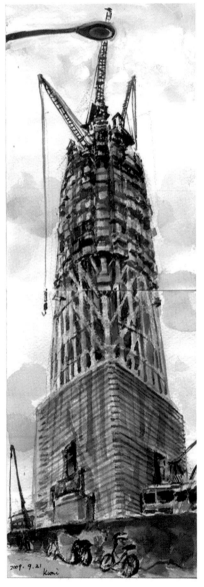

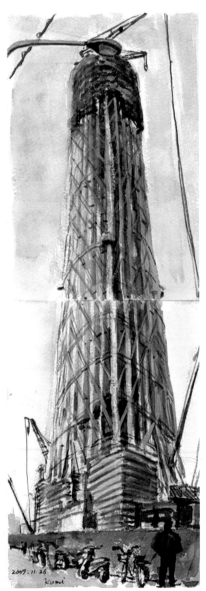

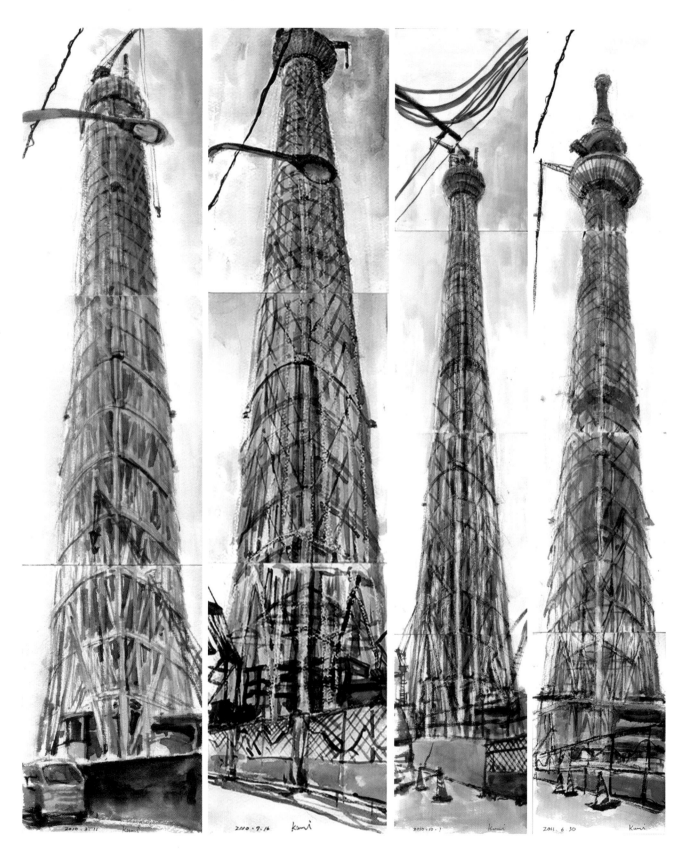

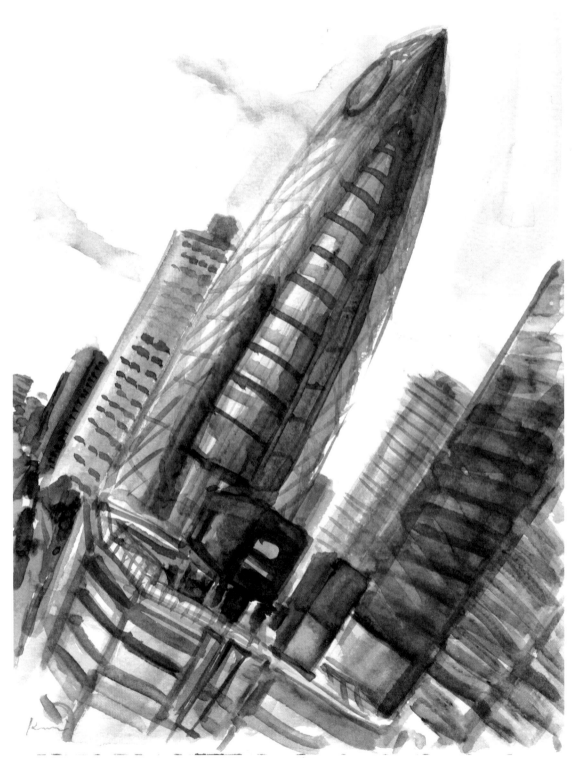

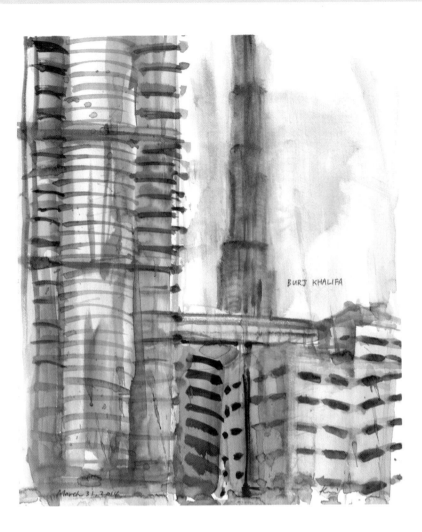

BURJ KHALIFA

March 31, 2014

DRAWING DIAGONALLY

This is the cityscape as seen through the window on the twelfth floor of Odakyu department store in Shinjyuku, Tokyo (opposite). This time I followed the advice of German sketcher Omar Jaramillo, who says one good way to compose tall buildings is to draw diagonally, utilising the longest space of the sketchbook. I like this composition, the way it gives dynamism. The difficult part of drawing things diagonally is you can't refer to the horizontal and vertical lines of the paper's edges, therefore you have to always pay attention where the eye lies along the horizontal line in your drawing. Since I don't make a mark of that line, I often misjudge perspective, for example the building on the right in this drawing.

MAKING THE MOST OF A POOR VANTAGE POINT

Burj Khalifa is one of the tallest structures in the world. When I went to Dubai, I was determined to sketch this ever-evolving city view. It was 3:30 P.M. when I arrived this site. It wasn't the ideal location if I wanted to sketch Burj Khalifa only, but there was little time left to walk around to find a better place, so I decided to capture it including the foreground buildings. I sketched it directly with watercolour. I couldn't fit the top part of the structure in my drawing; if you draw a really tall structure from a distance, you will have to draw it smaller to fit it into your composition – or like this, trim off some parts and depict more details. I don't think this is a well-composed drawing, but I recall the excitement of my encounter with this structure whenever I see this piece.

OPPOSITE: A view from Odakya department store, Tokyo, Japan

THIS PAGE: Burj Khalifa, Dubai

ALL IMAGES KUMI MATSUKAWA

DEALING WITH SHADOW

Almudena Catedral is a huge structure in Madrid, Spain. I composed only a part of the front of the structure in this drawing (right). I drew rough contour lines using orange coloured pencil and finished using watercolour. My vantage point on that day was a really good one. I was able to sit on the grass, without any obstructions. However, the sun at that moment was behind the cathedral, so the white building looked shadowy. But I didn't want to make it look as dark as it actually was, so I only lightly added shadow tone. The sketchbook I used was made in the paper mill in Capellades, Spain. This new paper surface also made me refrain from overworking because it was more fragile than my usual paper.

ACHIEVING A HARMONY OF COLOUR BALANCE

I first figured out this tower's proportions (opposite) by measuring the relative ratios of the width of the top part against its height. Then I figured out the height of the trees as well as the other buildings. This time I used primary colours only and drew directly with them. I like to achieve a gradational change of colours by controlling the mixture of them. That way I think the picture has more harmony, since each part consists of the same mixture of pigments. I wanted to draw a structure with high contrast, showing strong light and shadow, but that day it was cloudy and windy. Still, I asked myself which side of the structure was brighter than the other. I captured the composition and colours more or less similar to the original scene, but when it came to capturing people, I needed a more expressive way of drawing. I had no time to accurately portray the colour of their clothing.

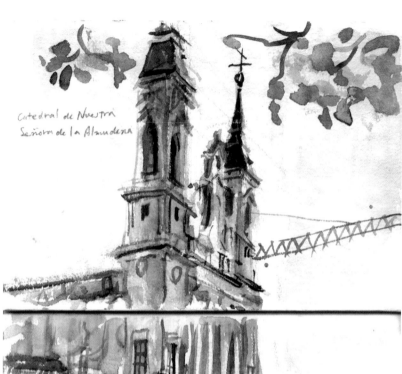

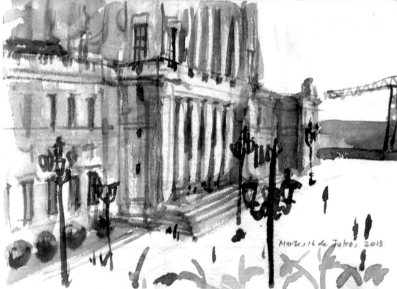

THIS PAGE: **Almudena Catedral, Madrid, Spain**

OPPOSITE: **Cherry blossom trees and Landmark Tower, Yokohama, Japan**

ALL IMAGES KUMI MATSUKAWA

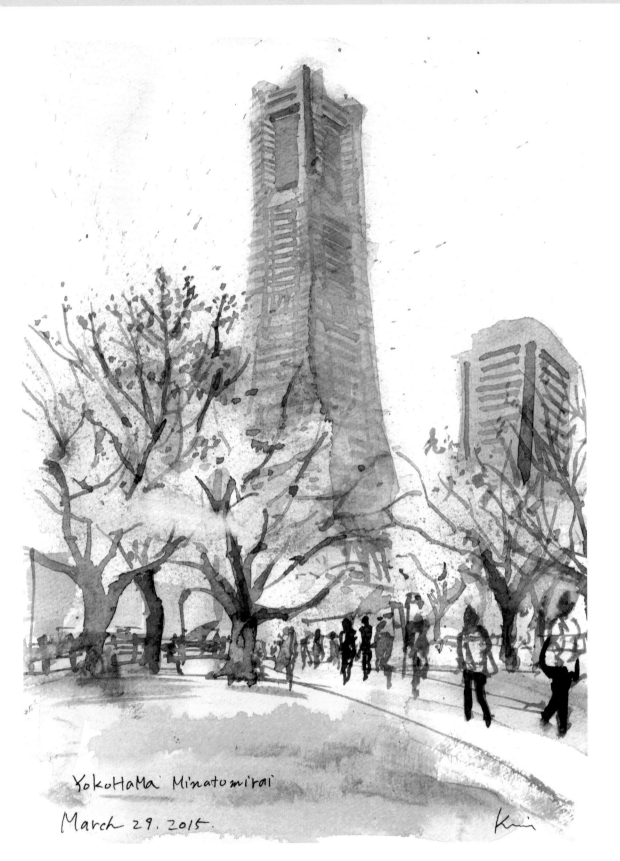

YokoHaMa Minatomirai

March 29. 2015.

DRAWING A BUILDING WITH SHAPES: Paul Wang

Sketching a complex architecture scene on-location can often be daunting, especially if everything in front of you is trying to grab your attention. Learning how to step back and examine the complexity can help you establish a road map to sketching. The key is the ability to identify shapes and understand their relationship to one another.

IDEAS TO GET YOU STARTED

1. Identify shapes. Take some time to stare at the small cluster of buildings in front of you. See if you can identify the primary (squares, triangles, circles) and secondary shapes in the buildings. Some larger complex objects are actually made up of smaller and simpler shapes. Start with a small area that is the most interesting to you. Often it can be overwhelming, so don't forget to breathe and have fun.

2. Trace the shapes. Now try a little shape sketch. Keep your initial practice sketch small. Draw the shapes as you see them. The roof could be a big triangular shape and most windows can be reduced to small rectangles. You can choose to start with the most interesting portion of the building. Do several quick practice sketches and see how quickly you will improve.

3. Find the relationships between the shapes. Look at the buildings and your small shape sketch. Notice how the shapes that you have captured are interacting with each other in several interesting ways. Some shapes will overlap, and some will sit adjacent to each other. Larger shapes also contain a lot of smaller and more intricate shapes. Some create tension as they merge into each other.

4. Look at dominance and variations. Use one or two dominant shapes in your sketches to create focus and emphasis. Shapes can also be repeated with subtle variations to break up monotony.

5. Study everyday objects. Sketching at a café is a good way to observe and capture objects. Treat your tea pots, cups and cakes as interesting shapes. Create a conversation using these familiar objects on your table.

6. Look at what is in front and behind objects. Identify their placement in space so that you can enhance spatial depth.

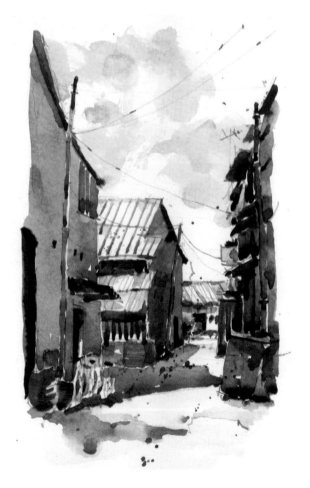

THIS PAGE: Back lane of Georgetown, Penang, Malaysia

OPPOSITE TOP: Surry Hills, Sydney, Australia

OPPOSITE BOTTOM: Old sheds on Cockatoo Island, Sydney, Australia

ALL IMAGES PAUL WANG

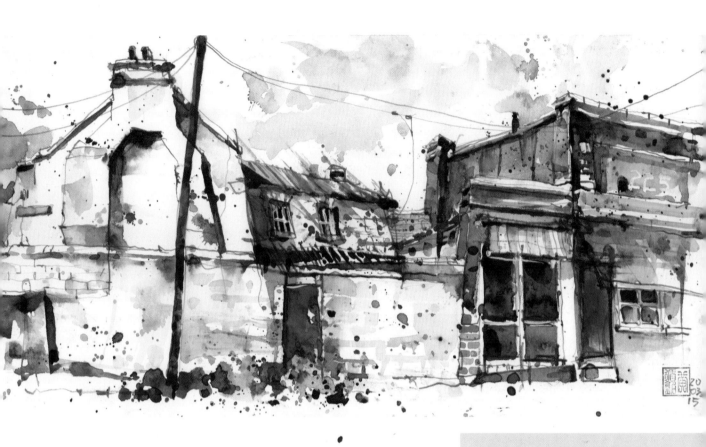

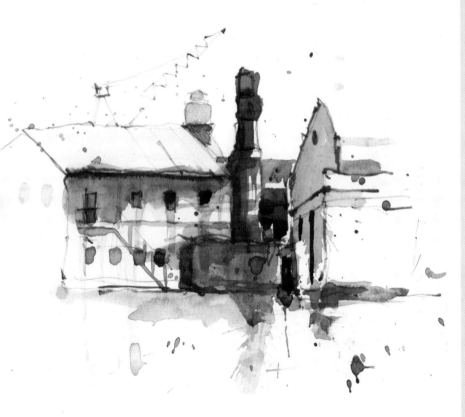

THIS EXERCISE WILL HELP YOU:

- Simplify a complex architecture scene to basic shapes

- Observe the relationships between shapes

- Use a family of shapes to tell a sketch story

- Create interesting compositions with a focus

Find a place with a cluster of interesting buildings to try out this exercise.

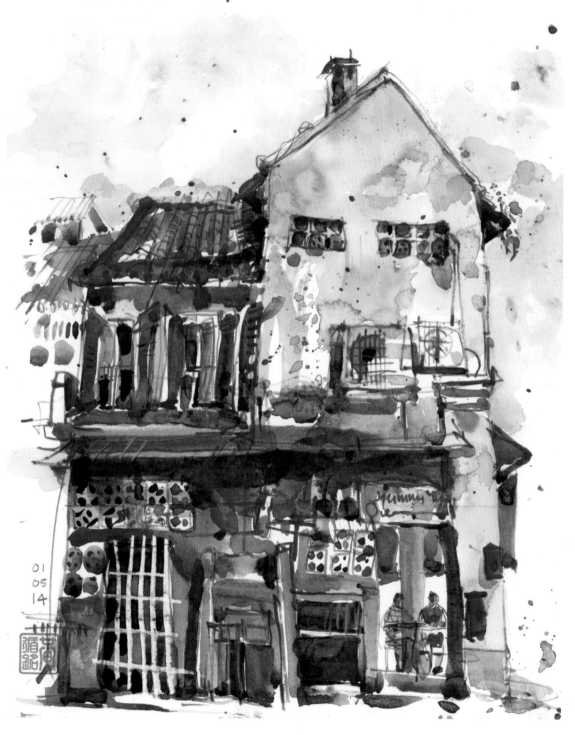

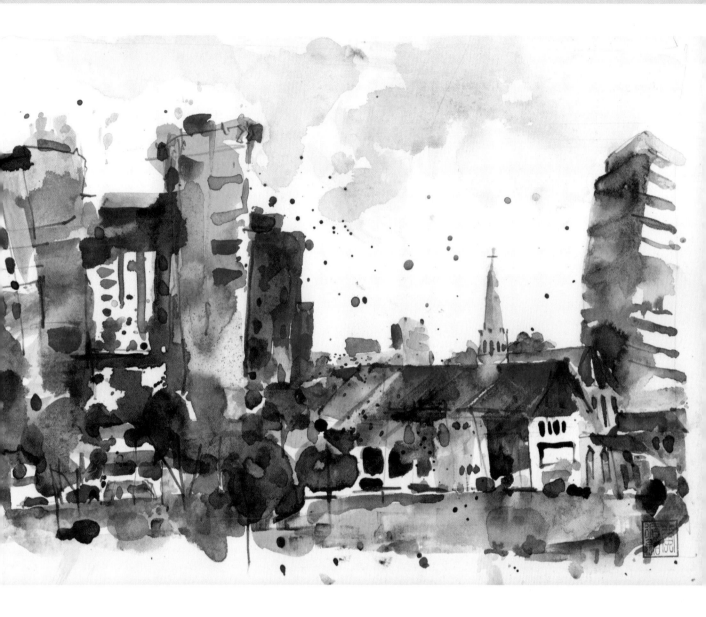

LOOK AT THE BACK OF THE BUILDING

I found a nice interesting corner to tell my story when I was walking past a row of old shophouses (opposite). If you run out of ideas, always check out the back of the building. I like how dominant the bigger yellow side of the shophouse looks. The other portion of the building connects and is subservient to the more dominant yellow shape. This is very helpful way to make a sketch more connected and cohesive.

FIND RHYTHMS AND PATTERNS

Try to see if you can find rhythms and patterns in a busy and complex architecture scene. Here you can see how the tall vertical apartment blocks are lined up in a linear, orderly fashion. I punctuated this rhythm with the church spire to break up the monotony.

OPPOSITE: **Rear of shophouse at Sultan Gate, Singapore**

THIS PAGE TOP: **Victoria Street, Singapore**

ALL IMAGES PAUL WANG

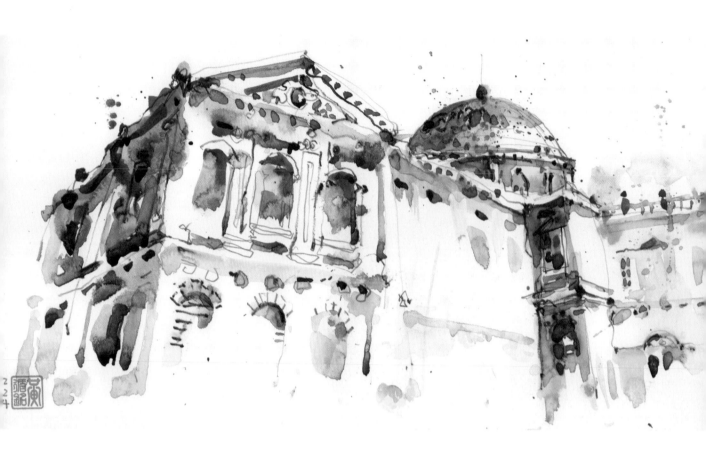

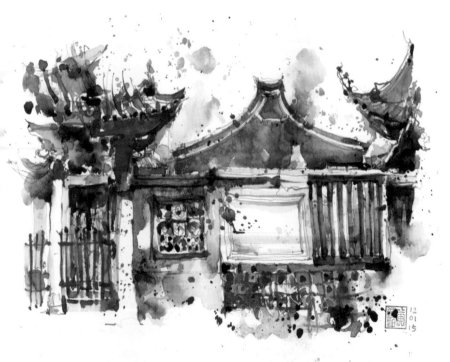

SIMPLIFYING SHAPES

In this sketch (above), I tried to simplify the classical ornate details and architecture of this museum and turn them into simpler shapes. Some shapes are drawn while others are allowed to fade away and to create an illusion of space and depth.

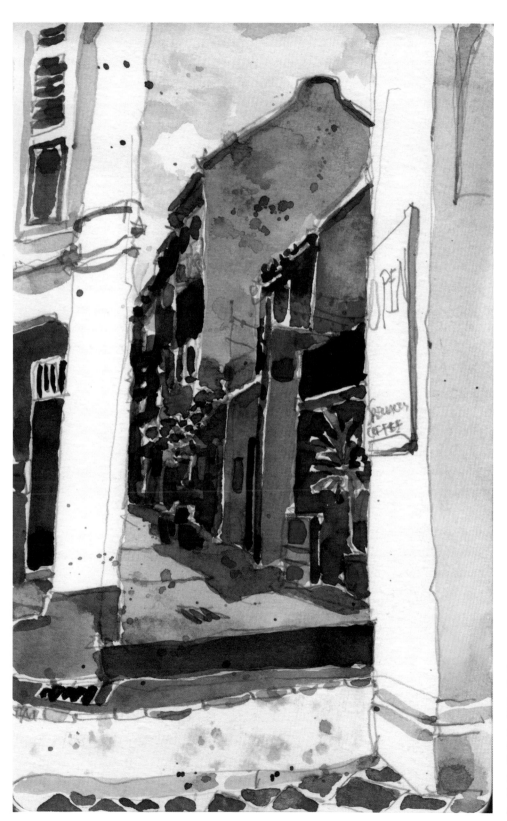

OPPOSITE TOP: National Museum of Singapore, Singapore

OPPOSITE BOTTOM LEFT: Thian Hock Kian Temple, Singapore

OPPOSITE BOTTOM RIGHT: Old Chinatown shophouses, Singapore

THIS PAGE: Back alley, Neil Road, Singapore

ALL IMAGES PAUL WANG

TRAVEL PORTRAITS: Samantha Zaza

People are a wonderful subject to sketch while travelling to a new country or exploring a different culture. Sitting silently across from someone while studying their face and drawing them is a powerful experience – even if you can't communicate verbally.

IDEAS TO GET YOU STARTED

1. Ask for permission. Even if you don't speak the same language, approach the person with your best barrier-breaking smile. I usually gesture to them with an open hand (never pointing), circle my face with the same hand, then showing them my sketchbook I 'mime draw' on a blank page. Showing other portraits you have drawn will make this much easier; if you have them, use them! Getting permission is a fundamental step, as cultures differ. In some cultures you might find it difficult to draw people of the opposite sex. Once, while sketching a fishmonger in Oman, another man approached me for a portrait of himself. Though he seemed excited by the idea at first, he soon became uncomfortable with a female staring at him, and suddenly ran away. Generally I find that people are happy to be drawn, but some are not, and it is important not to be bothered by this or to push the issue.

2. Think about where to start your drawing. It helps to lightly sketch the larger, general shapes (such as the facial outline) and work your way towards the details. Establishing the larger shapes first acts like a map, and helps you see where to place the more distinctive facial features.

3. Look at the eyes. Divide the face in half both horizontally and vertically. The horizontal halfway guideline is the line where the eyes sit, and there are about five eye widths across the span of the face, with one eye width between the eyes. This trick is helpful in getting the placement and the size of the eyes anatomically sound, but remember that everyone's eyes are different.

4. Look at the nose. The nose plays a major role in what makes someone distinctive, so pay close attention to the overall width, length and curves of your subject's nose. Generally the nose will end somewhere around halfway between the eyes and the chin. The edges of the fleshy parts of the nostrils tend to line up with the inner corners of the eyes, and the holes are seldom circular, but more comma-shaped.

5. Look at the mouth. The opening of the mouth lies slightly above the halfway point between the tip of the nose and the chin line, and the corners of the mouth tend to line up with the inner edges of the irises. Look at your subject's lips – are they thick or thin? Does the upper lip form an M shape, or is it more rounded? Try to follow the way the lips curve and sketch the contour on your drawing. Generally the upper lip is angled inwards towards the opening of the mouth, giving it a darker shadow than the lower lip, which is often thicker and protrudes more. There is usually a highlight along the centre of the lower lip that changes shape with the lip's creases, and the corners of both lips fall into shadow.

6. The details. Now that you have captured the major structures of the face, scan your subject's face for any distinguishing features such as wrinkles and moles, facial hair and their hairline. It is not necessary to draw every hair on your subject's head, and they would surely abandon you if you attempted such a thing, so sketch in the general shape that the hair makes while shading in the shadows, and add a few lines to indicate hairs closest to the scalp.

OPPOSITE: Jamyang Tashi, Shechen Monastery, Boudhanath, Kathmandu, Nepal

ALL IMAGES SAMANTHA ZAZA

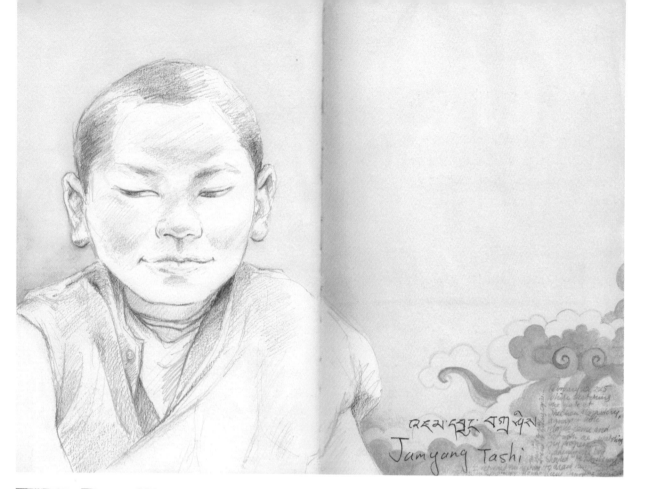

འཇམ་དབྱངས་བཀྲ་ཤིས
Jamyang Tashi

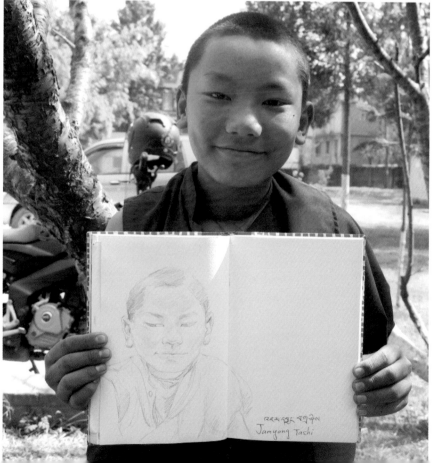

འཇམ་དབྱངས་བཀྲ་ཤིས
Jamyang Tashi

THIS EXERCISE WILL HELP YOU:

- Develop your understanding of facial proportions

- Develop your observational drawing skills

- Feel more comfortable approaching people for portraits

In these examples I focus on frontal portraiture, with the subject facing me. Choose someone who you would like to draw, who does not seem to be too busy; you do not want to inconvenience them, and portraiture can take time to get the likeness right.

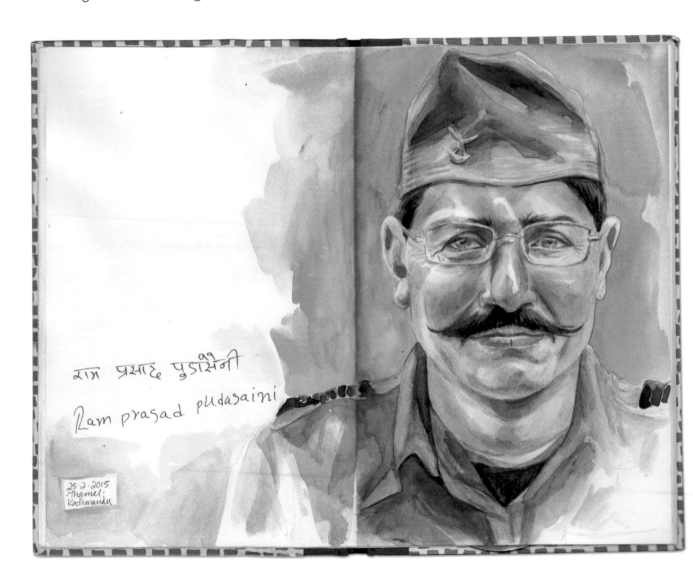

राम प्रसादे पुडासैनी

Ram prasad pudasaini

25·2·2015
Thamel;
Kathmandu

THIS PAGE: Ram Prasad, Thamel, Kathmandu, Nepal

OPPOSITE: Self-portrait, Istanbul, Turkey

ALL IMAGES SAMANTHA ZAZA

THE HUMAN FACTOR

I used to be more timid about approaching people, and would sneak a portrait of an interesting-looking person from a distance. This is an excellent way to get started in travel portraiture; however, you miss out on the often comical and very human experience of trying to connect with someone who you have never met before, who has no idea why you want to draw them (opposite). Even if your portrait is not your finest work, the experience will generate joy.

UNDERSTANDING FACIAL PROPORTIONS

Having a basic understanding of facial proportions (right) will make portrait drawing less intimidating, and after some practice, it will help give you the courage to get a little closer to your subject. I found that the more confident I was in my drawing, the bolder I became in asking people if I could draw them. Start with a quick circle to represent the cranium; this is the main part of the head, where the brain is housed. The jawline begins and ends from the outer left and right edges of the circle, and is about the same length as the cranium; everyone's face is different, but the human face is generally symmetrical. Observe your subject's jaw – is it wide? Square? Narrow?

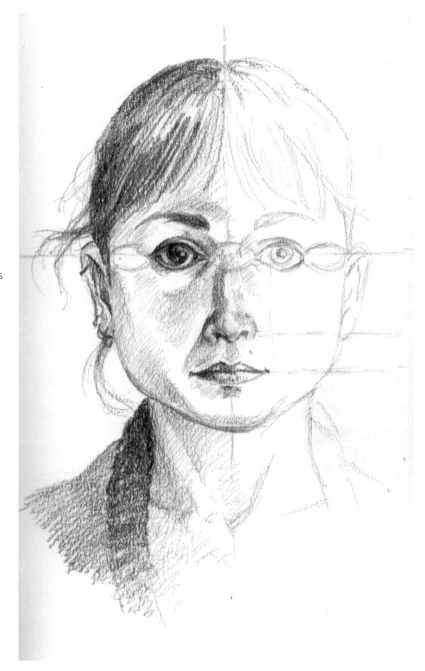

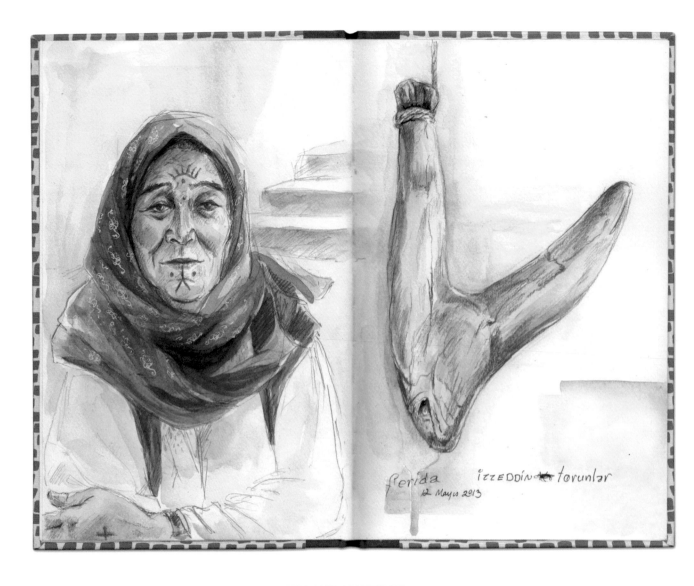

Ferida
12 Mayıs 2013 İzzeDDİN torunlar

EYES, JEWELLERY AND TATTOOS

THIS PAGE: **Feride Hanim,** Urfa, Turkey

OPPOSITE: **Yunus Bey, Urfa, Turkey**

ALL IMAGES SAMANTHA ZAZA

The eyelids are what make the shape of the eye. Study your subject's eyelids – do they angle up or down? Are the eyelids heavy or can you barely see them? Can you see the inner corner of the eye? In which direction do their lashes point? The irises are the colourful parts of the eye, with the dark pupils in the centre. If your subject is making eye contact with you, then these parts of the eye will be central. The eye is a ball, and as such, there are shadows in the outer corners of the whites of the eye as the edges of the ball move away from you. There is also a shadow that is formed under the eyelid. Eyebrows tend to follow the shape of the eye. How large is the distance between the eyes and eyebrows, and in which direction are the hairs growing? Are they pointing upwards or downwards? Left or right? Are the hairs thick or sparse? Where do the ends of the brows line up? Items such as clothing, jewellery and tattoos also give context, identifying the culture to which your subject belongs. I never leave this part out of a portrait. How someone dresses themselves is often a source of pride, tied to their identity.

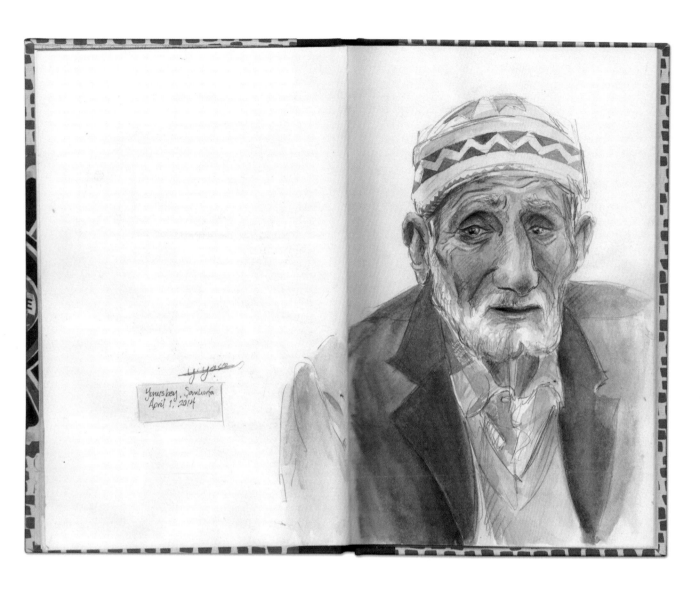

Yunusbey, Şanlıurfa
April 1, 2014

THE NOSE IN DEPTH

The lack of distinctive lines makes a nose challenging to draw; with the exception of the edges of the nostrils, everything else is dependent on shading. Observe which direction the light is coming from. If you squint your eyes, you'll be able to see the shadows and highlights on your subject's face a lot easier (this trick works for any observational drawing). You will most likely notice that the fleshy part just above the nostril holes has a very delicate shadow; including this shadow, which is often overlooked, will make your nose pop forward.

I like to finish a portrait by asking the person who has graciously given up his time to sit for me to write his name on my drawing in his own language. If you are reluctant to give your sketch away and a photocopier is accessible, your subject will undoubtedly love to have a copy. At the time of sketching Yunus Bey in Urfa, I was unable to make a copy, so when I returned to Urfa a year later, I had one for him in hand. This unexpected surprise was deeply appreciated!

PEOPLE IN MOTION: Kumi Matsukawa

Go to a place where you can see people in motion (preferably dancing): a festival, a concert, a party, a disco. Try to draw gestural form quickly. Details and real colours are of secondary importance in this exercise.

Don't try to make up your drawing using your imagination or your own conception of anatomy because, if you do, your drawing will become less truthful to what you have observed. So don't be worried about an unfinished look in your drawing. Just create a series of sketches to get the knack.

IDEAS TO GET YOU STARTED

1. Pick your ideal sketching materials. I prefer to use watercolour and brush because I like to capture the whole of a figure with brushstrokes, while at the same time giving the drawing light and shade by controlling the density of the pigments. My approach is to capture large then go into detail if necessary. But colour pens or coloured pencils are also great tools – you don't have to mix and dilute each time and you don't need to wait for the paint to dry. Or if you prefer to draw with black line, that's fine too. It all depends on your style. You will also want to use a size of paper that is portable and easy to handle as well, especially if you are drawing on your feet.

2. You are not drawing a moment in time. By all means draw quickly, but even if you do, it's no use trying to capture a particular moment or motion, and waiting for the person you are drawing to repeat that same motion in order to continue your sketch. You are not necessarily copying an exact moment of pose; rather your drawing should express consecutive movements of the motion or dance. And that's how your drawing will tell the story, the flow of the motion or dance.

3. Concentrate on the light and shade. By concentrating on the light and shadow in the form of your subject rather than adding details of facial expression or precise colours, you will give the figure depth. Take note of where the light is coming from, and don't forget to look at shadows on the ground; all this will help you to achieve a sense of depth and space in your drawing.

4. Think about page management. When you sketch dancing people, you may wind up with a bunch of unfinished-looking drawings in your sketchbook as a result. Sometimes you might feel unhappy with this outcome as they may look like nothing but practice pages. But when you keep filling pages with these fractions of drawings, then the images start to tell a story; the passionate feel of dancing can be seen with an animated feel. Or you can add details of the room interior, or people observing the dancers. This way, your drawings will speak of the ambience of the space, and in comparison with the motionless spectators your sketchy-looking dancers will appear more alive, even though you have only depicted the hint of gestures. Make your pages enjoyable in their own right.

5. Indulge in every sketching opportunity. You'll have many occasions to sketch in a variety of circumstances, and whatever that circumstance is, enjoy it. You might be sketching at a dinner show, where you can draw comfortably on a chair in an air-conditioned room with a glass of wine. You might be outside, your vision might be obstructed by the heads of other spectators, or you might be distracted by the scorching sun or cold wind. You might be drawing a scene during a break from your own dancing, perhaps at a disco. On every occasion, enjoy the moment and the opportunity to tackle your subject.

6. When drawing a pair of dancers, be careful about the coordination of their poses. To capture a single dancer is challenging enough, but to draw a pair is a challenge of a different order. The most important thing is to match the movements, to make it look like a natural dynamic between two dancers. You have to pay extra attention to this during a drawing; it's like a race against time. But relax: you can always add the hint of a body part – an arm, a head, legs – glimpsed behind the foreground person. For me, a dancing pair is one of the most rewarding subjects to sketch.

OPPOSITE TOP: Belly dance show, Tokyo, Japan

OPPOSITE BOTTOM: Japanese drum performance, Tokyo, Japan

ALL IMAGES KUMI MATSUKAWA

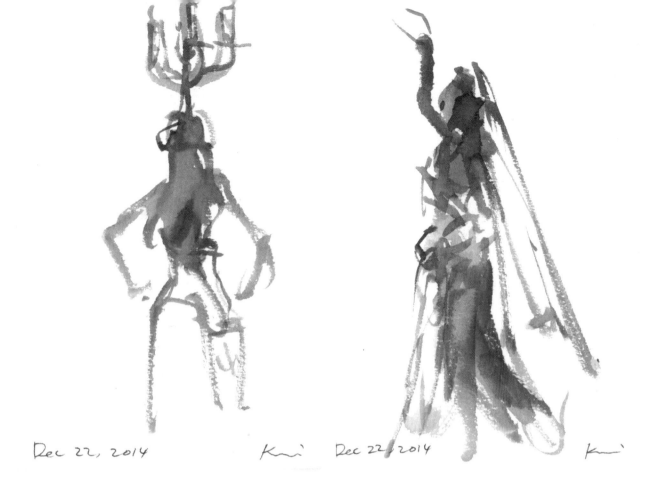

Dec 22, 2014 Kmi Dec 22, 2014 Kmi

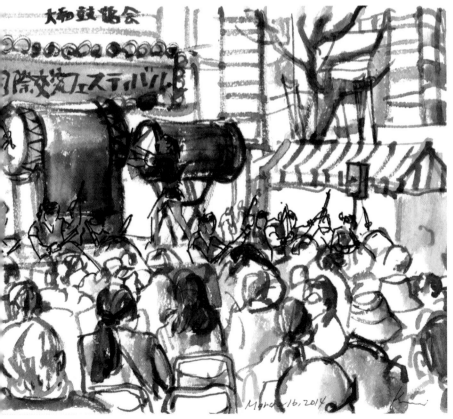

March 16, 2014

THIS EXERCISE WILL
HELP YOU:

- Develop your drawing speed

- Learn to vary your line

- Draw convincing gesture in motion

- Compose surrounding elements

- Express the feel of light and space

- Observe and seize on the informative
 essence

Behind every drawing of people in motion there is a unique story. Sometimes sketchers attend a scene specifically to practice, sometimes they simply encounter a scene and record it as a precious memory.

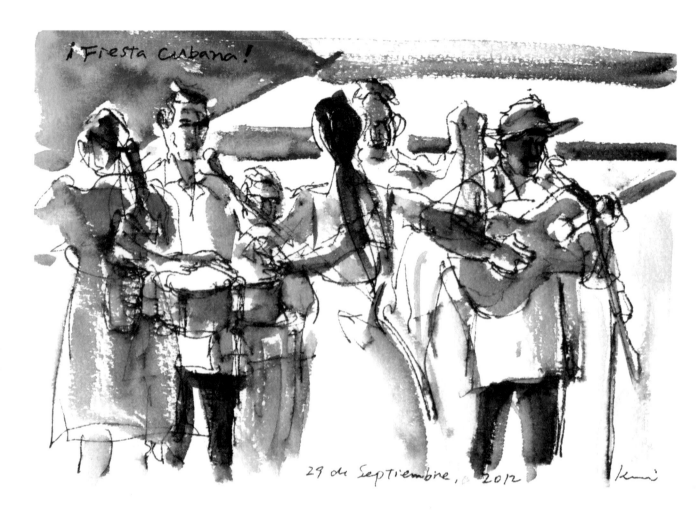

¡Fiesta cubana!

29 de Septiembre, 2012

EXPRESSING MOTION IN DANCERS

THIS PAGE: ¡Fiesta cubana!, Tokyo, Japan

OPPOSITE: Desert safari, Dubai

ALL IMAGES KUMI MATSUKAWA

This was done when I went to a party called ¡Fiesta cubana!, which was held in a Spanish language school in Tokyo. There was a band playing Cuban salsa music, an exhibition by a Cuban dance group and visitors enjoying the dancing, Cuban cuisine and drinks. The guitarist and the vocalist were relatively static, standing in the same position, while their arms and hands moved busily and repeatedly, but I made marks of their hands in motion, then focused on the contours of the dancers. The dancers kept moving back and forth and making turns, so I first captured the woman's pose, then added her partner's posture behind her and in relation to hers. I wanted this dancing couple to appear animated in the drawing, so I kept the look of them unfinished, partly transparent and fluid. That's my way of expressing motion.

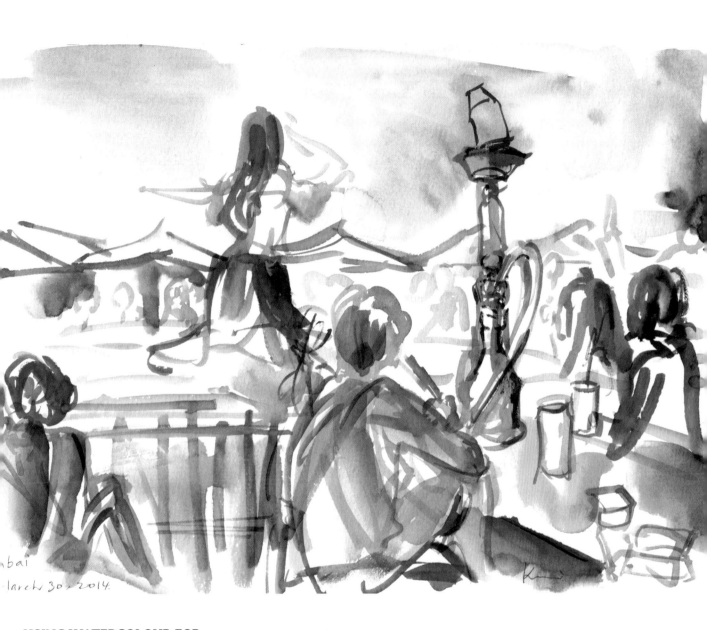

USING WATERCOLOUR FOR TONE AND LINE

In the desert in Dubai one evening, a dancer performed several belly dances on a stage, with spectators surrounding the stage in the dim light. I sketched this using a straight-to-watercolour method. Although I used colour pigments, my intention wasn't to copy the actual colours I saw – I couldn't tell the precise colours in the dim light – so I picked any colours in my palette to create tonal tint and gradation and lines. I wanted to capture the dancer's beautiful posture with the dynamic flow of her long hair and her dress. I completed my study of her body by observing several motions she made repeatedly. At the same time, for contrast, I observed and captured the spectators, sitting still and gazing at her.

Dec. 17. 2011

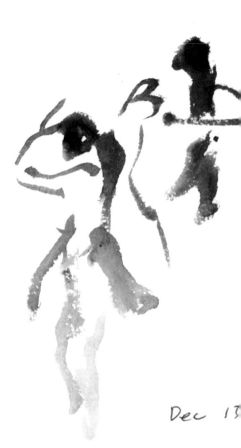

Dec 1?

CONTRASTING MOVEMENT AND STILLNESS

THIS PAGE: **At Bodeguita, Tokyo, Japan**

OPPOSITE:
Dancing people 1, Tokyo, Japan
Dancing people 2, Tokyo, Japan
Dancing people 3, Tokyo, Japan

ALL IMAGES KUMI MATSUKAWA

I was at a Christmas party held in a restaurant called Bodeguita in Tokyo, where a pair of dancers exhibited a salsa dance and people in chairs observed them. For this drawing I could only capture the gestural impression of the salsa dancers. Their movement was so quick and passionate I couldn't keep up with the speed of their motion. Instead of overworking them, I used minimal brushstrokes to depict their figure. But I put more emphasis on and added detail to the people in the foreground. That way, I gave the drawing a sense of contrast between stillness and movement. This drawing was done using a straight-to-watercolour method. I like working this way because I can add volume, gradation and colour in a single stroke.

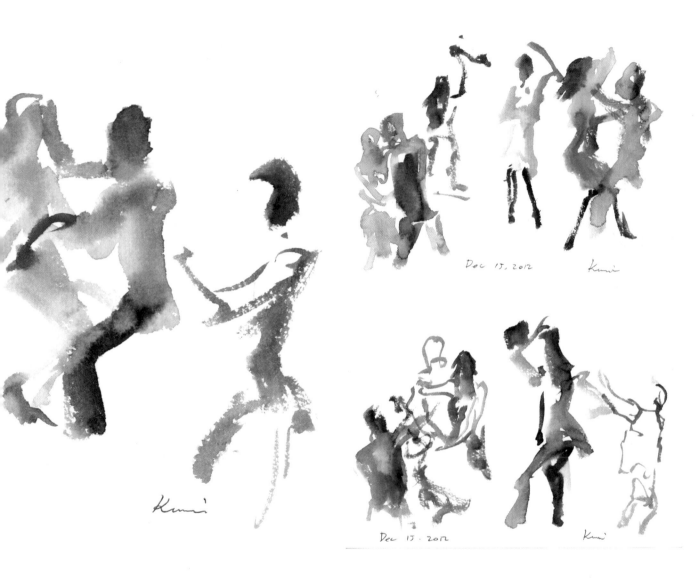

Dec 15, 2012 Kumi

Dec 15, 2012 Kumi

CAPTURING A MOOD

These drawings were done at a salsa dance event in Tokyo. People kept dancing and I kept capturing them in my sketchbook over the course of the event. The room was dimly lit, so I had little clue as to the exact colours I was using; but from my memory and experience I more or less correctly judged the right proportions of pigments to mix, and to make tonal tints. These drawings are the result of my effort to pin down the participants' passion and joy of dancing. After I scribbled snatches of the dancers' gestures on the pages, I realised what I failed at and what I achieved: I wasn't able to depict each and every detail, but as a whole I succeeded in recording the mood of the dance floor.

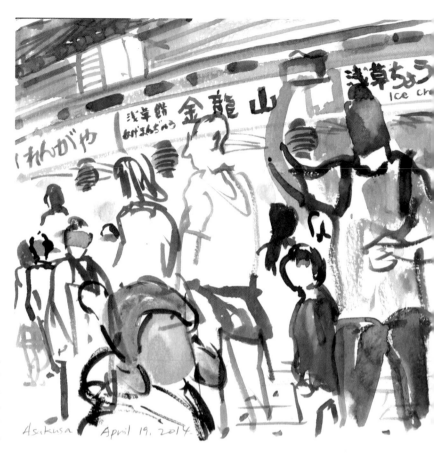

THIS PAGE TOP: Asakusa
Nakamise, Tokyo, Japan

THIS PAGE BOTTOM: Ginza
4-chome intersection,
Tokyo, Japan

ALL IMAGES KUMI MATSUKAWA

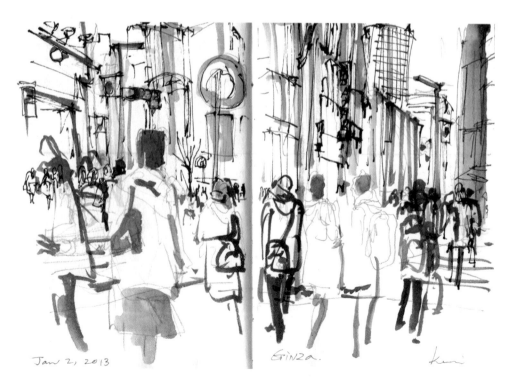

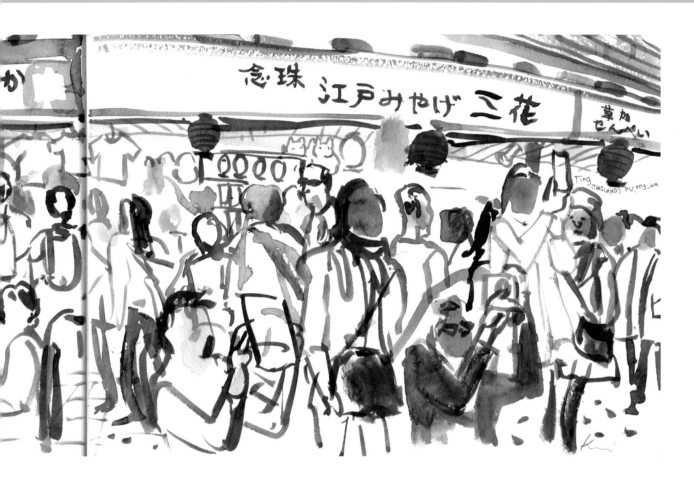

DRAWING CROWDS IN MOTION

This is Ginza 4-chome intersection, in Tokyo (opposite). I sat on the corner in front of the prestigious Wako building. So many people kept coming and going, and also standing still while waiting at the red traffic lights. It was tough to capture masses of people all moving at once. Sometimes my vision was blocked by pedestrians in the foreground, and sometimes they receded into the distance. Either way, I tried to put them on my pages, sometimes using pencil, and sometimes with watercolour or pen. The most fun part of drawing motion is you never know what and how much you can capture until you finish.

INTERACTING WITH A CROWD

Asakusa is one of the most famous tourist sites in Tokyo. This Asakusa Nakamise street is always busy and crowded with both locals and people from overseas. There are a variety of shops selling traditional Japanese sweets and delicacies, souvenirs, clothing and so on. I sat in the street in front of a full blooming cherry blossom tree. As a result, people stopped nearby and took pictures of it with their mobile phones or tablets. This was a good opportunity to capture stationary people while others passed by behind. One woman realised I was sketching and asked me to draw her – so I did, on the right side of the paper, and asked her to write her name on the sketch. This is a fun memory. Sketching people often brings such interactions.

PORTRAITS AT HOME: Ilga Leimanis

Portraits are fun and engaging, an opportunity to introduce narrative, tell a story and explore identity. When working at home, time is an advantage; there is no need to rush, you can return to the same drawing again and again, or do multiple drawings of the same subject.

Difficult areas or problems that come up with your portraits can also be worked through with practice. Take time to research and find interesting subjects, as well as explore different materials, colour and working on longer drawings.

IDEAS TO GET YOU STARTED

1. Source subjects from wherever you can. Ask your friends and family if they would sit for you and draw them from observation. Try a self-portrait in the mirror, though these tend to be fairly intense and unnatural looking. Try working from other sources as well, for example online images or photos from the newspaper or magazines of politicians or celebrities. Visit a museum, or look at museum collections online for sculptures or portrait busts, which make for really good subjects.

2. Practise perfection. It will take time to learn how to make a perfect portrait. Start with a whole – an oval head shape – and divide that into parts. Try the head from different angles: front, side profile and a three-quarter view. Think of where the light is coming from and add shading.

3. Go for character development. Tell a narrative about your subject. Who is the person and what is her story? Give us a glimpse of the person's energy and emotion. Think of which tools you have to best communicate this character: colour, shapes, textures, shading and light.

4. Experiment with textures and shapes. Find opportunities in your drawings to bring in textures and interesting shapes in addition to the features of the face – for example, drawing hair, jewellery, clothing and other adornments such as a headdresses, tattoos, hats, make-up and glasses. All of these also aid in developing character.

5. Find a way to add colour to the portrait. While realistic skin tones and hair colour can be hard to master, find ways to work with other colours to add interest to the drawing. Experiment with layers of washes or contrasting colours.

THIS PAGE: Ilga Leimanis, Bust at Wallace Collection, London, UK

OPPOSITE TOP: Ilga Leimanis, Profile no. 33

OPPOSITE BOTTOM: John Booth, Paul, London, UK

THIS EXERCISE WILL HELP YOU:

- Look for interesting subjects to draw anywhere

- Develop observational skills

- Balance shading, line and textures

- Practise telling someone's story through your work

- Become confident using colour and contrasting colour

Portraits can include your own in a mirror, drawing someone you live with from observation, or drawing from found images, video stills and photographs.

PRACTISE PERFECTION

Build your observational drawing skills. This takes time and patience. I start by establishing an oval head shape, then divide that shape into parts: a line at the height for the eyes, cheeks, nose, mouth, chin, eyebrows and hairline. Check to see if these are in at the correct height in relation to the whole head. Then look for planes: establish the front and sides of the head, for example; see how Ana Peigneux Ortega draws a line to distinguish the side of the head from the front, and the front of the nose from the side (right). Finally, think about your light source and use these planes to help with the shading.

THIS PAGE TOP: Ana Peigneux Ortega, No te Veo, Saint Martins, London, UK

THIS PAGE BOTTOM LEFT: Ilga Leimanis, Bust at Victoria & Albert Museum, London, UK

THIS PAGE BOTTOM RIGHT: Ilga Leimanis, Bust at Victoria & Albert Museum, London, UK

THIS PAGE TOP: Gazala Haq, Clifford

THIS PAGE BOTTOM: Loretta McGregor, Portrait

ADDING COLOUR

An easy way to practise getting a realistic drawing yet also introducing colour is to work on a prepared ground of pastel and charcoal. Smudge the dusty materials together on your page. After laying out a head shape and dividing it into planes, Gazala Haq (above) and Loretta McGregor (right) add light by removing the ground with an eraser and add shadows with charcoal or more pastel. Work back and forth, alternating between light and shadow until the image emerges. Rub away anything you don't like with a tissue and start over.

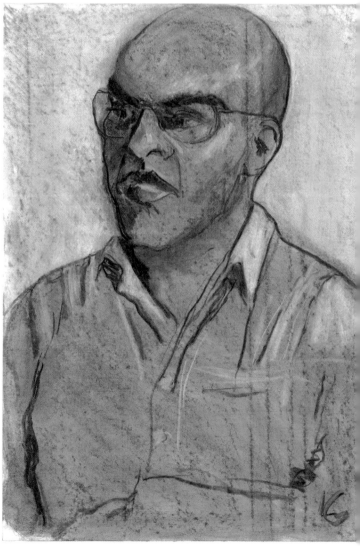

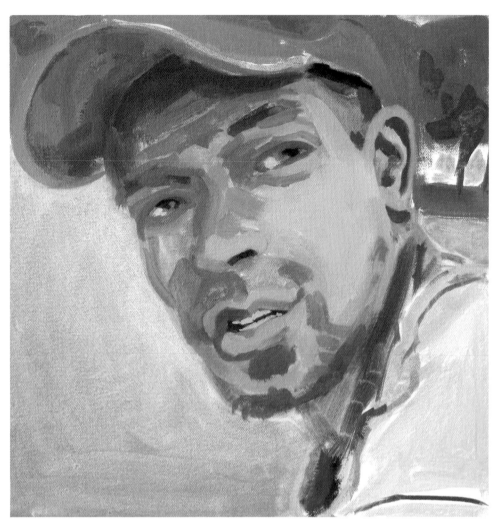

THIS PAGE TOP: Ilga Leimanis, Profile no. 36

THIS PAGE BOTTOM: John Booth, Joe, London, UK

CONTRASTING COLOURS

Think of the colours you would like to use in your drawing and start the drawing with a colour you would not use in the portrait. This colour will still be visible through the layers, even though it will be drawn over – for example, the green I used in the portrait with the baseball cap (above). It also helps to think about warm and cool colours (i.e., those opposite each other on the colour wheel). If your portrait will be warm, start the drawing with a cool colour. Fashion illustrator John Booth (left) experiments with colour washes, thinned paint or inks, working in layers and saving the details, drawn in line, for last. At home you can come back to a drawing and rework it over many sessions.

TEXTURE AND ADORNMENTS

Make it a mission to find a subject with interesting features or additions to the basic portrait – perhaps adding texture or other shapes to the obvious face and head. John Booth has added glasses, a beard and hair, which he loosely scribbled using directional strokes (right). These add an energy to the sitter, and also communicate the amount of time it took for him to make the drawing. Similarly, I like to find interesting sculptures with headdresses, in this case with horns and plenty of facial hair (below). Again using strokes in the general direction of the beard, I simplified the complex mass into basic directions.

THIS PAGE TOP: John Booth, Jake, London, UK

THIS PAGE FAR LEFT: Ilga Leimanis, Bust at Kenwood House, London, UK

THIS PAGE LEFT: Simon Foxall, Disco Venus Jerry

FINDING SUBJECTS

Simon Foxall draws celebrities and superheroes from images found online. I made an entire series of portraits taken from profile photos from social networking websites. Similarly, film stills make for interesting drawings. Start your search for captivating, characterful subjects and see how you can alter the found photographic images to make them your own.

A DAY IN THE LIFE OF A CHILD: Rita Sabler

If you spend a full day in the company of a child, you will be treated to a day of wild imagination, strenuous activity, laughs, occasional tyranny and unbelievable magic. By the end of the day you will be absolutely exhausted and incredibly satisfied.

Even if you don't have a child of your own, chances are you have friends or close relatives who would gladly accept your offer to follow their child around for a day in exchange for some light babysitting. Drawing children poses a fun challenge.

IDEAS TO GET YOU STARTED

1. Practise drawing a child's features and body proportions when they are relatively still. Meal times or naps work great. Children's heads are a lot larger in proportion to their bodies compared with adults, but their ears and noses are small, their necks are short and their features are softer than those of an adult.

2. Focus on giving a glimpse of their particular personality, not achieving photographic likeness. Is it a child who is shy and afraid of strangers? You can draw just a pigtail lurking behind mum's body. Is she an overactive child who literally stands on her ears? Draw her upside down, huge grin and all.

3. Draw their world. Children are surrounded by their endless entourage of toys and other objects that they often turn into toys. Draw their Lego pieces, their dolls, their fire engines and crayons, their sippy cups and scooters. They will be delighted you take so much interest in their world.

4. Bring in the playful details. Focus on the colourful details of their clothing, the design of their lunchbox or the wallpaper in their room. Children love bright colours and bold patterns. Bringing these details into your drawing will instantly infuse it with a childlike flavour. Be careful not to overdo colour; bringing in more than three or four strong colours can quickly turn the

drawing into a fruit salad without any focal point. If you choose to draw a bright pink dress, make sure you exercise restraint with colour in other areas of the drawing.

5. Turn waiting times into sketching times. If you are taking a child to their routine doctors' appointment, dance or music lessons or playdates, you spend a lot of time waiting. Use the times you would normally be sitting around or checking your phone to draw. My favourite times to sketch my daughter are during her music lessons or dental checkups.

6. Tell the story of their day. Here they are swinging in the back garden, then off to colour with crayons, and then before you know it, they're wreaking havoc in their room. Try to move at their rhythm, capturing a little bit of everything, from them eating their cereal to building a tower out of blocks to having a meltdown on the floor.

7. Draw with a child. You are likely ready for a break after all of the running around. Find a quiet place to sit with your subject and have them draw alongside you. Kids love to draw, especially if you pull a cool drawing tool out of your bag of tricks and let them use it. Sit down and draw together. Have them tell you a story while you draw them and make that story part of your drawing.

THIS PAGE: Karin Schliehe, Julius in Rivert, Spain

OPPOSITE TOP: Rita Sabler, Dental visit, Portland, USA

OPPOSITE BOTTOM: Sheila Rooswitha Putri, Live sketching of baby daughter, Jakarta, Indonesia

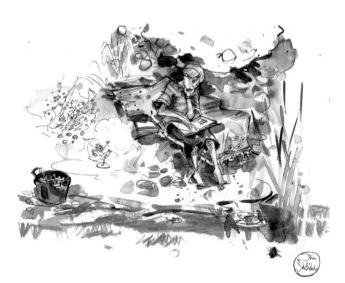

THIS EXERCISE WILL HELP YOU:

- Draw children's faces and proportions

- Focus on objects that are part of a child's world

- Capture movement quickly

- Detail the fabrics and patterns present in children's clothing and surroundings

- Become a little person's hero for the day

When drawing a child, I suggest starting small, as you will have a lot of false starts. Try not to get frustrated and focus on capturing the flowing progression of their day in small gestural drawings. I find an accordion-type sketchbook is best suited for this exercise, as one activity organically grows into the next.

MOMENTS OF STILLNESS

Use rare moments of stillness to work out the child's features and proportions. I tried to exaggerate the effect of a larger head in proportion to the body in this sketch, but really overdid it for the neck. I tried to capture general features, expression and posture while she was still, knowing that I would have plenty of time to fill in the patterns on her clothing and accessories as soon as she took off.

DOCUMENTING A DAY IN THE LIFE OF A CHILD

I used a little accordion-fold book to document what happened over the course of twenty-four hours in the life of my daughter. One panel organically evolved into the next – just as her activities would flow from one to the other depending on her mood or interest. I filled the pages with her quotes and the objects, colours and textures that surrounded her as well as her many changes of outfit.

OPPOSITE: Wreath of spring flowers, Hood River, USA

THIS PAGE: A day in the life of Isabelle, Portland, USA

ALL IMAGES RITA SABLER

DRAWING A CROWD: Melanie Reim

Sure, it can be intimidating to draw a crowd of people, but what a
great way to tell a story – and also to feel empowered as you
capture more than a single figure in a drawing!

When you first set out to draw a crowd, think of it in the same
way that you first see it – as a big shape. By beginning this way,
you don't have to challenge yourself to think about drawing all of
the individuals who make up that crowd – and there is no need to
feel as if you have to. It is the essence of the gathering that you
want to get onto your page, and then call out certain faces or
details. You are going after the feeling of a crowd, to give a sense
that there are multiple people.

IDEAS TO GET YOU STARTED

1. Look at the crowd as a single shape, with dimension.
It could be similar to the shape of a long rectangle, as if you
are drawing people either marching in, or looking at a parade,
or a triangle if you are in a long line of people, waiting on line for
a movie or concert. You can even lay down a light pencil line
of a dimensional geometric shape to guide you.

2. Establish a horizon line. Then start to draw the shapes
of the heads and shoulders as they vary in height and position.
Remember to keep the shapes simple. The farther away, or the
deeper the crowd, the smaller the people become.

3. Look for the negative spaces. Look for these in-between
heads, hats, noses in profile, sunglasses, eyeglasses. Start to draw
the shapes that represent the negative spaces in-between the
people. Test your shapes by filling them in. Do they have variety?

**4. Look for a geometric shape or shapes in the masses of
people.** Draw that lightly as a guide to begin. Then, start to fill it
in. This will usually help you to create a sense of dimension.

5. Draw some action lines if your crowd is in motion. Some
crowds might be walking along a path, marching in a parade,
running or walking a race. To get started, you can follow the
action and draw that line, giving you a guide. Though the cast
of characters changes as they walk by you, there are repetitive
movements. Don't get flustered. The point is to capture the
essence of a crowd, not the exact likenesses of the people. It is
fine to start with one figure, block in another, and when someone
else passes you with the same or similar motion, fill it in.

**6. Put down a wash in a big shape that represents the mass
of the people.** Start to draw detail on top of it. In this way, you
need not articulate every aspect of the crowd; the undertone will
fill in what you do not capture and give the impression of the
whole crowd.

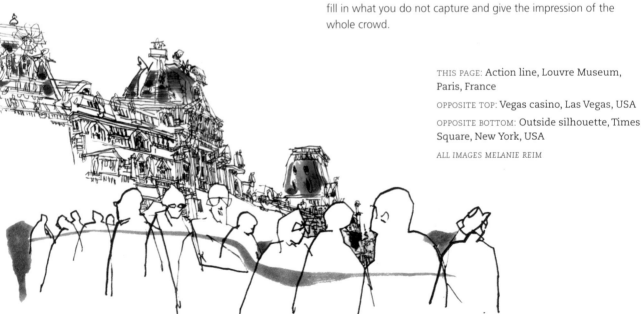

THIS PAGE: Action line, Louvre Museum, Paris, France

OPPOSITE TOP: Vegas casino, Las Vegas, USA

OPPOSITE BOTTOM: Outside silhouette, Times Square, New York, USA

ALL IMAGES MELANIE REIM

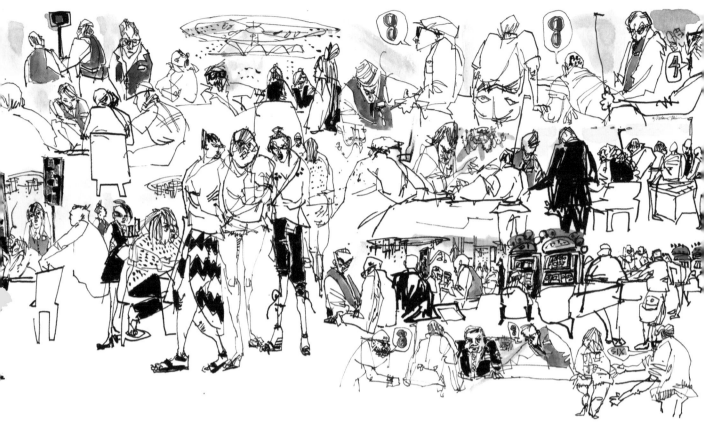

THIS EXERCISE WILL HELP YOU:

- See a crowd as a shape
- Draw a single outline to represent a mass of people
- Look for negative spaces
- Identify pattern in a crowd
- Represent movement in a crowd
- Use wash to represent a crowd

It's great to have a toolbox that you can access when you take on drawing multiple people. But a lot depends on where you are, what your vantage point is and how much time you have.

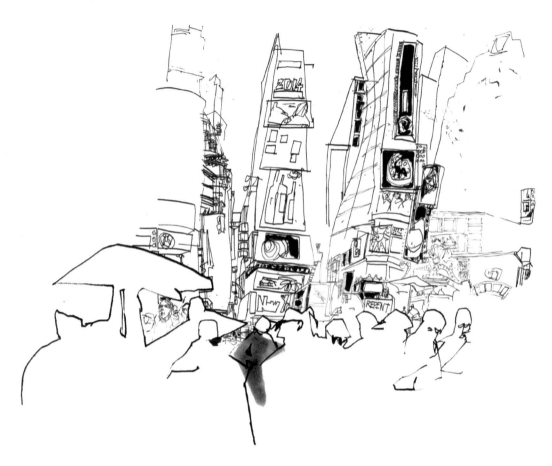

DRAWING A SINGLE OUTLINE

THIS PAGE: Melanie Reim, Crowd on line silhouette, Times Square, New York, USA

OPPOSITE TOP: Melanie Reim, Breast Cancer Walk, Riverside Park, New York, USA

OPPOSITE BOTTOM: William Bil Donovan, Broadway Bach Ensemble, Broadway Presbyterian Church, New York, USA

This might be the simplest and least intimidating way to start. With a single, simple line, 'trace' the outline of the crowd, or a portion of it. You can begin super simple and draw a geometric shape. Or you can try to be a bit more detailed. Make your 'left and right turns' represent hats sitting on heads, heads expanding to shoulders, shoulders becoming more narrow for arms, expanding for hips and becoming narrow again for legs, knees if they are showing, ankles and shoes. Continue to create the plane upon which the figures are standing and come up to finish the shape that you are following with your eyes.

Once you have the outside shape, look for the negative spaces within the shape, representing the spaces in-between one person's legs, under the arms and/or the spaces between the figures. Fill in the shapes that you just made and you have begun your crowd. Test the shapes that you are making. Fill in the background with marks that are smaller and more detailed to make the shape that you created in the front stand out. Vary them – they should not have the same symmetry, for this would flatten the shapes.

ACTION LINES

One Sunday, I was waiting for the bus in New York and I looked up to see a sea of pink coming towards me. This needed to be captured, and these women (mostly) were on a mission: the annual Walk for the Cure for Breast Cancer – and they were not to be stopped! It was joyous, jubilant and fast-paced. I tried to see the shape that was created by their masses. As they moved in the distance, the triangle of their march took shape. I used the park path that they were walking along as my action line. As they passed by me, I was able to capture motion and movement, but remember that the actions are repetitive. The life and energy inspired me to draw faster and almost move along with them. The pink baseball caps provided the pattern. The upraised arms and salutes from those who cheered them on was a nice contrast in the composition to the triangle of the walkers.

WILLIAM BIL DONOVAN'S NOTES ON DRAWING A CROWD

Think about simple shapes, such as the heads, that fold into bigger shapes as they move back into a bigger, underlying shape, as in the triangle that the players form. Think about adding the contrast in a different direction, as the bows of the instruments do, creating depth in the image. The contrast of the collection of smaller shapes of the architecture, and the vertical direction, adds dimension to the overall drawing. Settle the drawing in by adding large solid shapes, such as the suits. In scenarios such as this, there are most certainly repetitive movements. So, be patient, and work the entire picture at once, filling in as the movement that you need presents itself.

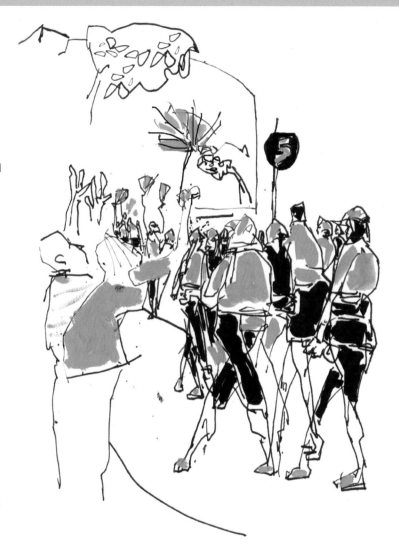

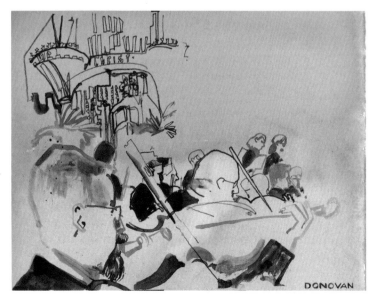

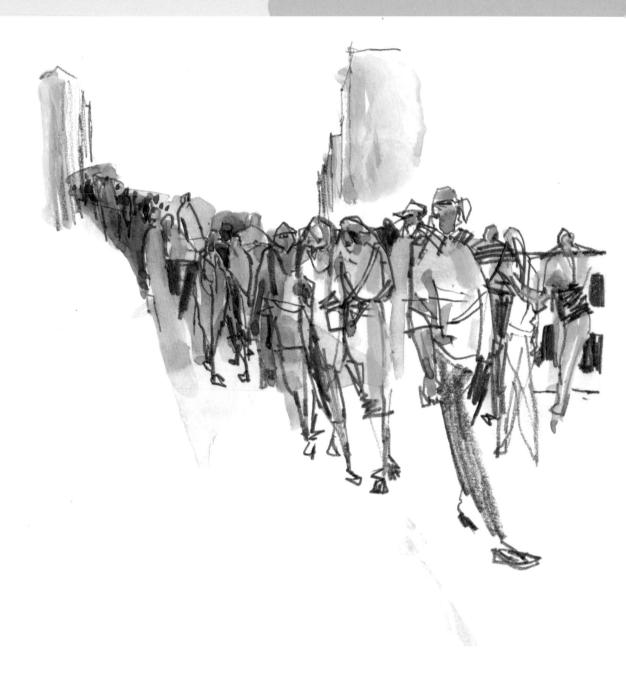

A WALKING CROWD IN COLOUR

THIS PAGE: Melanie Reim, High Line, New York, USA

OPPOSITE TOP: Melanie Reim, Oxford Commencement, Oxford, UK

OPPOSITE BOTTOM: Bill Martin, Almost spring, Rockefeller Center, New York, USA

To record a walking crowd, start by drawing the undulating lines and shapes of the heads and shoulders; this serves to establish the negative spaces in-between, and actually sets up dimension. There is a rhythm to a crowd – up and down, high and low. This also creates depth. Establish varying heights – this again creates depth, dimension, movement and above all interest. For the legs, you can use the side of a graphite pencil to create mass. Use confident, long strokes. Change the direction on the right to left leg to foster movement and, if you can, when drawing a fold. This crowd had a definitive light source. Whatever was facing the light I painted with a quick stoke of the brush, all at once, to establish the highest planes and the direction of the light. All else commanded a shadow stroke. I added bits of highlighted colour to flush out the crowd, and used the same colour to indicate the sheer numbers of people at the back.

DRAWING A PATTERN

Drawing multiple figures can be intimidating – but that does not mean that you cannot draw a crowd. Another device for getting the sense of lots of people is to look for pattern and to repeat those shapes that you see. Before you know it, your crowd drawing will emerge! Pattern can come by way of all kinds of elements. Some examples are hats, hair, stripes on a shirt and signage. Instead of seeing the challenge of drawing all of the people, look for the repeating shapes in a sea of people. For example, in this image from Oxford, England, I was sitting outside at a café having a morning coffee, when I found myself in the midst of the march towards the commencement ceremony, with all of the pomp and circumstance of the robes – big, flowing shapes and hexagonal hats. The crowd was rushing by and I knew that I was in the middle of something special. I looked for the shapes of the robes – essentially big ovals – the bodies and the sleeves. The hats and heads followed. I anchored the figures with the architecture behind them – patterns of windows and gates – as well as the pattern of cobblestones on the street. You could think about putting the shapes down in a single stroke of a brush pen or marker – or drawing the shapes and assigning the 'colour' quickly. The negative shapes that emerge also create an opportunity for smaller figures and a sense of dimension.

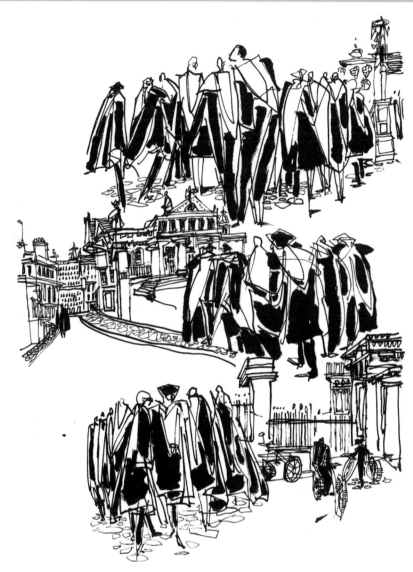

GEOMETRIC GUIDES

You can see where artist Bill Martin uses his geometric guides to set up a somewhat extreme sense of space and foreshortening. The lines become a significant part of his graphics and blend into the image. The larger figures are drawn in front, and as the figures recede, they get smaller. Each is acutely designed but maintains an outline. The equally strong design of the trees provides the capsule for the colur and offers the contrast to the crowd. There is a lyrical sense of body language and fashion sensibility that echoes the venue itself.

MUSICIANS AND THEIR INSTRUMENTS: Rita Sabler

Drawing musicians in action is an incredibly thrilling experience. Music has a stimulating effect on the creative process, and when combined with the visual experience of watching musicians practise their craft, offers an unparalleled drawing opportunity.

There are many perks to drawing musicians. For once, you don't have to steal discreet glances at your human subject – musicians are accustomed to being observed, photographed, filmed and even sketched. Secondly, compared to other performers, musicians don't tend to move as much. You could budget the time of one song or a concert to produce a quick sketch or a detailed drawing.

IDEAS TO GET YOU STARTED

1. Get comfortable drawing musical instruments. Musical instruments, especially string instruments such as violins or cellos, can be fairly complicated to draw. Visit a music shop in your community and get comfortable drawing various instruments, from flutes and trombones to upright basses and grand pianos.

2. Make a drawing of a pianist. While a violin and a bow would never be in the same exact position throughout the performance, due to its very nature a piano is a completely stationary instrument. A pianist also moves little in comparison to other musicians, with the exception of their hands. Try to position yourself either to the side or slightly behind a pianist, so you get a good view of their hands and body, as well as their instrument.

3. Practise making quick gestural drawings of musicians. A bar with a live music show is the best setting for this exercise as you would need to be able to move around. Give yourself a time limit before you change your location. Don't worry about composition or making a cohesive rendering of the stage. Don't stop if you make a mistake; adding colour will often help make sense of the drawing. If things get really loose it will only help reinforce the effect of a live show unfolding.

4. Draw an ensemble playing together. If you are a fan of a particular style of music the choice of a show will be easy for you. Arrive early and sit as close to the stage/performance area as you can. Drawing performers has a huge bonus – you don't have to worry that your subject will get self-conscious. Musicians are used to being in the spotlight with eyes, cameras and mobile phones directed at them at all times. You also don't have to worry about your subjects leaving halfway through a song.

5. Give a sense of the setting. Give some information about where you are. Symphony halls are often elaborate old buildings with a lot of ornate detail. Pubs or bars could hold their own charm and an array of colourful clientele. If you are attending a live show in a bar, draw a couple of customers sipping on their drinks while listening to the music. If you are at a symphony, draw the silhouetted heads in front of you or, as it often happens, someone nodding off in the front row. Maintain your main focus on the subject – the performers – while also 'mentioning' the place they are inhabiting.

6. Learn to draw the light. Due to the nature of live performance – turning the spotlight on a group of performers – live music shows often force the most dramatic lighting conditions. Strong areas of highlights and shadows created by stage lights distort the normal flesh tones and even shapes of your subjects. It becomes even more important to observe and draw what you see, not what you know. Watch how spotlights, stage fog or disco balls affect the natural colours of human skin and so forth. Practice bringing the lighting drama into your sketch and you will dramatically increase the overall effect of your drawing.

OPPOSITE TOP: Celia Burgos, Jazz, Cadiz, Spain

OPPOSITE BOTTOM: Lynne Chapman, Ireby Music Festival, Cumbria, UK

THIS EXERCISE WILL HELP YOU:

- Draw musical instruments either stored or being played

- Create quick gestural drawings of musicians

- Draw a pianist

- Focus on the physical and creative relationships among musicians in an ensemble

- Capture what happens to familiar subjects in dramatic lighting conditions

Look to capture the expressiveness of musicians' faces and hands, the shape of their instrument in the wonderful act of magic that happens when a live music performance unveils in front of your eyes.

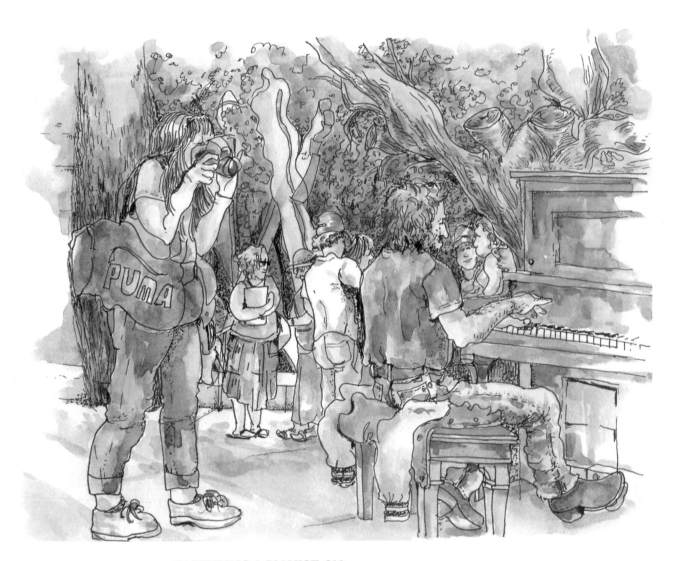

CAPTURING A PIANIST ON THE STREET

THIS PAGE: Piano! Push Play!, Portland, USA

OPPOSITE: Tango ensemble practice, Portland, USA

ALL IMAGES RITA SABLER

My town is home to several travelling street pianos that are part of a project of rescuing these instruments and making them available to the public at large. They show up in unexpected places and any passer-by can sit down and play one. As I drew this street pianist I stood to the side and slightly behind him so I could capture both his face and his hands. There was a lot of activity on the street that day, so I made sure I included other characters in my sketch.

DRAWING AN ENSEMBLE REHEARSING

Drawing an ensemble rehearsing gives a glimpse into the individual personalities of the musicians as well as the overall dynamic and the interaction between them. Being a musician myself, I often get the first row seat during band practices. I drew this group rehearsing together while being coached by their teacher at the back. I tried to capture their individual personalities and convey the concentration on their faces as they attempted to learn a new part.

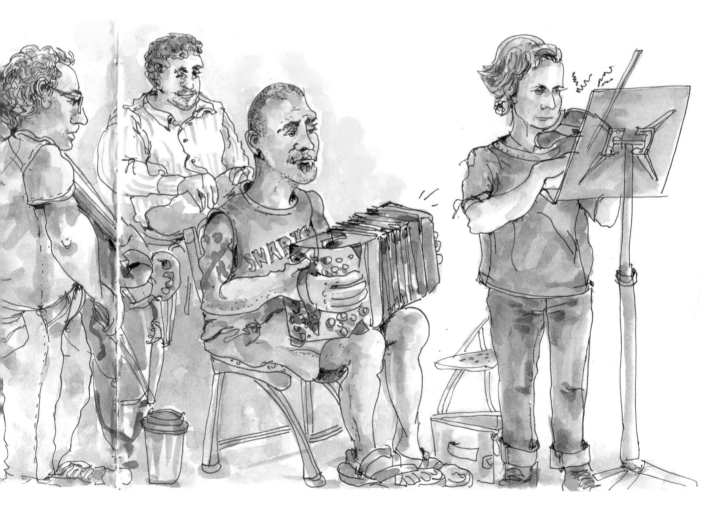

DRAWING MARIACHIS

THIS PAGE: **Mariachis at Salon Tenampa, Mexico City, Mexico**

OPPOSITE: Free spirit, Tulum, Mexico

ALL IMAGES RITA SABLER

Garibaldi square in Mexico City is a birthplace of mariachi music. On any given day one is guaranteed to witness scores of colourful mariachis dressed in coordinated costumes wandering from bar to bar or even approaching people on the street offering to sing a song. I tried to work quickly capturing the details of their accessories and their tired but expressive faces, as well as the shapes of their instruments during a couple of songs that the table next to me ordered. The historic Salon Tenampa in Mexico City has almost as much personality as the performers themselves. I tried to give some information about the place where the music was happening.

IMPROMPTU PERFORMANCES

Even in the contemporary world, with its prevalence of recorded music, we are presented with numerous occasions to witness and draw musicians, from buskers on street corners to symphonies, student recitals to chamber jams and jazz clubs. Sometimes you don't have to go to a concert hall to find some musical expression.

I ran into this free spirit by the ocean and she made me smile with her beachside chanting. Since she wasn't wearing much herself I focused on the patterns and textures around her body, as well as the dramatic shadows created by the late afternoon sun.

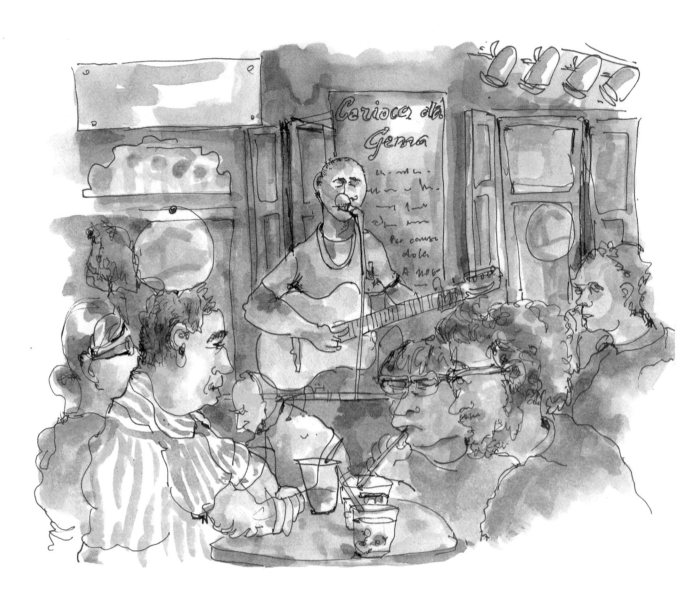

CAPTURING THE BAR CLIENTELE DURING A BOSSA NOVA SHOW

THIS PAGE: **Bossa nova at Carioca da Gema, Rio de Janeiro, Brazil**

OPPOSITE: **Bandoneon, Portland, USA**

ALL IMAGES RITA SABLER

Carioca da Gema is a bar featuring live samba music in Rio de Janeiro. Locals and tourists frequent the place and enjoy contemporary Brazilian music while sipping on their caipirinhas. Since the place is so popular I found myself quite a way from the stage, which I tried to use to my advantage by drawing the bar's clientele. I used more muted colours for the subjects that were farther away from me, and tried to capture the drama created by the lighting on the face and body of the performer.

A BANDONEON PERFORMANCE

Bandoneon is a fairly rare and complicated
instrument that lies at the heart of Argentine
tango music. Here a duet of piano and
bandoneon is performing live for the dancers
at a milonga (social tango dancing venue).
I was limited by where I could position myself,
but I really wanted to get both of the musicians'
heads into the picture, so the result looks a bit
like a two-headed dragon.

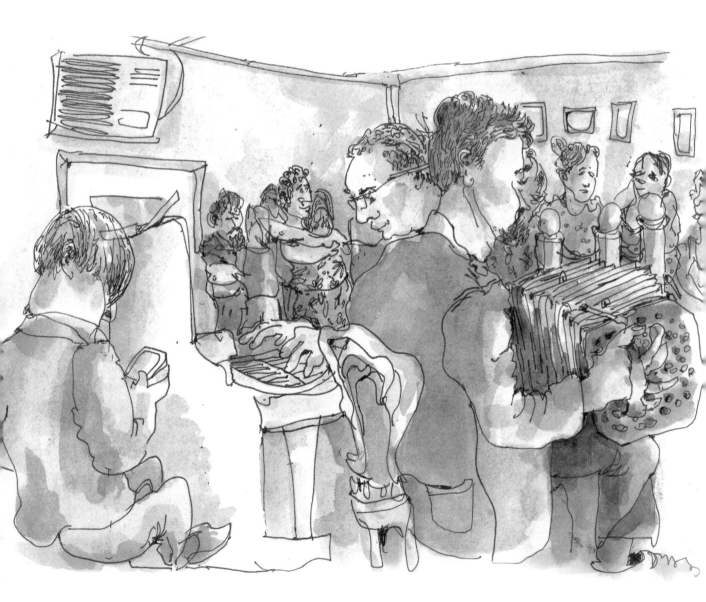

PETS AND ANIMALS: Ilga Leimanis

Your own pet will provide you with an endless source of interesting poses to draw, while the variety of other animals can keep you busy for a very long time. At rest or on the move, animals are captivating and full of humour.

IDEAS TO GET YOU STARTED

1. Find live animals. Start with your own pet, visit someone with a pet, or even offer to pet sit when someone goes away. Alternatively, explore other options for finding animals: visit farms, zoos, equestrian centres, greyhound racing tracks, aquariums and so on to find a good range of different types of animals.

2. Consider a visit to the museum. If you want to do a longer, more in depth study, visit a natural history museum or look out for sculptures or architectural ornaments that feature animals.

3. Observe birds. Look out of your window to see birds, or visit an aviary. Start with a basic shape, and then fill in details. Try drawing the birds from different points of view.

4. Do quick sketches of moving animals. Use appropriate materials, such as ink and brush, and experiment with coloured inks. Start with a general animal shape, then once dry, use marks or doodling and scribbling for textures of fur and feathers.

5. Begin a daily drawing practice. Your pet makes for an ideal subject to draw every day in a different pose. Set a time of day and a length of drawing time – even an alarm if necessary. Aim to fill a sketchbook in as many days as pages.

THIS PAGE: Ignacia Ruiz, Koala, Natural History Museum, London, UK

OPPOSITE LEFT: Ilga Leimanis, Goats, Surrey Docks Farm, London, UK

OPPOSITE RIGHT: Ilga Leimanis, Lion, Victoria & Albert Museum, London, UK

THIS EXERCISE WILL HELP YOU:

- Find interesting opportunities to draw animals

- Try long drawings of still or sleeping animals, and quick sketches of moving animals

- Work with a mix of wet and dry materials

- Build a daily drawing practice working from a single subject

- Do many quick sketches and edit the best to continue working on later

- Experiment with a blind contour line

Whether an animal is at rest or on the go will dictate what type of drawing you can make: a quick sketch or a longer study. Look for opportunities to draw real live animals, as well as finding animals in museum displays.

DRAW THE SAME ANIMAL DAILY

Artist Amy Wynne started a one hundred day drawing project, drawing her sleeping dog in different poses every day. Repetition makes it possible to be less precious about the work; you also become more familiar with the shapes, as these drawing form a daily habit. Aim for a full sketchbook. Your pet will provide endless poses to return to day after day. Take time to practise foreshortening, with the animal positioned coming out towards you.

WORKING QUICKLY WITH MARKERS

I used thick markers to draw the dogs at the greyhound racing track in Romford. Similar to ink, you can get a thick or thin line by using a chisel tip marker. Try catching a glimpse of the dogs at the end of the race, when they are paraded to the awards; it will give you just enough time to catch the shape of the dog. Try a few and edit the best. Markers are also great for longer studies at the museum, when working with wet materials is prohibited.

THIS PAGE TOP: Amy E. Wynne, My dog Captain

THIS PAGE BOTTOM: Ilga Leimanis, Greyhound, Romford, UK

OPPOSITE LEFT: Felix Siew, Birds

OPPOSITE RIGHT: Ilga Leimanis, Flamingos, Kensington Roof Gardens, London, UK

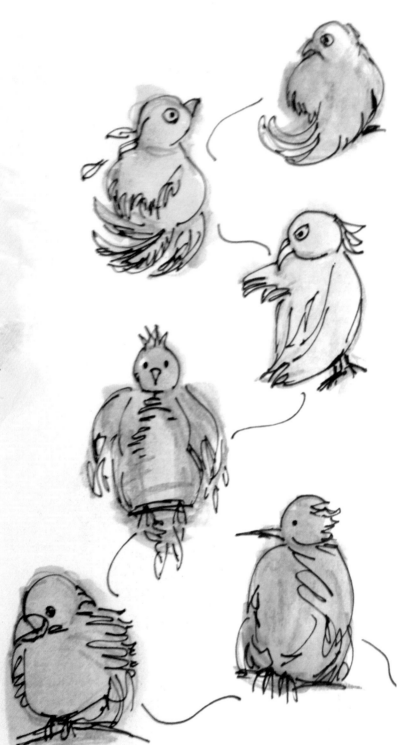

MIX WASH AND LINE

Another way to draw a moving animal is to block in a general shape with a wet material, such as ink, wait for it to dry, then use a black pen to add details and textures. Felix Siew started his drawings of birds with blobs of ink wash, then added lines to animate them (left).

LIVE SUBJECTS WITH WET MARKS

Drawing a living, moving animal can present quite a challenge! You'll need to keep your eyes on the animal and use appropriate materials that you can move quickly. On the same page, try out details again if you are not happy with them, to explore another version of an eye or a nose. When drawing flamingoes at Kensington Roof Gardens, I used a small watercolour set to best communicate the delicate pink colour and dappled light (below).

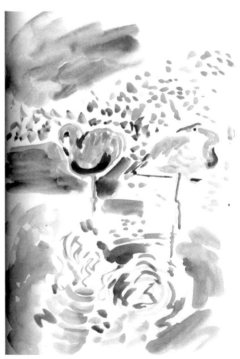

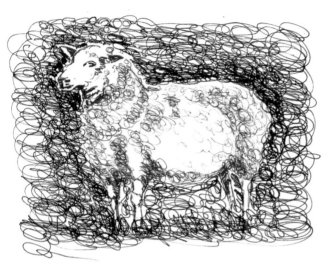

TEXTURES AND SCRIBBLES

Don't think too much about the types of marks you make. Try scribbling and covering the paper in a mass of marks. Sandra Cox drew her sheep on the Orkney Islands (above) using a great big mass of scribbled marks. Ignacia Ruiz covered the shadow on the rabbit's belly (below) in a mass of scribbles. This adds a dynamic quality to the drawing and is interesting to look at – plus it is a speedy way to cover an area.

DRAWING BLIND

Keep your eyes on the moving animal and draw at the same time, not looking too much at your drawing. The result will be a loose drawing with an interesting line quality. Ignacia Ruiz drew these frogs (above) using one long, continuous line, keeping her eyes on the frog most of the time. Using a similar line, this time redrawing a bull from preliminary sketches made at the Natural History Museum (below), Ignacia's line is quick and dynamic. A second layer of directional strokes in coloured pencil was added using a light table to see the line underneath, then assembled in Photoshop.

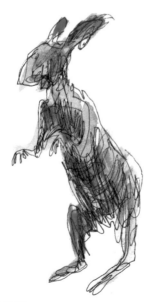

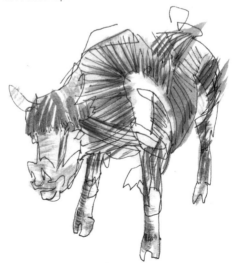

REWORK AT HOME

Take your drawings made from observation further by working and reworking them at home in different materials. Following a visit to the zoo, select the best drawings and rework them or add something to them, such as a background. Ortelius Drew glued green cut paper for grass underneath the drawing of a wildebeest in Amsterdam Zoo.

OPPOSITE TOP LEFT: Sandra Cox, Brown sheep, Orkney Islands, UK

OPPOSITE BOTTOM LEFT: Ignacia Ruiz, Rabbit, Natural History Museum, London, UK

OPPOSITE TOP RIGHT: Ignacia Ruiz, Frogs, Natural History Museum, London, UK

OPPOSITE BOTTOM RIGHT: Ignacia Ruiz, Bull, Natural History Museum, London, UK

THIS PAGE: Ortelius Drew, Wildebeest, Amsterdam Zoo, Netherlands

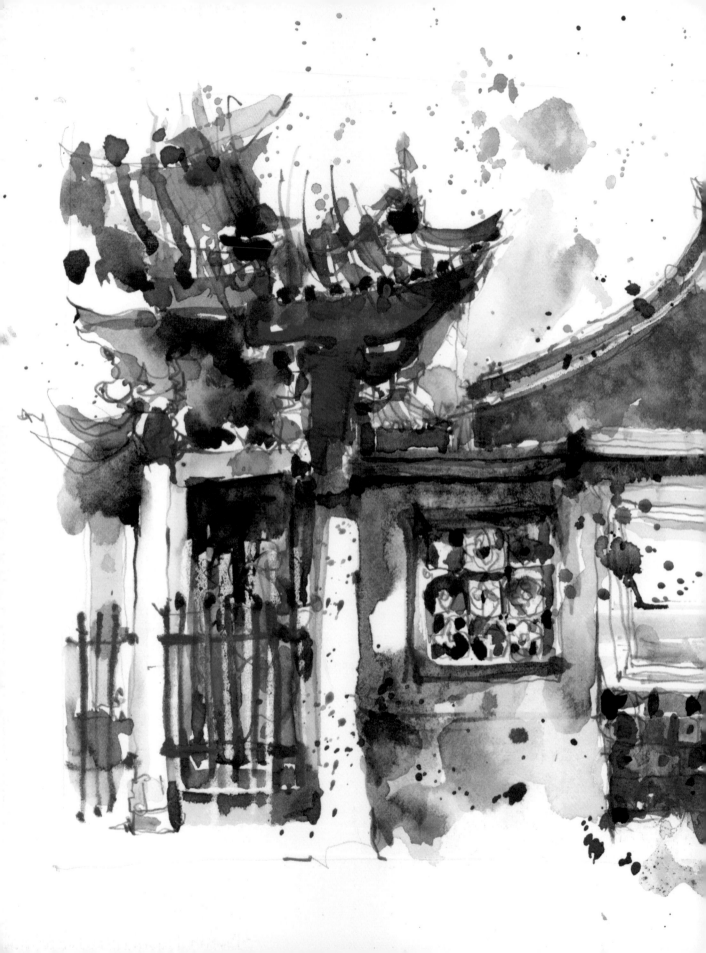

Sketching Guides

Paul Wang, Thian Hock Kian
Temple, Singapore

Perspective: One-point

The principles of perspective are important to understand for drawing three-dimensional shapes. It's easiest to explain this rule using buildings or roads as examples, but once you understand the basics, practice and apply them to your own sketches, or if you choose, break them deliberately. One-point perspective is applied when looking at an object straight on. The horizon line is usually at the same height as your eye level and the lines leading away from you converge at a vanishing point. Use the grid below to draw objects that are parallel to the diagonal lines, shrinking in size as they approach the vanishing point. On the page opposite, you can see how the same simple grid can be used on a more complex drawing, but the basic principles remain.

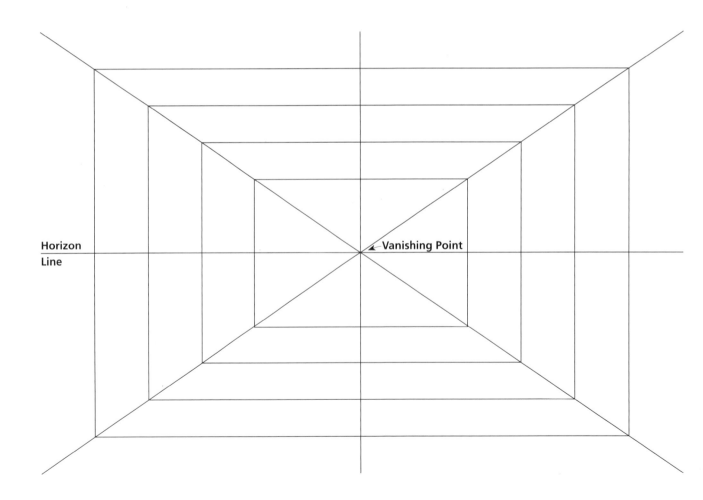

Horizon
Line

Vanishing Point

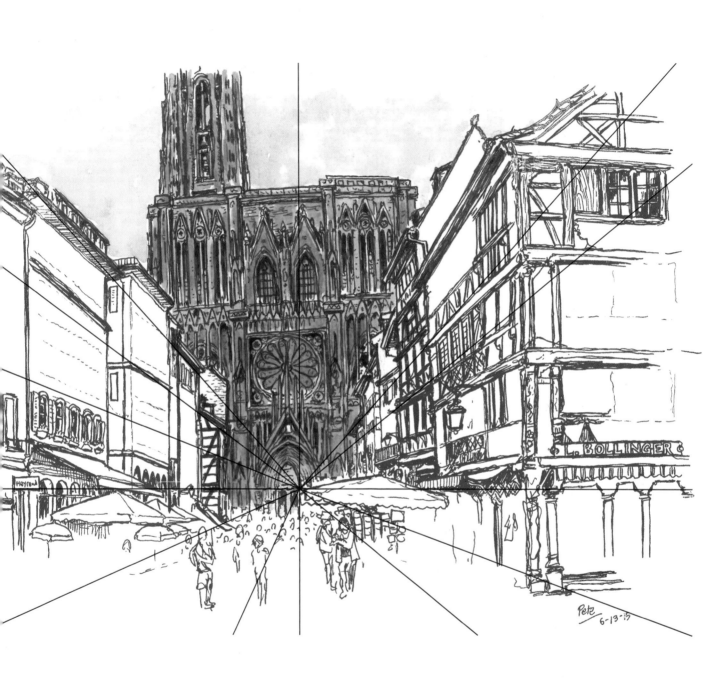

Pete Scully, Notre Dame,
Strasbourg, France

Perspective: Two-point

Two-point perspective allows us to show objects from more than one angle. The different sides of regularly shaped objects may have horizontal parallel edges that converge in different directions, creating two vanishing points. A simple way to understand this is to look at a square box with the corner facing you. As with the example on the previous page, the lines converge towards a vanishing point, but here you can see two, not one and so objects closer to the vanishing points are smaller. Use the grid below to draw rows of people or a stack of books and see how a similar grid is used on the sketch of a street corner opposite.

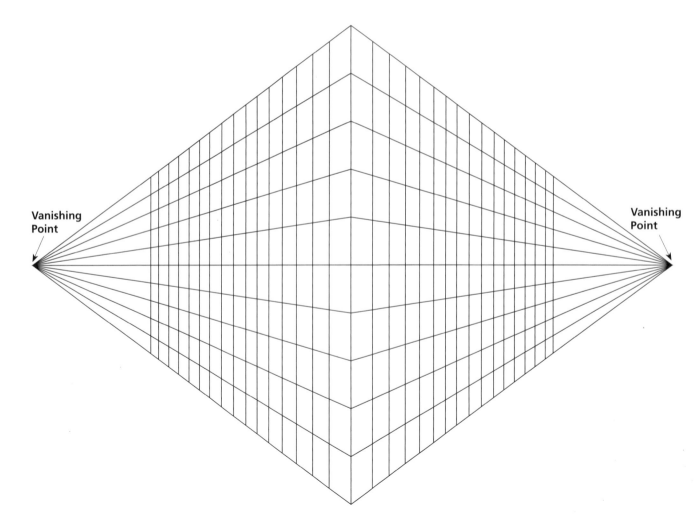

Vanishing Point

Vanishing Point

Pete Scully, Phonebox, Davis, USA

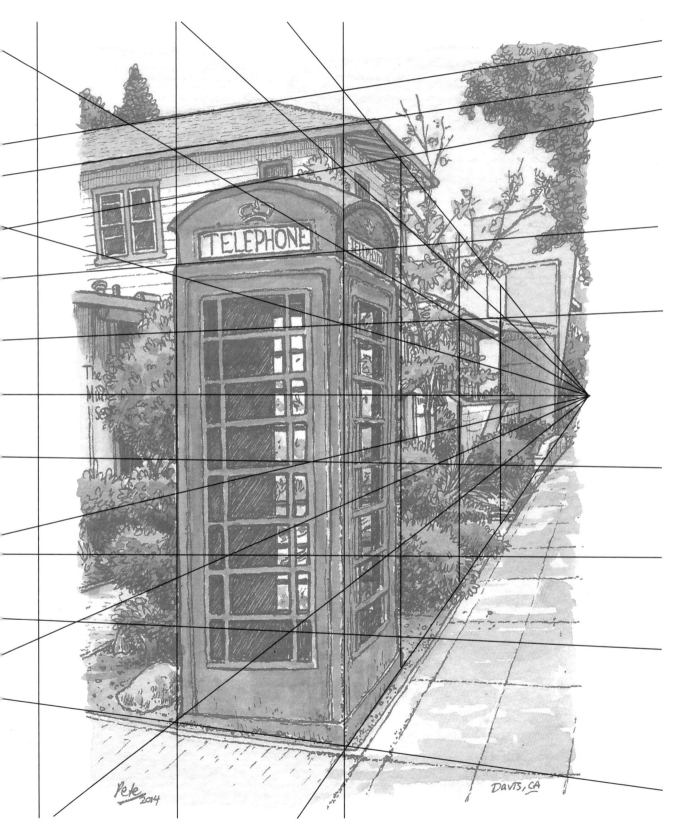

TELEPHONE

Pete 2014

Davis, CA

Perspective: Three-point

Three-point perspective allows you to draw objects that taper up or downwards, as in the sketch of Westminster Abbey opposite. Here you use a third set of parallel lines converging in another vanishing point. In most cases, these vanishing points are formed off the page, and you can use the same principle to create a fourth vanishing point, tapering down, if needed.

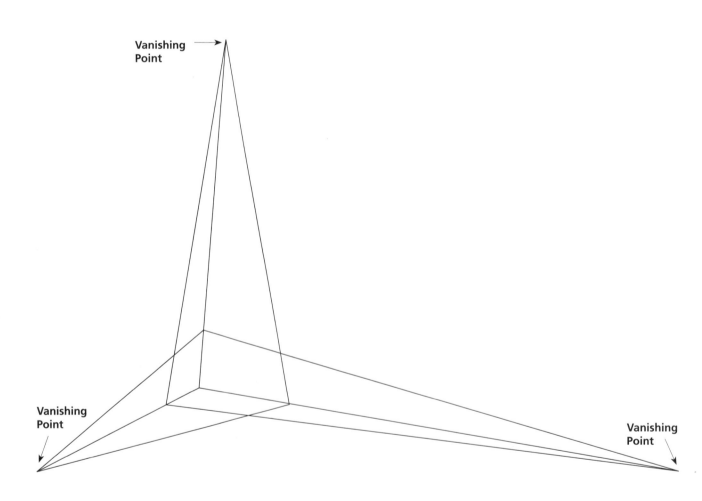

Vanishing Point

Vanishing Point

Vanishing Point

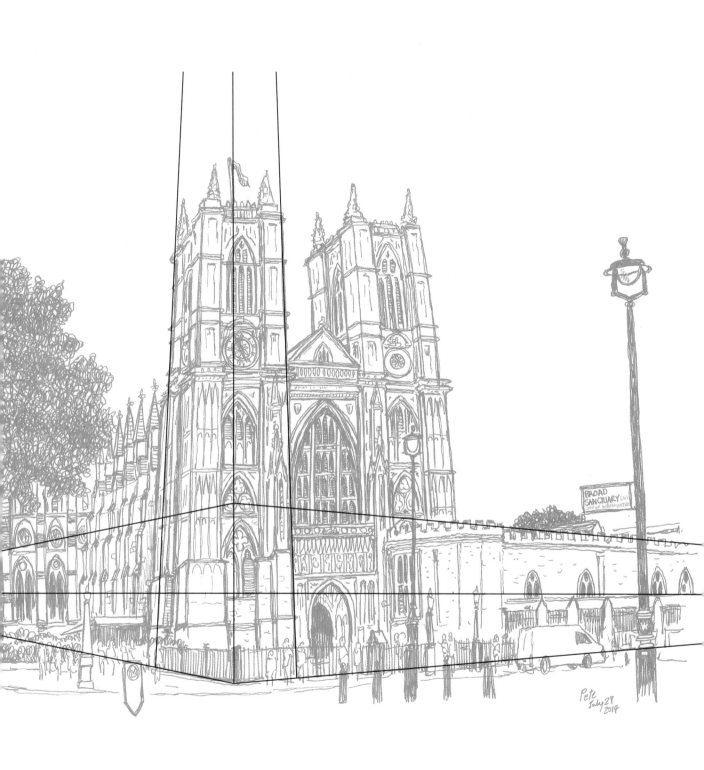

Pete Scully, Westminster Abbey,
London, UK

Faces and Forms: Measuring a body

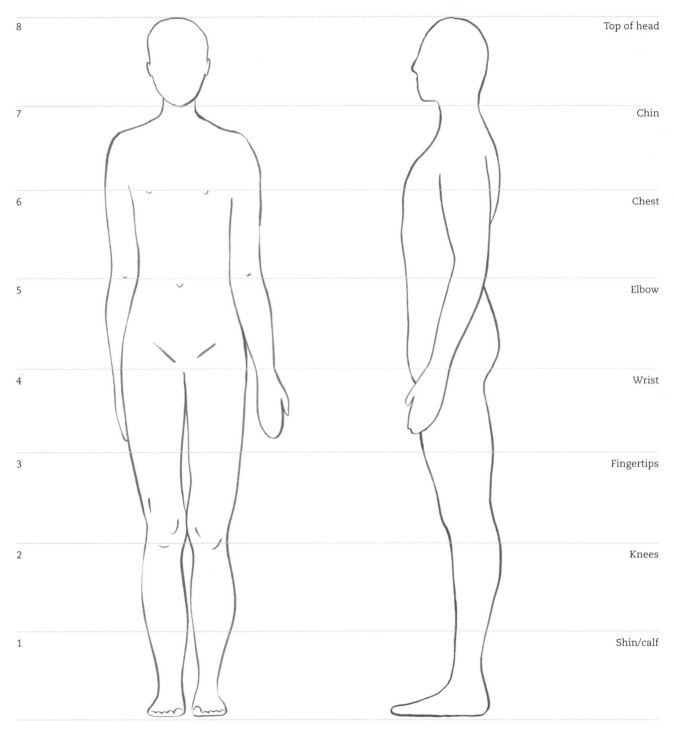

8	Top of head
7	Chin
6	Chest
5	Elbow
4	Wrist
3	Fingertips
2	Knees
1	Shin/calf

Use the head as a unit of measurement

Faces and Forms: Measuring a head

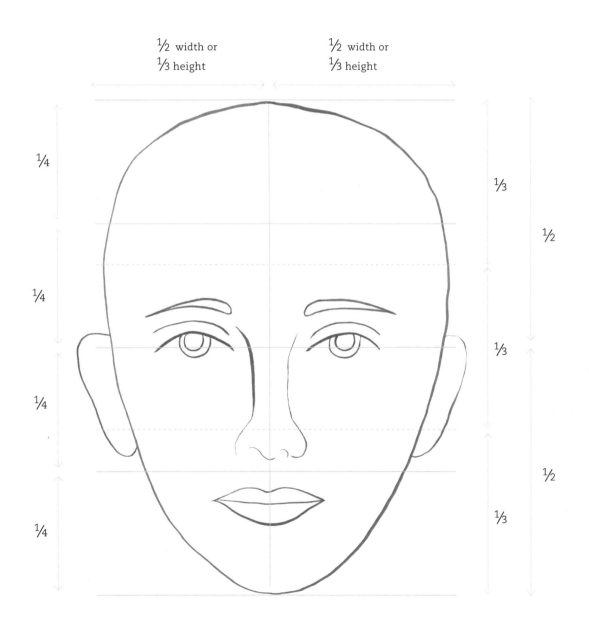

½ width or
⅓ height

½ width or
⅓ height

¼

¼

¼

¼

⅓

½

⅓

½

⅓

⅓

Sketching and Shading Marks

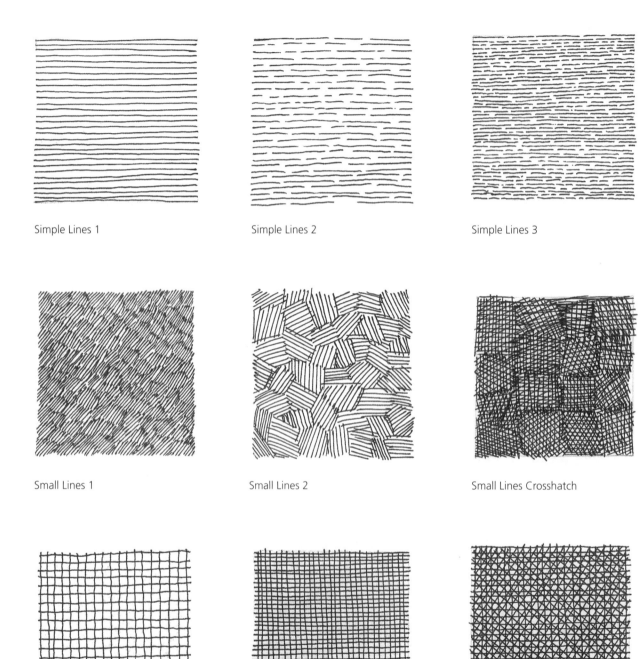

Simple Lines 1

Simple Lines 2

Simple Lines 3

Small Lines 1

Small Lines 2

Small Lines Crosshatch

Crosshatch 1

Crosshatch 2

Crosshatch 3

Crosshatch 4

Loose Crosshatch 1

Loose Crosshatch 2

Loose Crosshatch 3

Stippling 1

Stippling 2

Scribbles

Curly Scribbles 1

Curly Scribbles 2

Contributor Biographies

James Hobbs

James Hobbs is a freelance journalist and artist, and the author of *Sketch Your World*. His work has been shortlisted for the Jerwood Drawing Prize and Hunting Art Prize, and is in the Berardo Collection, Lisbon. He is a board member of Urban Sketchers, the international blogging network, and a founding member of the London Urban Sketchers. Prints of his drawings of London scenes are currently on sale in IKEA stores worldwide. He never goes far without a sketchbook.

www.james-hobbs.co.uk

Virginia Hein

Virginia Hein lives in Los Angeles, California, and besides sketching on the road, the landscape of the city continues to be her favourite subject. She has worked as a concept and character designer for toys and entertainment, and as an art director, illustrator and fine artist. Currently she teaches drawing in Los Angeles, and also enjoys teaching location workshops. She has contributed her work to exhibitions and several books about location sketching.

worksinprogress-location.blogspot.com
www.flickr.com/photos/virginiaworksonlocation/

Nina Johansson

Nina Johansson lives and works in Stockholm, Sweden. Nina graduated from University College of Arts, Crafts and Design in Stockholm in 2002, and teaches fine arts, design and photography. She is an avid on-location sketcher, with urban environments as a favourite subject. She also paints, mainly watercolours, and does illustration work.

www.ninajohansson.se

Ilga Leimanis

Ilga Leimanis is a London-based artist and educator. Her artistic practice comprises drawing, painting and (interdisciplinary) collaboration. She is a member of artist-run gallery Five Years, and one half of Ortelius Drew, a collaborative urban drawing duo. Ilga has run a location drawing group, *Drawn in London* since 2007, and teaches courses and workshops in drawing and creative process to students and professionals in various fields in the UK and internationally.
www.ilgaleimanis.com

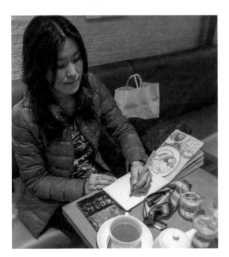

Kumi Matsukawa

Kumi Matsukawa was born in Japan and graduated from the accredited Musashino Art University, majoring in oil painting. She has more than 20 years of experience in the advertising industry as a freelance illustrator, drawing storyboards for TV commercials, and since 2001 has been teaching pastel and watercolour classes at learning centres near her home. In 2009 she joined the Urban Sketchers community as a blog correspondent from Tokyo.
www.flickr.com/photos/macchann/
ungaaa.cocolog-nifty.com/blog/

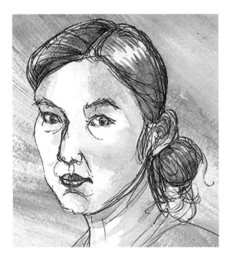

Shiho Nakaza

Shiho Nakaza is an illustrator and a graphic artist. A correspondent on the popular art blog Urban Sketchers, Shiho also creates art for publications and galleries. Originally from Okinawa, Japan, Shiho currently lives near Los Angeles, California.
www.shihonakaza.com

Melanie Reim

Melanie Reim is an award-winning illustrator with a sketchbook never far from her side. She is the chairperson of the MFA in Illustration program at the Fashion Institute of Technology in New York. As a documentary artist and Fulbright Scholar, her visual journals and reportage have been the subject of articles across the globe and are part of the Air Force Art Collection in the Pentagon in Washington, DC.

www.sketchbookseduction.blogspot.com

Rita Sabler

Born and raised in Saint Petersburg, Russia, Rita has travelled and lived in many places but currently lives and works from Portland, OR. She holds a BA in Psychology and Art History, an MA in Linguistics from UC Davis (CA) and a Masters in Interface Design from the Elisava School of Design in Barcelona. After such an extensive academic exploration she has finally settled into a career of graphic design and illustration, working part time as a musician, playing piano and directing an ensemble of musicians who perform traditional Argentine tango music. She is currently working on a book of drawings dedicated to Portland artisans and makers.

www.portlandsketcher.com

Pete Scully

Pete Scully is an urban sketcher originally from London, who has lived in Davis, California, since 2005. He records the world in his sketchbooks, primarily in ink and watercolour, and has had several solo exhibitions of his sketch work. Pete is an original member of the Urban Sketchers website and global sketching community, and has organised sketch crawls in Davis and London to encourage the art of location drawing. He lives in Davis with his wife Angela and son Luke, whose shoes and toys provide constant drawing inspiration.

petescully.com

Liz Steel

Liz Steel is a Sydney-based artist, teacher, illustrator and architect. She never leaves home without her sketchbook, pens and paints – always ready to document her daily life through quick, spontaneous ink and wash sketches. Liz runs the very popular online SketchingNow courses and teaches regular sketching workshops around Australia. She is an active member of the global online community of Urban Sketchers and coordinates Urban Sketchers Australia.

www.lizsteel.com

Paul Wang

Paul Wang's passion for the arts blossomed from a very young age and he went on to study Interior Architecture and Technical Theatre Design with support from National Arts Council. With his multi-disciplinary and multi-sensory training, his sketches and paintings are always bursting with dramatic colours, just like a stage set. As an extension of this creative process, he teaches actively as an art and design educator in Singapore and abroad. He is also an active Urban Sketchers blog correspondent and an advisory board member.

www.flickr.com/photos/fireflyworkshop

Samantha Zaza

Born in California but raised a nomad, Samantha Zaza spent her childhood moving between North America, Europe, the Middle East and North Africa. Having been Urban Sketchers' Istanbul Correspondent for the past seven years, Zaza is about to start sketching Morocco, her new adopted home. She is currently developing her travel portraits from past adventures in Eastern Anatolia into a series of large-scale ink drawings, the progress of which can be seen on her website.

www.szaza.com

Index

Other Contributors

Amy E Wynne
www.amywynne.com

Ana Peigneux Ortega

Bill Martin
www.wdmdesigns.com

Carol Hsiung

Celia Burgos

Chris Haldane
www.flickr.com/photos/chaldane7

Felix Siew
www.facebook.com/felix.siew.5

Gabi Campanario
gabicampanario.blogspot.com

Gail Wong
www.glwarc.com

Gazala Haq

Ignacia Ruiz
www.ignaciaruiz.com

John Booth
instagram.com/john_booth

Karin Schlieche
www.schlieche-mark.de
www.zeichenfest.de

Kinga Kowalczyk
printandword.com

Lulu Baldrac
lulubaldrac.tumblr.com

Lynne Chapman
www.lynnechapman.co.uk

Ortelius Drew
www.orteliusdrew.com

Sandra Cox

Sheila Rooswitha Putri
www.facebook.com/sheilasplayground

Simon Foxall
simonfoxall.tumblr.com

Stephen Reddy
stevenreddy.com

Sylvie Bargain
www.bigoudene46.net

Tia Boon Sim
Tiastudio.blogspot.com

Tim Baynes
www.timbaynesart.co.uk

William Bil Donovan
www.bildonovan.com

Acknowledgements

Thank you to all of the contributors who wrote chapters for this book; they are my teachers. They are Nina Johansson, Shiho Nakaza, Rita Sabler, Kumi Matsukawa, Samantha Zaza, Liz Steel, Virginia Hein, Melanie Reim, James Hobbs, Paul Wang and Ilga Leimanis. I am also grateful to all those who contributed sketches for this book. Huge thanks to Isheeta Mustafi, Nick Jones and the creative staff at RotoVision for making this book possible.

I am grateful to Gabi Campanario, who founded the Urban Sketchers website and invited me to be one of the original correspondents. To everyone else who has shared their sketching journeys online, you continue to provide me a constant source of inspiration, challenging me to improve myself.

On a personal note, I am eternally thankful to my Mum and Dad, who let me draw all the time when I was a kid and made sure I always had pens and paper. To my wife Angela, thanks for always supporting me and letting me go sketching. And my son Luke, for being my hero and having great shoes.

Finally, cheers to anybody who has been inspired to pick up a pen and start drawing the world. The more people sketch, the less we have to explain why we do it...

Pete Scully